NATIVE AMERICAN PAINTING

Selections from the Museum of the American Indian

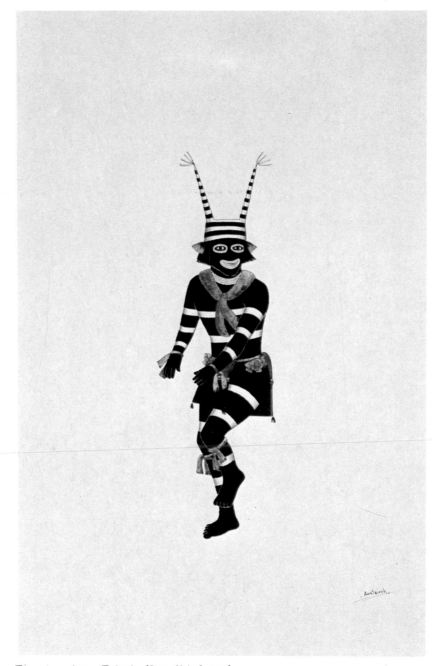

Fig. 1. Awa Tsireh (San Ildefonso).
Koshare kachina, c. 1930.
28.2 x 18.2 cm. Ink on Paper. 22/7874.

NATIVE AMERICAN PAINTING

Selections from the Museum of the American Indian

David M. Fawcett and Lee A. Callander

Photography by Carmelo Guadagno

Library of Congress catalog card no. 82-060422

ISBN 0-934490-40-6

Printed in U.S.A.
by ALF Associates, Emerson, N.J.

Cover. Awa Tsireh (San Ildefonso).
 Buffalo, deer, antelope dance, c. 1930.
 28.5 x 71.0 cm. Watercolor on Paperboard. 22/8609.

FOREWORD

In the lonely places of the American west the work of ancient artists still survives. Faded pigments, clinging tenaciously to rocky canyon walls, ravaged by centuries of exposure to the elements, stand as mute testimony to the compelling tendency of mankind to communicate through graphic representation. Human figures and those of animals along with designs whose meanings are as lost as the hands that created them so long ago, attest to an essential human characteristic -- artistic creativity. In fact, no continent is without the renderings of men who sought to produce some artistic statement.

Mankind has long possessed a rich symbolism and has expressed it in appealing techniques over the years, utilizing materials of many kinds. The native artist has always been inventive, has always been possessed of elements of creative genius. To speak of primitive art is no longer meaningful. The term "primitive" is too full of negative overtones. Perhaps the greatest recognition of the value of what might better be called native art was in the tribute paid it by latter day Western artists who saw that it was sui generis and who borrowed from it liberally in the production of their own works.

Native American art is steeped in ancient traditions: in the paintings on boulders in the deserts of the land, in the carving of masks from living trees, in the weaving of intricate designs in loomed fabrics, in the decoration of pottery, in the plaiting of fine basketry, in the fashioning of ornaments of precious metals, in beadwork, in the painting of hides, in the creation of stone sculpture, and in so many more endeavors of artistic merit. It is, then, of little wonder that Indians should have adapted such deep-seated tendencies to paper and canvas; to the use of pencils and crayons, and watercolors and oils. And that they should have done so with such remarkable results.

The Indian artist takes his inspiration from both tribal and Western sources, at times offering a blend. Some of his work reveals experimentation with techniques. Some of it bursts forth with emotion-laden impacts that have their roots in the pathos of a people whose lives have been set in turmoil as a result of Western cultural domination. Some Native American artists have sought to capture the essence of their cultural origins; perhaps to record it for all time before it is lost forever. And at times, one suspects, to discover something fundamental about cutural origins for personal reasons. There is in many native people an entirely understandable search for self; for personal identity. In his work the native artist sometimes participates in this quest.

The authors of this catalog have attempted in their selections of the works that are illustrated, and those that are included in the exhibition the catalog accompanies, to focus on a representative selection from the much larger number of works in the entire collection. They range from early ledger drawings executed in the mid to late 19th century to works done in 1982. A wide range of media and talent is encompassed. Different schools, different styles, different statements; a rich and varied compendium. The penetrating thread? The works are Indian. And they consistently reflect their Indianness. They spell out a continuum: one that began long, long ago, perhaps in a bleak western canyon where, in the bright searing sun, an artist outlined a figure against the rock wall with pigments fresh from mixing. Where a creative human being set something down about his or her people. Said something he or she was compelled to say.

Native American painters are still speaking out. And their message is still valuable.

Roland W. Force
Director

ACKNOWLEDGMENTS

A project such as this requires the knowledge, support, and talents of many individuals and organizations. Three separate grants from the National Endowment for the Arts funded portions of this catalog, conservation for the paintings, and the exhibition. Additional funding was provided by the Museum of the American Indian and the Henry and Lucy Moses Foundation. Essential support for the project was provided by Dr. Roland W. Force, Director of the Museum, and Dr. James G. E. Smith, Curator of North American Ethnology. Elizabeth Beim, Development Officer, and George Eager, Assistant Director, helped generate and manage the required funds.

Mary Davis, of the Huntington Free Library, and Nancy Henry, Manager of the Museum's Indian Information Center, cooperated in every way with the research of the collection. Registration staff, including Nina Golder, Mary Purdy, and New York University Intern Deborah Brinckerhoff, assisted with the cataloging, photography, and computerization of the information. Especially appreciated is the generous assistance in a number of registration and curatorial areas that was provided by Registrar's Assistant, Ruth Slivka, who also wrote all computer programs for the sorting of collection information. Former Museum Conservator, Phyllis Dillon, supervised the conservation survey, which was completed by Evelyn Koehnline in consultation with Antoinette King of the Museum of Modern Art. Valuable additional information about the collection was gained from the following consultants: Dr. J.J. Brody of the Maxwell Museum, University of New Mexico; Arthur and Shifra Silberman of the Native American Painting Reference Library in Oklahoma City; Father Peter J. Powell; and the Museum's Assistant Curator, Gary Galante.

Individuals at other museums who expressed support for the exhibition are Michael Fox of the Heard Museum, George Quimby of the Thomas Burke Memorial Washington State Museum, and David Mickenberg of the Oklahoma Museum of Art. Carmelo Guadagno of the Guggenheim Museum produced the photographs for the catalog, and Art Fleisher assisted in the design and printing. The Gallery Association of New York State provided matting, framing, and crating of the paintings in the exhibition. The text was skilfully edited by Sadie J. Doyle.

Finally, the painters themselves must be acknowledged for their enormous contribution, not just to this collection but to the continuing traditions of Native American artistry.

David M. Fawcett
Lee A. Callander

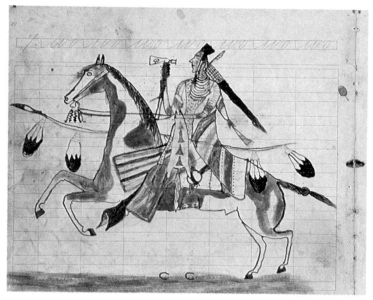

Fig. 2. Artist unknown (Blackfeet). Book of drawings.
14.5 x 17.6 cm. Ink, Crayon on Paper. 14/3394.

The figure pictured in this penmanship book is a Crow man on horseback dressed for a festive occasion. Friends or relatives of the man would recognize the drawing as a portrait by the details of his accoutrements.

NATIVE AMERICAN PAINTING

Native American painting is an enduring art form that began hundreds of years before the New World was discovered by Europeans and it continues today as a vivid means of expression. When we realize that much of the known history of the continents of North and South America has been passed to us through art and artifacts of their native peoples, we appreciate these relics not only as art objects but as important documentaries of life as it was long ago.

Only in recent times has a wider audience begun to appreciate American Indian artifacts as more than exotic curiosities. This holds true for painting by Native American artists as well. As early as a century ago, individuals admired and collected such painting and in addition had a considerable impact on its maturation.

The role a museum plays in the development of a new art form can also be considerable. This has been the case with Native American painting. Just as individuals were able to influence artists through purchasing power and training, museums played a part in the developmental directions of painting. A wider range of painting styles and forms was made possible because institutions such as the Museum of the American Indian collected and commissioned from an anthropological point of view. That is, esthetics were only one of several considerations when viewing a work or set of works. Paintings by children, not necessarily of high artistic merit but of great anthropological importance, were often collected. A glimpse of the world through the eyes of a young Eskimo child (see Fig. 37) or a Navajo student at a boarding school can thus be obtained.

Paintings have been used as a primary source of information about cultures. Byron Harvey III directed the massive "Ritual in Pueblo Art" project, which resulted in hundreds of watercolors by Hopi artists depicting various aspects of life on the three mesas. At the turn of the century the noted anthropologist M. R. Harrington commissioned Earnest Spybuck, a Shawnee, to paint scenes of Indian life. The resulting portfolio contains a wealth of minute details about dress, food, ceremonies, games, and transportation.

Entire portfolios were commissioned specifically for the Museum of the American Indian. One, by Fred Kabotie, contains dozens of fine paintings of Hopi kachinas. An anthropological point of view was also important in collecting various types of paintings by one artist. A small greeting card

by Awa Tsireh or Pablita Velarde is just as informative as a larger painting that may be more pleasing esthetically. The Museum has both in its rich collections.

The Museum was also able to obtain assembled collections from individuals and thereby enhance its holdings. A portion of the personal collection of Oscar B. Jacobson, a central figure in the development of Native American painting, is at the Museum. Other large collections include those of Major John Gregory Bourke, Dr. Henry Craig Fleming, Ruth and Charles DeYoung Elkus, and the Harvey family. Each of these and many others have contributed greatly to the value of the total collection. The Museum has in the past contributed to the research and exhibition of Native American painting. Jeanne Snodgrass's American Indian Painters and Dawdy's Annotated Bibliography of American Indian Painting, published by the Museum of the American Indian, have added a great deal to our knowledge of this subject.

The collection of the Museum of the American Indian thus spans the entire history of Native American painting. The bulk of the works was collected from the very early period through The Studio era to the 1950s, although later artists, such as R. C. Gorman, Jerome Tiger, and King Kuka, are represented. When added together these works on paper form one of the largest collections of American Indian painting in the world.

Until this year no complete catalog of the collection existed, only a fraction of the paintings had been photographed, and no comprehensive conservation measures to insure the preservation of these works had been taken. Two years of work funded principally by the National Endowment for the Arts has changed this considerably. All essential information about each work has been computerized for cross-indexing and quick retrieval. Black-and-white photographs as well as color transparencies have been made of every painting for research use. A conservation survey has been completed that has resulted in the expansion of archival storage space and conservation treatment on some pieces. Well-known scholars J. J. Brody, Father Peter J. Powell, and Arthur Silberman have reviewed the entire collection, offering valuable information concerning the documentation and significance of many of the paintings.

Finally, this catalog has made available for the first time a complete list of holdings in the collection. Scholars, Native Americans, and the public alike can benefit from this comprehensive information. In addition, seventy of the best paintings have been selected for exhibition and publication.

PLAINS AND FORT MARION ARTISTS

Like so many of the objects of European origin that profoundly affected Native American cultures on the Great Plains, artists' materials--paper, pencils, crayons, and ink--changed the form of the existing art styles. Painting as a means of expression had a long tradition for men and women on the Plains. While men's exploits in hunting, courtship, and war had formerly been recorded by pictographic representations on garments and tipi covers, the availability of books and paper to draw on allowed for a smaller, more portable means of describing significant events.

The small leather-bound book shown in Figure 21 has a poignant history that takes the viewer through several months in the lives of two groups of bitter enemies, the U.S. Cavalry and the Northern Cheyenne. The book, known as the "Double Trophy Roster", was first kept in 1876 by First Sergeant Brown of G Troop, 7th Cavalry. Although it is known that many pages are missing, the first entry is dated April 19, 1876. Brown chronicled the daily duties of the men in his troop, places and distances marched, and supplies ordered or received. The last remark that Brown recorded was "McEgan lost his carbine on the march while on duty with pack train, June 24, 1876."

On June 25, 1876, Custer's infamous battle with the Indians at Little Big Horn, Montana, took place. Sergeant Brown was apparently killed in the battle and the roster was taken from him by a Cheyenne named High Bull. With pencils and wax crayons, High Bull and his friends drew pictures of important events in their lives. Often the drawings were done over Sergeant Brown's writing, obscuring some of the words. The scenes depict brave battles of famous Cheyenne warriors against such enemies as the Crow, the Shoshone, and, of course, the U.S. Army. On November 26, 1876, General Mackenzie and his troops charged and destroyed Dull Knife's (a.k.a. Morning Star) village. High Bull was there and was killed during the battle. The roster book was recaptured by First Sergeant James H. Turpin of L Troop, 5th Cavalry.

The history of this book may never have been known had it not been for the efforts of George Bird Grinnell, the renowned ethnologist and collector. In 1898, at the request of the roster's owner, John Jay White, Jr., Grinnell took the book to the Cheyenne to see if any of the drawings could be identified. He stated in his correspondence to White, "I was fortunate enough to find among the Cheyennes Old Bear who had been an intimate friend of High Bull, and who, as I drew the book from my pocket, and held it out to him said, before

he had taken it into his hand, 'Why, I know that book. I have seen it often. High Bull owned and kept it.' The identifications in the book are all by Old Bear."[1]

Mr. White's wife donated the roster book to the Museum of the American Indian in 1921 along with Grinnell's documentary research papers.

Another great warrior who was at the Little Big Horn when General Custer was defeated was a Hunkpapa Sioux named Rain-in-the-Face. A set of small drawings done in colored pencil in 1885 by Rain-in-the-Face gives us a glimpse of what Sioux artists typically chose to depict in their drawings in this period (Fig. 15). The pictures were apparently done at the request of De Cost Smith, a noted collector of Sioux material culture. In addition to sharing drawing techniques, Smith taught Rain-in-the-Face and Sitting Bull how to write their names in English on these drawings during a session together at Standing Rock Agency, North Dakota.

Many of the drawings done by Plains Indian artists in the late 1800s are pictographic representations of themselves in scenes of bravery or of notable occasions in their lives. These drawings are executed on a wide variety of papers including the backs of government documents, cardboard box lids, opened envelopes, lined paper torn from composition books, and fine bond paper. Pencil, crayon, and a variety of black and colored inks were used to draw the pictures. Occasionally pigments and vegetal dyes like those used to decorate skin and cloth items were used. Many of the artists are unknown, although on some of the works English captions have been written that give the names of the persons or the event portrayed (Figs. 14 and 18).

The late nineteenth and early twentieth centuries were times of great upheaval for Native Americans on the Great Plains. The European commercial goods that were becoming increasingly available changed the ways that many objects were made and decorated. The rapid disappearance of the buffalo and frequent battles with the U.S. Army resulted in radical changes in traditional Plains life. The banning of warfare between long-standing Indian enemies and the enforcement of the reservation system led to many men from various Plains groups being incarcerated in army prisons for continuing to follow traditional customs.

In the spring of 1875, after a major campaign by the U.S. Army against four Southern Plains groups to subjugate "hostile" Indians, 72 warriors were taken to Fort Marion in St. Augustine, Florida. Jailed without benefit of trials, the charges against all of the prisoners ranged from murders of army officers and civilians, to stealing, or being known as warriors and troublemakers.[2]

Many of the Indian prisoners at Fort Marion began to draw and paint pictures during their incarceration. They were offered paper and other drawing materials and were encouraged to draw as a means of passing the time. Captain Richard Henry Pratt, the officer who escorted the prisoners on their train ride from Oklahoma to Fort Marion, was particularly instrumental in promoting the artists' work. The prisoners quickly gained recognition locally in St. Augustine, and soon throughout the country. The combination of Pratt's promotion of their work through his belief that the Indians could learn a trade to make livings for themselves, and the popularization of Plains Indian lore in the east, led to an enormous demand for drawings by the prisoner/artists.[3] Numbers of tourists from the north escaping winter's chill in St. Augustine could be seen visiting the fort bringing books to be sketched in and ivory lady's fans to be painted on. Once the artists recognized that there was indeed a market for their work, they would accumulate a stock of drawings and other items during the off-months to sell during the popular winter season.[4] The prisoners were all permitted to keep the money that they earned through the sale of their works. To further encourage their desire to support themselves, Pratt would issue passes for the Indians to go into the town of St. Augustine to purchase art supplies, clothing, food, and a few luxuries.[5]

One day, it seems, a group of the prisoners was taken on a shark fishing trip just outside of the St. Augustine harbor near Anastasia Island. The expedition out on a boat must have been a memorable experience for the men. When they returned, two artists, Bear's Heart, a Cheyenne, and Zotom, a Kiowa, recorded scenes from that day on several pages of the two drawing books here.

The exceptionally charming drawings done by Bear's Heart shown in Figures 19 and 20 are found in a composition book twenty-four pages in length. The pictures include St. Augustine scenery, prison life, and bygone days of warfare and buffalo hunting on the Plains. Zotom also produced many drawings. He was known as one of the bravest warriors in the group and was one of the last to surrender to the army. Months after he arrived at Fort Marion he was labeled "so perverse and insubordinate" that his jailers considered shooting him as an example to the other prisoners.[6] Zotom's drawings reflect the strong feelings that he had about traditional life on the Plains (Fig. 16). Recently two paintings have come to light that are believed to have been done by another Fort Marion artist, Little Chief. The drawing of a Sun Dance encampment

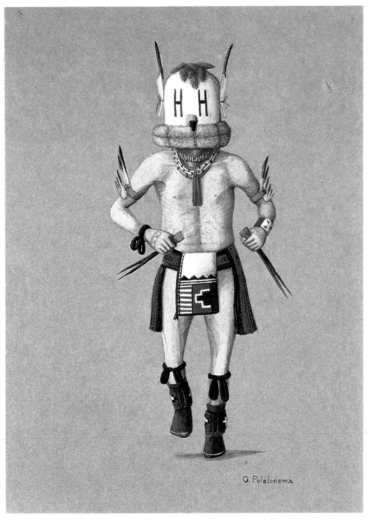

Fig. 3. Otis Polelonema (Hopi). "Kisa Kachina," c. 1935.
31.8 x 21.9 cm. Watercolor on Paperboard. 23/1245.

Polelonema's talents are well developed in this painting of the Chicken Hawk Kachina. A slight horizon line grounds the figure and the proportions of the body are more realistic. Polelonema painted intermittently after this period through the 1960s.

in Figure 11 bears no signature or remarks. The painstaking details that are executed on this sizable work make clear the artist's intent to record a specific event. Unfortunately, there are few known examples of Little Chief's drawings in existence to further compare with the stylistic elements of the Sun Dance scene and second drawing,[7] so the true artist may never be known.

Life in prison was not always easy for these men. They had arrived in chains, exhausted and malnourished after months of running from the army.[8] Homesick and humiliated, the force of their spirits led them to make adjustments to their situation. They were to rise above the prison walls as the great men that they were. Some, like Bear's Heart and Zotom, chose the white man's world after being released. Captain Pratt not only took a deep interest in the lives of the Indian prisoners while they were together at Fort Marion, but after their release as well. When they were let out of prison in 1878, many chose to return to their homes and families. Those who hoped to stay in the east were aided by Pratt to enroll in vocational or religious training schools. Pratt himself later founded the Indian school at Carlisle, Pennsylvania. A few lines taken from a letter from Bear's Heart convey his attitude toward his past and future,

"First they took us to Florida; they first teach us the good way and I find Indian road very hard, so I thought, I will never walk the Indian road any more; I find that the white people and colored people are very good friends to the Indians. I think I will be kind to everybody and work for white people...I am trying very hard to do well; I want to be the best Indian here."[9]

The circumstances at Fort Marion are a clear example of the great influence that non-Indian patronage played on the development and production of Native American art in the late 1800s. There were many army officers, scholars, and museum collectors actively seeking the creations of Native American peoples at that time. Indian artifacts and drawings were frequently bought and traded for, commissioned, or taken in battle by whites who were interested in acquiring these objects.

Such an individual was Major John Gregory Bourke. Bourke was an accomplished army officer, whose campaigns in the Indian wars throughout the Great Plains and the Southwest brought him into contact with many Native American groups and individuals.[10] He developed an absorbing interest in Indian life and actively collected and learned what he could about Plains

material culture and art. In 1880-81 Bourke collected a series of drawings that are now in the collection of the Museum of the American Indian. These are documented as being by Yellow Nose, a famous warrior who was a Ute by birth but was captured and raised by a Cheyenne man named Spotted Wolf. [11]

These drawings are done in pencil and colored inks on tracing paper. Now yellowed with age, many of the pages in the series of 350 drawings bear faint register marks in the left and upper margins. It is apparent that several of the drawings are tracings of other works. Often, figures end abruptly at the margin when there is sufficient space to complete them (Fig. 13). Others are not as obviously traced (Fig. 12), but still feature the telltale register marks. A few of the drawings have outlined patches or are missing parts of figures that Father Peter J. Powell suspects may be the rendering of a hole in the support of the original drawing. It has also been suggested by Father Powell that Major Bourke, and not Yellow Nose, produced most of the drawings in this series. [12] A close inspection of the drawings suggests that the works of several artists are represented.

Perhaps Bourke wished to gather a collection of Indian drawings by tracing originals himself during his travels. If the majority of these tracings are from originals drawn by Yellow Nose, perhaps Bourke worked with the Cheyenne artist at some point. Father Powell has found and identified several of the original drawings that are represented in the tracings. If Bourke's hand did the tracing and filling in, he often took liberties with the color and layout of the figures.

The drawing in Figure 23 is done on tracing paper and is recorded as being by Yellow Nose. While it does not have register marks, it bears a striking similarity to the drawing in Figure 22. The artist for Figure 22 is unknown, but was possibly an Assiniboin. It is tempting to speculate that the unidentified drawing is an original Yellow Nose and the second is Bourke's rendering of the scene. It may also be that two different Indian artists chose to depict this unusual event of a mounted warrior shooting or counting coup on a woman.

These drawings, like many other works done by unidentified Plains artists, require much research. A fascinating history of Plains art can be told once the keys are found.

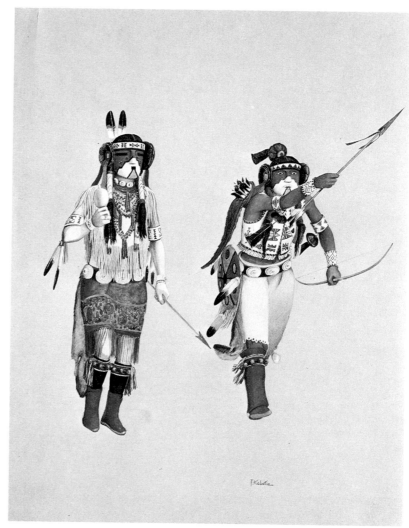

Fig. 4. Fred Kabotie (Hopi). Two Komantsi dancers. 35.7 x 27.2 cm. Watercolor on Paper. 22/8645.

This well-known Hopi artist had a profound influence on the development of Hopi painting on paper. The subtle shading of the figures creates a striking and powerful image, full of movement as well as detail.

EASTERN WOODLANDS ARTISTS

Some of the most engaging works done by Native American artists were created by painters who never attended art classes or had any formal training. This was the case for two Shawnee painters, Earnest Spybuck and Johnny John. Both artists were born in Oklahoma and attended the Shawnee Indian Boarding School.[13]

A teacher of Spybuck remarked that, at an early age, he would do nothing but draw and paint pictures in school.[14] Spybuck's fascination with detail makes his paintings an invaluable source of ethnographic data (Figs. 6 and 24). His paintings are filled with action and color. The two scenes shown here tell of the bustle and excitement of the procession around the camp before a Shawnee War Dance, and the dance itself. Moline wagons and Studebaker buggies are shown, and the details of each figure's costume are carefully rendered. Unlike most of his contemporaries, Spybuck attempted to paint in a realistic style and used atmospheric perspective to convey relative distances.

When he was twenty-seven years old, Spybuck met M.R. Harrington in Shawnee, Oklahoma. Harrington was there on a collecting trip for the Museum of the American Indian. After seeing some of the painter's work, Harrington commissioned Spybuck to paint a series of twenty-four watercolors for the Museum. Many of these works depict different phases of Shawnee, Sac and Fox, and Delaware ceremonies and dances. In his 1921 publication, Religion and Ceremonies of the Lenape, Harrington used two of Spybuck's paintings as illustrations.

Johnny John's work closely resembles that of Spybuck. He also dealt with the human form in a realistic style (Figs. 25 and 26). The non-Indian subject in Figure 26 gives the viewer a lighthearted glimpse of what "hot times" were really like in the west at the turn of the century.

A young Seneca artist named Jesse Cornplanter began to draw before he was nine years old. He and his sister, Carrie, produced sets of drawings that they sent from their home on the Cattaraugus Reservation to Joseph Keppler, a collector for the Museum of the American Indian, in New York City. It seems that Keppler must have encouraged a lively correspondence, for some of the pictures are fondly inscribed "from yours truly friend, Jesse J. Cornplanter." Perhaps Keppler was responsible for supplying Cornplanter with copies of Puck magazine, illustrations from which he sometimes copied

(Fig. 28). Cornplanter grew up to become a distinguished chief among the Seneca and a master carver of False Face masks in addition to his career as a painter.[15] While this drawing does not reflect the height that he reached as an artist, the young eyes of Jesse Cornplanter keenly observed a world that inspired him to draw.

Another Seneca artist who began to paint at an early age is Ernest Smith. Smith was also a sculptor. He produced most of his artwork during the 1950s and 1960s and depicted many scenes and legends that are part of Seneca life.[16] The watercolor shown in Figure 27 was completed in 1972 when Smith was sixty-five years old. It conveys an aspect of the powerful supernatural qualities of the False Face Society.

Woodlands Indian artists working in the first half of this century did not develop an identifiable style that strictly separated them into a "school" of art. Rather, working in widely separate geographic areas with different cultural influences, each artist painted in an independent style. Paul Billie (Fig. 33) is an example of an artist working in the Southeast who developed a distinctive perspective that expresses a unique interpretation of Everglades scenery.

THE FIVE KIOWAS AND TWENTIETH-CENTURY OKLAHOMA ARTISTS

In 1916 Mrs. Susan Peters arrived at Anadarko, Oklahoma, as a field matron for the Kiowa Agency. Mrs. Peters began holding art classes for Kiowa youths who showed an interest in painting. She bought paper and paints herself and provided an atmosphere where the "Oklahoma art expression, true and fresh" could thrive.[17] Among the first group of painters to attend her classes were Monroe Tsatoke, Stephen Mopope, Spencer Asah, James Auchiah, and Jack Hokeah. These men became known as the Five Kiowas. By encouraging these young artists to paint, Mrs. Peters was to play an important role in the development of the Kiowa school of painting.

During the fall of 1926, Mrs. Peters introduced the work of a few of her students to Edith Mahier and Oscar B. Jacobson, professors at the University of Oklahoma at Norman. Professor Jacobson was sufficiently impressed with the talent exhibited in the work that he made arrangements to enroll Tsatoke, Mopope, Asah, Hokeah, and a young Kiowa woman named Bougetah Smokey at the university. When their first year at classes had ended, the students returned to their homes to work on their families' farms. The following semester, Auchiah joined the original five at the university.[18]

It is notable that a woman was included in this group of Kiowa painters. Traditionally among Plains groups it was not appropriate for women to draw or paint human or representational figures. Rather, women usually painted geometric designs that were considered decorative. Realistic and stylized representations of human and animal forms were considered to have ritual associations that were, for the most part, in the realm of men. Although Smokey and other women were included in Mrs. Peters' classes, it was apparently difficult for Smokey to continue to paint in the style of human figure studies in which she was trained.[19] Smokey, one of the original Five Kiowas, eventually dropped from the enrollment at the university, married, and devoted her time to her family.[20]

With the support and direction of Professors Jacobson and Mahier, the Five Kiowas continued to develop their work. Financial assistance was provided by Mr. L.H. Wentz, an oil multimillionaire from Ponca City, Oklahoma, at the request of Professor Jacobson. This allowed the students to pursue their painting at the university on a full-time basis.[21] It was during this period that the Five Kiowas produced many of their finest works. In 1929 Professor Jacobson published a portfolio entitled Kiowa Indian Art and later further promoted their works through exhibitions in the United States and abroad.

There are many stylistic similarities in the paintings of the Five Kiowas. Each predominantly used tempera or casein paint on colored paper. The colors used are vibrant and clear. Their subjects are often single figures in motion shown at either a three-quarter turn away from the viewer or in profile. The five artists were active in Kiowa ceremonial life in their home towns. In addition to their careers as painters, Mopope and Tsatoke were also talented dancers and musicians who performed at many Kiowa ceremonial occasions. The intimate knowledge that these artists had of dance movements and costume is reflected in their paintings (Figs. 39-43). One can almost hear the pounding drumbeats, the jingling bells, and see the feathered bustles sway with the rhythm of the dance.

During the early 1930's Mrs. Peters continued to encourage local Indian painters. One of her students who was greatly influenced by the Kiowa style was Woody Crumbo of Creek/Potowatomi descent. Under the direction of Mrs. Peters, Crumbo, at an early age, was provided with artists' materials and taught to paint with the other students at Anadarko. At seventeen he returned to high school and from there went on to study art at the University of Wichita in Kansas and later at the University of Oklahoma with Professor Jacobson. Upon graduating from the University of Oklahoma in 1938, Crumbo took the position of Director of the Bacone Junior College art department in Muskogee, Oklahoma. There Crumbo's career continued as he developed a working relationship with the Gilcrease Museum and other museums in Oklahoma and Texas. Although he is widely known for his etchings and later mural paintings in the Department of the Interior building in Washington, D.C., and many other public buildings in Oklahoma, it is his early work (Fig. 44) that shows the strong influence of the Kiowa style.

Two contemporaries of Woody Crumbo who studied at Bacone Junior College were Dick West, a Cheyenne, and Fred Beaver, a Creek. West's early works show strong influence by Kiowa painting and that of Acee Blue Eagle, the founder of the art department at Bacone. West took over the directorship in 1947 and held that position until 1970. He portrayed fascinating pictorial records of dances, ceremonies, and stories that were in the traditions of the Cheyenne people. His formal art training led him away from the Kiowa style of painting and toward work that was influenced more by European sensibilities (Fig. 34).

Fred Beaver did not pursue the studio training that West did. The encouragement of Acee Blue Eagle at Bacone allowed him to develop his art by observing other painters and practicing on his own. The colors that Beaver uses in painting are subtle and muted (Fig. 32). His subjects are usually Creek and Seminole families engaged in everyday activities or portraits. His use of soft colors and a flat, formal application lends a feeling of quiet dignity and traditional life among his people.

One of the best known Native American artists who lived and painted in Oklahoma was Jerome Tiger, a Creek/Seminole. With little formal training, Tiger's ability to "put onto paper what the Indian has in his heart" earned him the reputation of a great painter at a very early age.[22] Tiger painted scenes of American Indian life and also captured universal human emotions--frustration, grief, anger, and elation.

His talent was initially recognized by Miss Nettie Wheeler of Muskogee, Oklahoma. With her support Tiger was able to exhibit and sell his works in her shop. A year's study at the Cleveland Institute of Engineering in 1963-64 helped develop his ability to render his figures in an illustrative style and gave him the technical expertise to depict human anatomy.[23] The subjects for which Tiger is best known are his series of the Trail of Tears portrayals, a series of Everglades settings (Fig. 31), and a group of stickball game scenes (Fig. 30). Most of his finest works were completed within the years 1965-67.

Jerome Tiger's life came to an untimely end in 1967 at the age of twenty-six when he accidently shot himself. His career was already well established and showed great promise for what might have come.

In the 1930's an increased awareness of the importance of Native American artists began to unfold in Oklahoma. The Kiowa and Oklahoma artists of this time were a part of the movement toward a deeper appreciation of Native American art. Non-Indian artists, scholars, and patrons encouraged Indian artists not only to paint but to paint what they knew best of their own cultural heritage. Museums that focused on Native American culture also played a vital part in promoting and exhibiting these works by relatively unknown artists. A similar movement also occurred in the Southwest with the founding of The Studio at the Santa Fe Indian School by Dorothy Dunn in 1932. Mutual support, competition, and exchange characterized the relationship between artists and teachers at The Studio, the University of Oklahoma, and Bacone Junior College. Opportunities for Native American artists to contribute to the art world in general developed where they had never existed

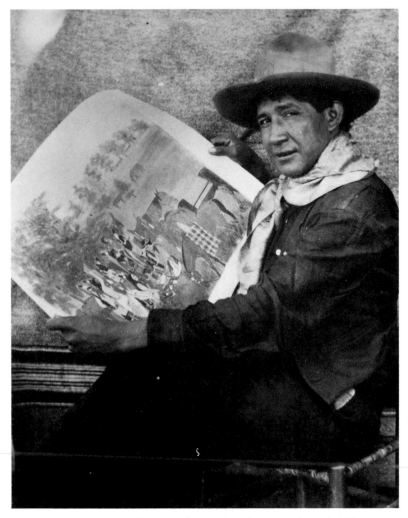

Fig. 5. The artist, Earnest Spybuck, photographed holding a painting similar to the one shown on the facing page.

before. These opportunities continue today. Modern artistic influences are sure to be incorporated into Native American painting creating works that stand on their own in the art world and yet reflect and retain their distinctive Indian quality.

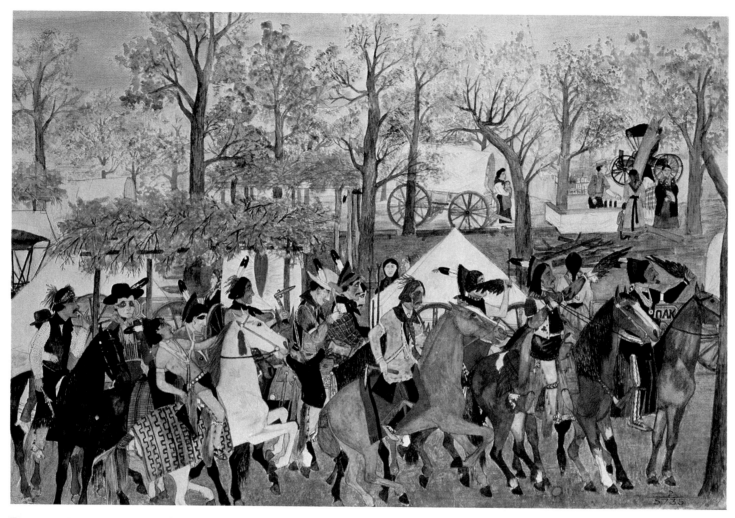

Fig. 6. Earnest Spybuck (Shawnee).
"Procession Before the Shawnee War Dance,"
44.2 x 63.9 cm. Watercolor on Paperboard. 2/5735.

Under a commission from M.R. Harrington, Spybuck painted this scene, which was meant to capture the details of the parade around camp before a War Dance. The elaborate garments, face paint, and horse trappings mark this as an important ceremony among the Shawnee.

SOUTHWEST ARTISTS

Native American painting in the Southwest is unique in that the tradition of painting has continued unbroken from prehistoric times. The Pueblos and the Navajos have long created ceremonial paintings and wall murals. Because these native societies are among the few in North America that have preserved their social integrity, the reason to paint was also preserved. At the turn of the century Jesse Walter Fewkes commissioned a series of drawings by Hopi artists, one of the first set of works on paper in the Southwest. A more refined, modern style of Hopi painting continues to develop today. Tanner,[24] among others, notes parallels between these modern paintings and prehistoric murals such as those at Awatovi and Kawaika-a. Features in common include a flat, uniform, density of paint with no shading, outlined features, no attempt at perspective, and a uniform subject matter of forms, dress, objects, and animals.

Many scholars and collectors have thus viewed Indian painting as one of the few remaining expressions of the Native American spirit. Many others declare these traditions to be pure, unhampered by European forms or influence. Tanner writes that the culture of Native Americans directly dictated a decorative style of painting.[25] Jacobson and D'Ucel note in the lack of modeling and stylized plants the strength of the Indian's long atavistic past and Asian origins.[26] Sloan and LaFarge praise the simplicity, balance, rhythm, and abstraction of Native American painting.[27]

It would, however, be a mistake to underestimate the importance of European contact on Native American painting in the twentieth century. As with other forms of native expression, the audience for the art dictated certain stylistic elements, some traditional, some certainly not. Painting on paper was never an integral part of Southwestern ceremonial activity, as was the case with painting on walls or with sand. Collectors, dealers, and museums, including the Museum of the American Indian, played a large role in the development of works on paper. J.J. Brody has traced the dramatic influence of this European audience on Southwestern weaving noting that modern paintings, like woven textiles, were created to be sold to outsiders.[28]

At the turn of the century Native American societies in the Southwest were changing slowly to a money economy. Craftsmen found that income could be earned by selling to outsiders, and the form and content of the articles sold soon reflected the expectations of white patrons. These expectations demanded that the paintings be well made, have the approval of the major arbiters of good taste, be made by Indians, and appear to have "traditional" content.[29] Such "typical Indian" features were defined and promoted by white patrons and through institutionalized art instruction of young Native Americans. Often with the best intentions such whites saw Indian painting "as something produced instinctively and spontaneously as the racial expression of a primitive people."[30]

The pricing systems for works on paper varied with patron and artist. Artists painting for the School of American Research and the Museum of New Mexico were paid by the hour; Hopi artist Fred Kabotie and San Ildefonso artist Julian Martinez (Fig. 46) charged by the number of figures in the painting; and Taos artist Pop Chalee charged by the number of hairs in a horse's tail.[31] Traders and museums also sponsored artists. One of the earliest large commissions undertaken by an Indian painter was the creation of a portfolio of Hopi ceremonial figures by Fred Kabotie (Fig. 4). Dozens of other commissions by the Museum of the American Indian and others resulted in the creation of fine portfolios which document Southwestern life, but which also reflect European values and the leading painting styles of the era.

The first generation of Indian painters consisted of a few Pueblo artists who took an interest in painting on paper between 1915 and 1920, and who quickly developed and refined styles while working under the guidance of white patrons. The first known painter was Crescencio Martinez of San Ildefonso, who in 1916 sold some paintings to Alice Corbin Henderson, a poet in Santa Fe. Martinez led the way in stylistic terms for the emerging group of painters, all of whom were in close contact with one another.

At this time there were several efforts to promote painting as a means of relieving the deteriorating economic situation among the Pueblos. C.G. Wallace, owner of a trading post, tried to encourage painting as early as 1918 at Zuni.[32] His efforts were stifled by intense religious pressure discouraging painting. In 1934 he abandoned his assembly-line production of paintings for the developing market in silver jewelry.

Efforts in Santa Fe were more successful. Edgar L. Hewett, Director of the School of American Research and the Museum of New Mexico, had been inspired by Fewkes's work with the Hopi and began supporting painting as early as 1916. He employed several artists in Santa Fe, including Fred Kabotie and Otis Polelonema from Hopi, Awa Tsireh from San Ildefonso,

and Velino Herrera from Zia. By 1920 the work of these artists had been shown in New York and Chicago and in Europe. El Palacio became the journal that most frequently promoted this new art form.

It is significant that these early artists were more productive in the white community of Santa Fe, away from their home villages. They came to Santa Fe with some art experience; most were also expert decorators of traditional pottery. The very early paintings were realistic and representational. Between 1920 and 1925 there was a shift toward abstract decoration. Brody[33] describes these changes: "environments disappeared and figures increasingly became firmly outlined...color (used) to describe and shape forms became instead colored drawings with color used to decorate and fill outlined areas." These artists in Santa Fe returned to their communities in time, bringing their personal style to villages where school children were already being taught to paint.

The San Ildefonso Day School began teaching painting as early as 1910.[34] The tribal economy was being revived by the sale of paintings with the support of Dr. Hewitt and others such as John Sloan, who in 1919 entered the work of San Ildefonso artists Awa Tsireh and Crescencio Martinez in a New York show of the Society of Independent Artists. Their popularity began to grow. Awa Tsireh began, like the others, with realistic portrayals of Pueblo life. In the 1920s such realism became modified by conventional themes, including koshares or clowns (Fig. 1), skunks, deer, and rainbows (Fig. 49). Some of these themes, such as the skunk motif, appear in San Ildefonso painting as early as 1920. Tse Ye Mu (Romando Vigil) may have invented the stylized Bambi-like deer that later pervaded Southwestern Indian painting.[35] Many other motifs came from Mimbres designs, which were becoming well known in the period. Later, in the early 1930s, the San Ildefonso artists became very abstract in their works, painting in flat colors and eliminating horizon lines. Dance scenes and animals became totally abstract (see Awa Tsireh Figs. 9, 48, and cover, and Tse Ye Mu Fig. 47). Julian Martinez, husband of the well-known potter Maria, painted stylized dancers. Tonita Peña, the only woman artist among the very early painters, was active at this time (Fig. 56), as were Oqwa Pi, who developed his own style in the 1930s (Fig. 55), and Louis Gonzales (Fig. 45), who often painted murals.

Other Pueblos were not as receptive to painting as San Ildefonso. At Zia in the 1920s Velino Herrera provided drawings of the sun symbol of his tribe to white officials who adapted it as the logo of the state of New Mexico. His behavior "was considered so outrageously individualistic...that he was cast out

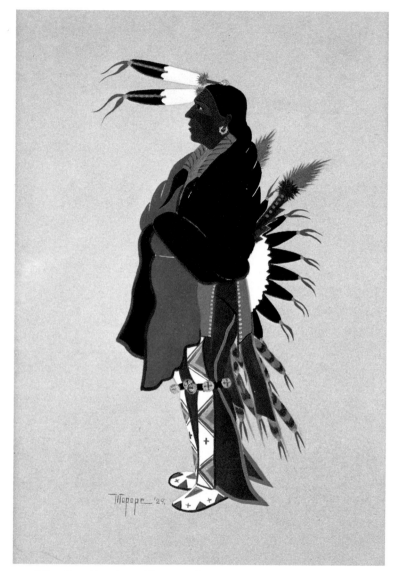

Fig. 7. Stephen Mopope (Kiowa).
Dancer with bustle, 1929. 27.7 x 17.8 cm.
Opaque Watercolor on Colored Paper. 22/8617.

Stephen Mopope was in the forefront of the development of the Kiowa style of painting. The dancer shown here is in a costume that reached its greatest popularity in Oklahoma in the 1950s and has become the hallmark of pan-Plains Indian costume today.

17

by his people, his property was confiscated, and he never again won acceptance by his tribe." [36]

Another center of early painting was the Hopi villages on the three mesas in Arizona. When Polelonema and Kabotie, who were taken from Hopi to attend the Santa Fe Indian School, returned home, they encountered resistance that "was not to be released...until an art-buying market was finally able to exert sufficient economic pressure to overcome the interdiction." [37] Despite the resistance, a distinct Hopi style emerged which included shaded color, bits of ground, shadows, and the very frequent use of kachina subjects.

Otis Polelonema returned to Hopi in 1921 and has had isolated periods of painting since that time. His early works emphasize volumetric, realistic figures in static poses [38] (Figs. 3, 8). Several other early Hopi artists were active during this period, but little is known about them. Waldo Mootzka is one such artist whose earliest work was collected for the Museum of the American Indian by John Louw Nelson (Fig. 53). Until now he has been best known for his later painting, completed shortly before he was killed in an automobile accident. T. Tomossee was influenced by Polelonema and Kabotie and also painted commissioned works for John Nelson. He usually painted single kachinas that resemble the early Fewkes drawings. One painting in the collection is unusual in that a group of kachinas is portrayed (Fig. 54).

The best-known Hopi painter by far is Fred Kabotie, who as a young man in 1927 began a series of paintings for the Museum. In his biography Kabotie writes " (Nelson) and I had some long talks about how I might paint some important Hopi ceremonies, under Heye Foundation sponsorship, to preserve the details for future generations." [39] The significance of Kabotie's purpose is clear in Figure 50, a painting of the Shalako kachinas and Hahai-i Wuqti. When Kabotie painted this in 1927, the Shalako had not appeared in a dance for thirty-one years. Furthermore, Kabotie was instrumental in the reintroduction of the Shalako to Hopi some seventeen years later, in 1944. The completed portfolio that Kabotie produced for Nelson is today in the Museum's collection. Kabotie drew his figures with great feeling and accuracy, using subtle shading to bring the watercolor forms to life. His efforts to preserve information are an unqualified success with single figures (Figs. 4, 50) and entire dance scenes (Fig. 51). He supervised the making of reproductions from the ancient murals of Awatovi and Kawaika-a, which probably had an impact on his own style. [40] By 1940 Kabotie began developing the landscapes in his paintings, placing his figures in a realistic environment. After 1937 he taught at Oraibi High School, influencing an entire generation of young Hopi artists and remaining one of the best-known and most influential artists of the Southwest.

In the 1960s the Museum again commissioned a series of paintings to record Hopi life. [41] Byron Harvey III worked with five Hopi artists (Leroy Kewanyama, Marshall Lomakema, Narron Lomayaktewa, Arlo Nuvayouma, and Melvin Nuvayouma) to create a series of ethnographically detailed paintings of the Hopi life cycle, ritual, the Kachina Cult, clowning, and curing which represent a very important contribution. The Museum also holds paintings by members of the Artist Hopid, founded in 1973 to encourage artistry, education, and research, and to instill Hopi pride and identity in the ongoing tradition of Hopi painting.

By the early 1930s the "self-taught" painters had received some notoriety. Various efforts had been made to institutionalize the training of young artists to insure the continuation of painting. In 1928 Miss Dorothy Dunn worked on a plan for such a studio at the Santa Fe Indian School. In 1932, with the support of the federal government, The Studio opened under the guidance of Miss Dunn and remained so until 1937.

The Studio at Santa Fe is the single most important institution in the early development of Southwestern Native American painting. Through The Studio, well-intended instructors insisted that "typically Indian" styles be adhered to. Miss Dunn's attitude is clear: "90% of the young Indians have to be trained away from the white man's influence...before memory awakens in them a vast store of their art tradition." [42] This vast store, according to Miss Dunn, includes for the girls "home life, baking, dancing, pottery-making, and the boys paint scenes of the hunt, racing horses, leaping deer -- and the method of approach, the only approach, is traditional, symbolic." [43]

Miss Dunn set four objectives for The Studio: an appreciation of Indian painting among students and public; to produce new paintings with high standards; to evolve new styles and techniques in character with old; and to maintain tribal and individual distinctions. [44] There were conflicts in the approach, however, as the "traditional" styles emulated by The Studio were strongly influenced by what white patrons of Santa Fe believed "traditional" styles to be. Characteristics included "strong outlines within which flat colors were confined and in which there were no specific backgrounds." [45] Classroom training was rigorous; students were not allowed to use pencils and had "no time for philosophy, but...rather to produce acceptable work for the white market or find other ways to make a living." [46]

Several of the first generation painters had contact with The Studio. In 1931 Awa Tsireh, Julian Martinez, and Jack Hokeah, one of the Five Kiowas, worked on a mural there. Velino Herrera was in Santa Fe and two Hopis, Mootzka and Riley Sunrise (Quoyavema), were at The Studio. Quoyavema was strongly influenced by the Kiowas although Kabotie's style is much more evident here (Fig. 52). Children of the first generation painters who studied at The Studio included Popovi Da, son of Julian and Maria Martinez, and Joe Herrera (Fig. 66), son of Tonita Peña. Other young Pueblo artists emerged from The Studio as major talents. Ben Quintana from Cochiti painted in the typical Studio style (Fig. 63) as well as in an idiosyncratic style indicating great promise just before his death in 1944 in World War II at the age of twenty-one (Fig. 58). Geronima Cruz Montoya, of San Juan, also painted in The Studio style (Fig. 59) and continued her work at the Santa Fe Indian School as chairman of the Art Department from 1937 until 1961.

The Studio was especially significant in the development of Navajo painting. Brody[47] cites three very early traditional Navajo painters (Choh 1885, Apie Be-gay 1902, and Klah-tso 1905-1912) but none in the period from 1912 to 1932. In 1932 several Navajo painters entered The Studio and eventually became the best-known artists of any Studio alumni: Harrison Begay, Gerald Nailor, Quincy Tahoma, and Andy Tsinajinnie. The style is characterized by "nostalgic themes" and pastoral landscapes[48] that include "flatly laid, strong but harmonic colors...confined to given areas by firm contour lines, all elements...placed close to the picture plane, and the landscape environments implied by a series of abstract plant forms."[49] Disney-like animals and botanically incorrect plants adorn landscapes typified by buttes and clouds. Despite their popularity this style did not reach the Navajo Reservation until the 1950s.

Quincy Tahoma often mixed plant species and included--and may have invented[50]--the common motif of two birds swooping across the sky. In "First Furlough" (Fig. 67) a Navajo soldier returns home from World War II to his family on the reservation. This important painting is probably autobiographical, for Tahoma was one of the famed Navajo "code-talkers" in the Pacific. He died in 1956 at the age of thirty-five. Andy Tsinajinnie is also a Studio artist who was influenced by many styles, including that of the Kiowas. "Deer Hunt on Horseback" (Fig. 69) is painted in typical Studio style. Beatien Yazz was another Navajo who was successful at The Studio. Encouraged in painting from an early age by the Lippincotts at the Wide Ruins Trading Post, he gained notoriety through an article about him in Collier's in 1944 and an

illustrated, fictionalized biography (Spin a Silver Dollar), both by Alberta Hannum. "Mounted Buffalo Hunter" (Fig. 68) was painted during this period of notoriety while he was still in his teens. Movement away from Studio esthetics is evident in this painting with more muscled forms and more action in the scene. Charley Yazzie's "Squaw Dance" (Fig. 64) is typical of the continuing Navajo style, although it was probably painted in the 1960s. Many figures are traced in order to expedite the painting. Similar dance forms are done by Ignatius Palmer, a Mescalero Apache (Fig. 70), although he also painted in Studio style (Fig. 62).

The influence of The Studio continued, although elements were added or changed and new techniques were introduced. The pioneer abstract artist Raymond Jonson at the University of New Mexico taught a spattering technique, which was used in some Native American paintings. Cubism was borrowed successfully by several artists, the most important of whom is Joe Herrera, a Cochiti man who was a major force in changing the direction of Indian painting. Oscar Howe, Tony Da, Michael Kabotie, Tyler Polelonema, and Helen Hardin all followed the lead of Herrera and his designs. While pursuing his graduate degree in art at the University of New Mexico from 1950 to 1952, Herrera used Jonson's spatterwork technique in the re-creation of the San Cristobal petroglyphs. The color obviously is Herrera's invention (Fig. 66). Tony Da, grandson of Julian and Maria Martinez, also experimented with spatterwork and abstract designs alongside traditional forms (Fig. 65).

Many other Pueblo artists broke away from Studio tradition. Jimmy Byrnes (Acoma-Laguna) includes a horizon line and well-formed figure in "Little Fire God and Others" (Fig. 57), which also shows an art deco influence. Charles Vicenti (Zuni) painted "Home Life" (Fig. 61) in 1955. This painting, with its bright colors and strong forms, reflects painting and other arts that were encouraged at Zuni in the 1940s and 1950s by Clara Gonzales. In "The Food Bearers" (Fig. 60), painted in 1959, Gilbert Atencio, nephew of Maria Martinez and a classmate of Beatien Yazz, paints a ceremonial scene typical of his work after 1959. In a deliberate break from The Studio, he is here emulating the early self-taught painters, such as Fred Kabotie.

The 1950s saw a continuation of institutional influences on Native American painting. The Philbrook Art Center annual competitions restricted participants to a "traditional Indian style."[51] Notions of "traditional" styles were again carefully defined, allowing little room for experiment until 1958, when the Philbrook introduced a new, nontraditional category. "Deer"

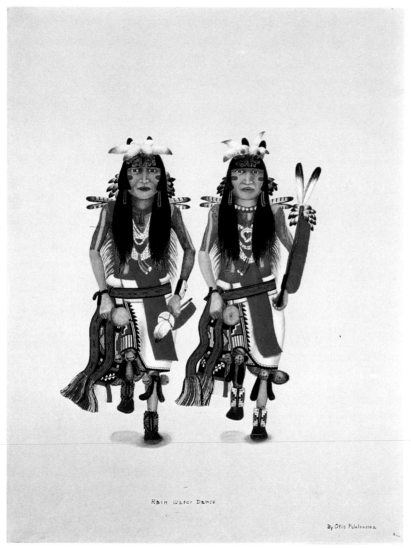

Rain Water Dance

By Otis Polelonema

Fig. 8. Otis Polelonema (Hopi). "Rain Water Dance," c. 1930. 48.5 x 35.6 cm. Watercolor on Paper. 23/1246.

These static yet detailed figures are typical of Polelonema's early works; the hands and bodies are not well proportioned. Several patrons, including Katherine Harvey, commissioned works by this artist and other self-taught painters as early as the 1920s.

by Maxine Gachupin (Fig. 71) was entered in the 1964 Philbrook competition; it exhibits stylistic elements rooted in The Studio tradition.

As more Native American artists began traveling and painting they borrowed extensively from various cultures and styles, resulting in what one author described as "treatments of burial and spirit ascension and confused ceremonials and historic reenactments in which tribal cultures are transposed with Kiowa braves being driven from the Florida everglades on Comanche ponies carrying Sioux shields."[52]

In 1962 an important event occurred with the founding of the Institute of American Indian Arts at the former site of The Studio. Young Native Americans from all over the country were encouraged to interpret their own cultural experience and heritage in terms of modern art. A new generation of such artists as Fritz Scholder emerged, decried by many as nontraditional, yet encouraged by many others as evidence of a living Native American painting tradition. Techniques and styles may have a greater, more individualistic range today, but all are united in their reflection of Native American culture in our age.

NOTES

1 Letter from Grinnell to White, October 15, 1898. MAI 10/8725.
2 Petersen 1971:15.
3 Ibid.:64.
4 Ibid.:65.
5 Ibid.:65.
6 Ibid.:172.
7 Ibid.:236. Petersen notes that there are only two known works by Little Chief. 11/1705 and 11/1706 may be an additional two.

NOTES

8 Ibid.:15.
9 Ibid.:102.
10 Anonymous, Indian Notes 1928:434-37.
11 Grinnell 1923 Volume I:196.
12 Powell, personal communication, November, 1981.
13 Silberman, personal communication.
14 Snodgrass 1968:179.
15 Ibid.:41.
16 Ibid.:176.
17 Ibid.:56.
18 Silberman 1978:16.
19 Snodgrass 1968:177.
20 Ibid.:177.
21 Dunn 1968:219.
22 Broder 1981:132.
23 Ibid.:132.
24 Tanner 1973:32.
25 Ibid.:12.
26 Jacobson and D'Ucel 1950:6.
27 Sloan and LaFarge 1931:7.
28 Brody 1971:27.
29 Ibid.:71.
30 Ibid.:91.
31 Ibid.:191.
32 Ibid.:112.
33 Ibid.:114.
34 Ibid.:81.
35 Brody, personal communication.
36 Highwater 1980:32.
37 Brody 1971:81.
38 Ibid.:110.
39 Kabotie and Belknap 1977:44.
40 Douglas and D'Harnoncourt 1941:208.
41 Byron Harvey III 1970.
42 Anonymous:3.
43 Ibid.:3.
44 Brody 1971:127.
45 Ibid.:115.
46 Ibid.:131.
47 Ibid.:74.
48 Ibid.:134.
49 Ibid.:143.
50 Brody, personal communication.
51 Strickland 1980:12.
52 Ibid.:22.

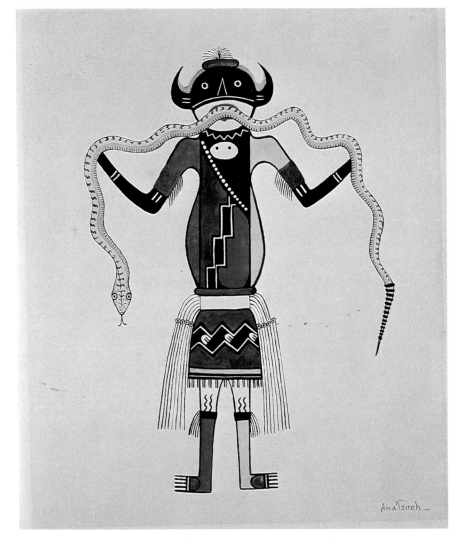

Fig. 9. Awa Tsireh (San Ildefonso). Stylized snake dancer, c. 1930.
25.3 x 20.4 cm. Watercolor on Paperboard. 24/2707.

Awa Tsireh's portrayal of a snake dancer is highly abstract, a style of painting he reached after earlier periods of more realistic portrayals. Like the other early painters, this artist created paintings to be sold to collectors.

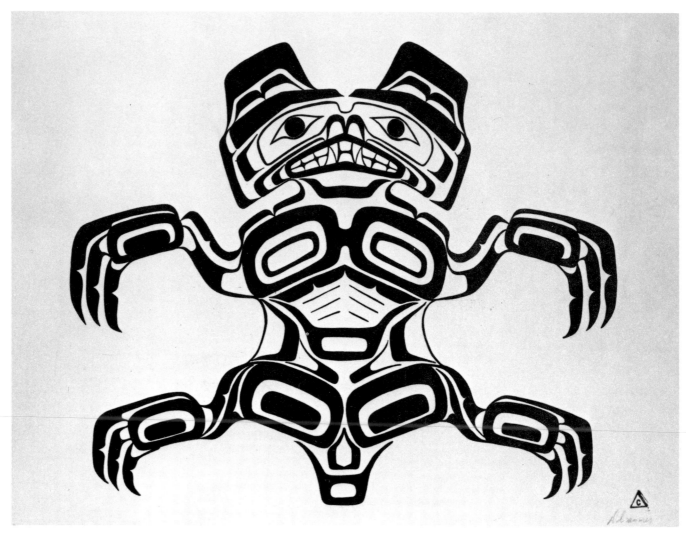

Fig. 10. Douglas Cranmer (Kwakiutl). "Head of a Bear," 1965.
46.9 x 58.9 cm. Ink on Paperboard. 23/6056.

*Many contemporary Northwest Coast artists, like Cranmer,
depict highly stylized figures of animals, fish, and birds in their
work. Although artists from this area have generally been best
known for carving, painting in a two-dimensional medium is
becoming an important art form producing powerful works such
as this.*

REFERENCES

Anonymous
 n.d. Pueblo Indian Painting. Indian Art Series, No. 1.
 Santa Fe: New Mexico Association on Indian Affairs.

Anonymous
 1928 The Major John Gregory Bourke Collection. IN
 Indian Notes, Volume V, Number 4. New York: Museum of
 the American Indian, Heye Foundation.

Broder, Patricia Janis
 1978 Hopi Painting: The World of the Hopis.
 New York: Brandywine Press.

 1981 American Indian Painting and Sculpture.
 New York: Abbeville Press.

Brody, J.J.
 1971 Indian Painters and White Patrons.
 Albuquerque: University of New Mexico Press.

Dawdy, Doris Ostrander
 1968 Annotated Bibliography of American
 Indian Painting. Contributions from the Museum
 of the American Indian, Heye Foundation,
 Volume XXI, Part 2.

Douglas, Frederic H., and Rene D'Harnoncourt
 1941 Indian Art in the United States. New York:
 Museum of Modern Art.

Dunn, Dorothy
 1968 American Indian Painting of the Southwest
 and Plains Areas. Albuquerque: University of
 New Mexico Press.

Fewkes, Jesse Walter
 1903 Hopi Katcinas Drawn by Native Artists.
 Washington, D.C.: Bureau of American Ethnology
 Annual Report No. 21.

Grinnell, George Bird
 1923 The Cheyenne Indians. Volumes I and II.
 Lincoln, Nebraska, and London, England: University
 of Nebraska Press.

Harrington, M. R.
 1921 Religion and Ceremonies of the Lenape. IN
 Indian Notes and Monographs Misc. 19. New York:
 Museum of the American Indian, Heye Foundation.

Harvey, Byron III
 1970 Ritual in Pueblo Art: Hopi Life in Hopi
 Painting. New York: Museum of the American Indian,
 Heye Foundation.

Henderson, Alice Corbin
 1931 Modern Indian Painting. IN Sloan and LaFarge,
 Introduction to American Indian Art. New York:
 The Exposition of Indian Tribal Arts, Inc.

Highwater, Jamake
 1980 The Sweetgrass Lives On. New York:
 Lippincott & Crowell.

Jacobson, Oscar B., and Jeanne D'Ucel
 1950 American Indian Painters, Vol. I.
 Nice, France: C. Szwedzicki.

Kabotie, Fred, with Bill Belknap
 1977 Fred Kabotie: Hopi Indian Artist.
 Flagstaff: Museum of Northern Arizona with
 the Northland Press.

Libhart, Myles
 1967 The Dance in Contemporary American Indian
 Art. New York: Indian Arts and Crafts Board, U. S.
 Department of the Interior.

Petersen, Karen Daniels
 1971 Plains Indian Art from Fort Marion.
 Norman: University of Oklahoma Press.

Silberman, Arthur
 1978 100 Years of Native American Painting.
 Oklahoma City: The Oklahoma Museum of Art.

Sloan, John, and Oliver LaFarge
 1931 Introduction to American Indian Art.
 New York: The Exposition of Indian Tribal Arts, Inc.

Snodgrass, Jeanne O.
 1968 American Indian Painters: A Biographical
 Directory. New York: Contributions of the Museum
 of the American Indian, Heye Foundation Vol.XXI, Part I.

Soustelle, Jacques
 1961 Daily Life of the Aztecs. Stanford:
 Stanford University Press.

Spindler, Herbert
 1931 Introduction to American Indian Art, Part II.
 IN Sloan and LaFarge, Introduction to American Indian
 Art. New York: The Exposition of Tribal Arts, Inc.

Strickland, Rennard
 1980 The Changing World of Indian Painting and
 Philbrook Art Center. IN Native American Art at the
 Philbrook. Tulsa: Philbrook Art Center.

Tanner, Clara Lee
 1973 Southwest Indian Painting: A Changing Art.
 Tucson: University of Arizona Press.

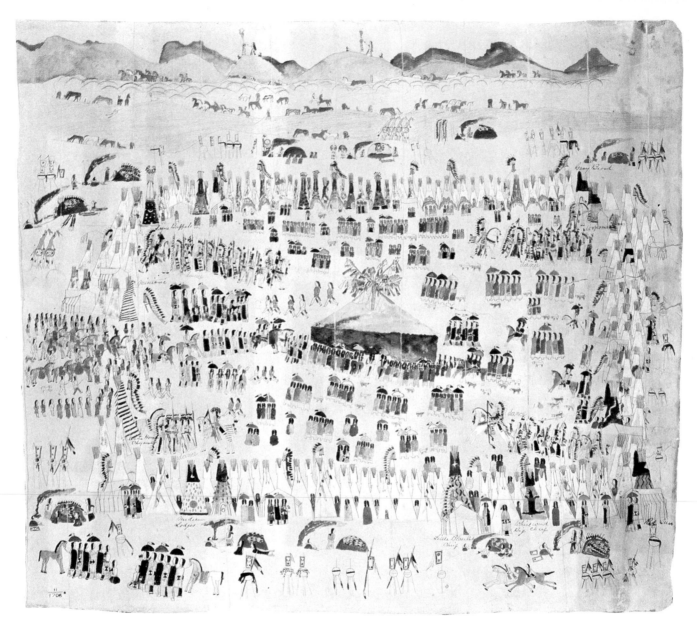

Fig. 11. Possibly Little Chief (Cheyenne). Sun Dance encampment.
59.5 x 65.8 cm. Ink, Graphite, Watercolor on Paper. 11/1706.

This drawing is remarkable for its size and detail in composition. It skillfully illustrates the many social and sacred activities associated with the Sun Dance. A large group of visitors can be seen entering the camp from the left and approaching the central lodge. Many small groups of women are shown in the center field sitting under umbrellas that were used as protection from the heat of the sun.

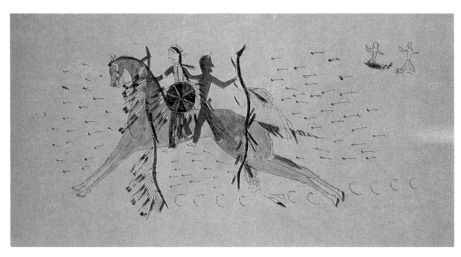

It has long been thought that these drawings were done by Yellow Nose, a Ute captive raised by a Cheyenne chief. Evidence gathered by Father Peter J. Powell now suggests that they are tracings of works by Yellow Nose and others. It is possible that Captain J. G. Bourke, the collector of these drawings, actually traced them himself from original drawings that he saw on his travels through Indian Territory. Whatever their origin may be, the drawings stand as an important documentation of Plains history and artistic achievement.

Fig. 12. Possibly Yellow Nose (Cheyenne).
 Two warriors on horseback in gunfire.
 c. 1880, 25.5 x 38 cm.
 Colored Ink on Tracing Paper. 23/4472.

Fig. 13. Possibly Yellow Nose (Cheyenne).
 Group of dancers or captives (?).
 c. 1880, 25.5 x 38 cm.
 Colored Ink on Tracing Paper. 24/1045.

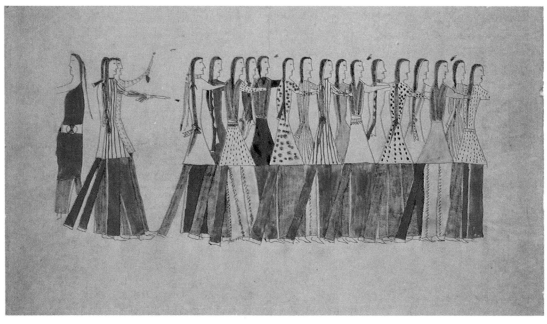

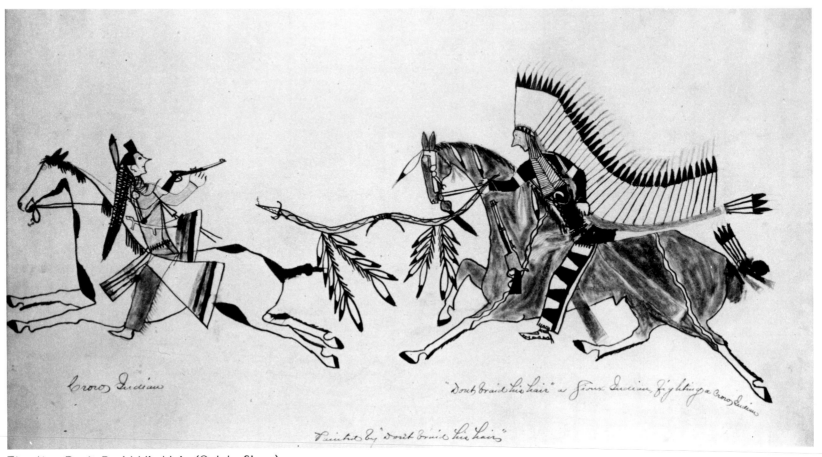

Crow Indian

"Don't braid his hair" a Sioux Indian, fighting a Crow Indian

Painted by "Don't braid his hair"

Fig. 14. Don't-Braid-His-Hair (Oglala Sioux).
Sioux and Crow on horseback, c. 1880. 28.1 x 50.9 cm.
Ink, Crayon, Graphite on Paper. 10/9627.

This scene shows two elaborately dressed warriors engaged in battle. The artist, Don't-Braid-His-Hair, depicts himself performing one of the greatest traditional acts of bravery — to count coup on (to touch) his armed enemy while his gun remains undrawn at his horse's side. The Crow man is shown with the distinctive "pompadour" hairstyle and the hero is splendidly bedecked in an eagle-feathered bonnet and hair-pipe bead breastplate and is carrying a feathered coup stick.

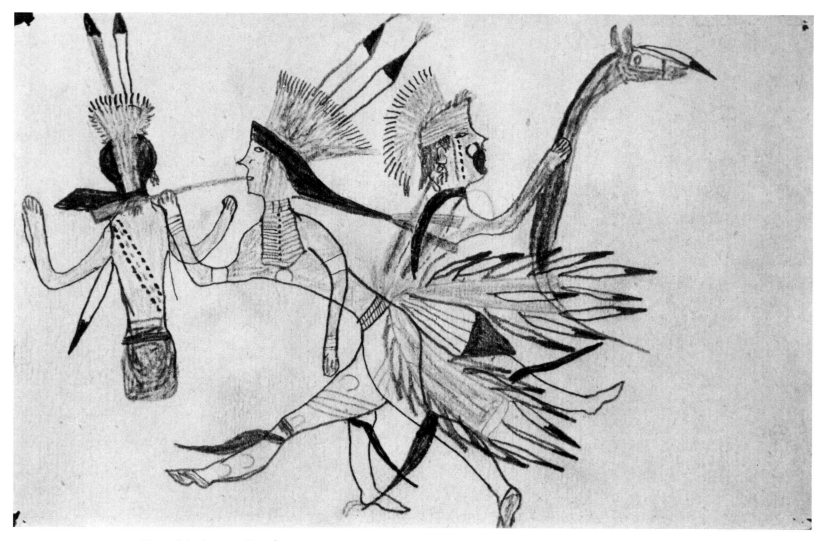

Fig. 15. Rain-in-the-Face (Hunkpapa Sioux).
Three men dancing, 1885. 11.4 x 17.7 cm.
Graphite, Crayon on Paper. 20/1628.

These three figures are dressed for dancing in the style popular among Sioux men during the 1880s. They wear yarn or fur turbans, porcupine and deer hair "roach" headdresses, fur garters and jewelry. During the Grass Dance, some men might commemorate brave war deeds with pantomime. For this, the man on the right carries a horse dance stick to indicate a favorite steed ridden into battle. The central figure wears an elaborate feather "crowbelt", or bustle, symbolic of the battlefield.

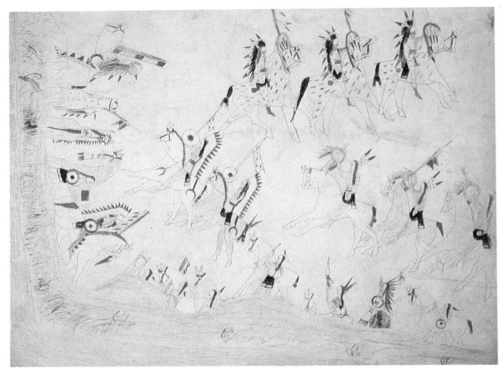

Fig. 16. Zotom (Kiowa).
 "Navajos," c. 1875. 19.8 x 26.2 cm.
 Graphite, Crayon on Paper. 20/6234.

While imprisoned at Fort Marion, Zotom produced many fine drawings such as this one. This page, selected from a book of his drawings, shows an innovative way of dealing with perspective. It is unusual to find figures drawn in a frontal view or any indication of a horizon in Plains drawings prior to this period.

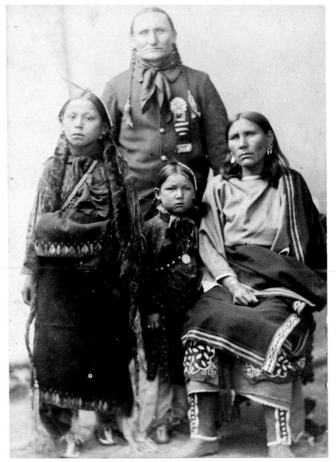

Fig. 17. Another Fort Marion prisoner/artist, Charley Oheitoint, in a studio photograph with his wife, Alice, and their sons, George and Andrew.

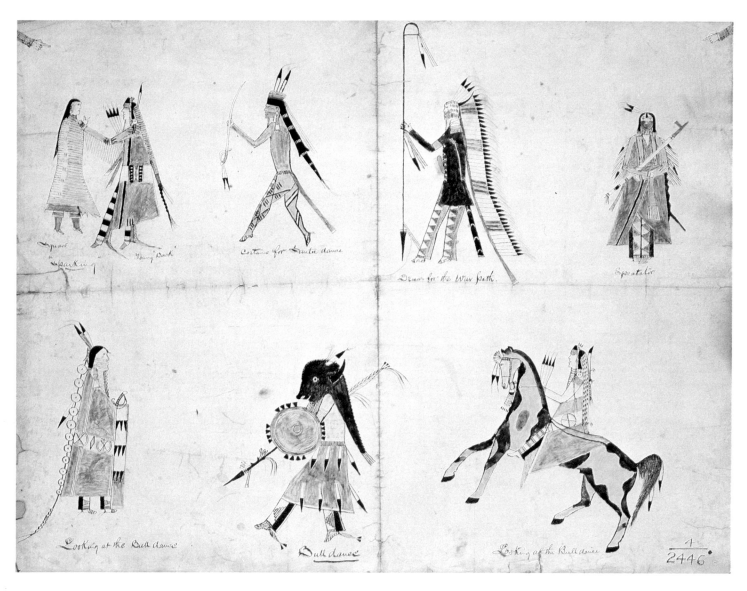

Fig. 18. Artist unknown (Gros Ventres). "Bull Dance." 43 x 55.8 cm.
 Watercolor, Crayon, Ink on Paper. 4/2446B.

Works from the turn of the century by Gros Ventres artists are rare. The central figure performing the Bull Dance wears a mask of a bison bull's head, decorated leggings, and moccasins with welts. The captions under each drawing and pointing hands in the upper corners were written in by an English-speaking person later and typify the expressions used at this time.

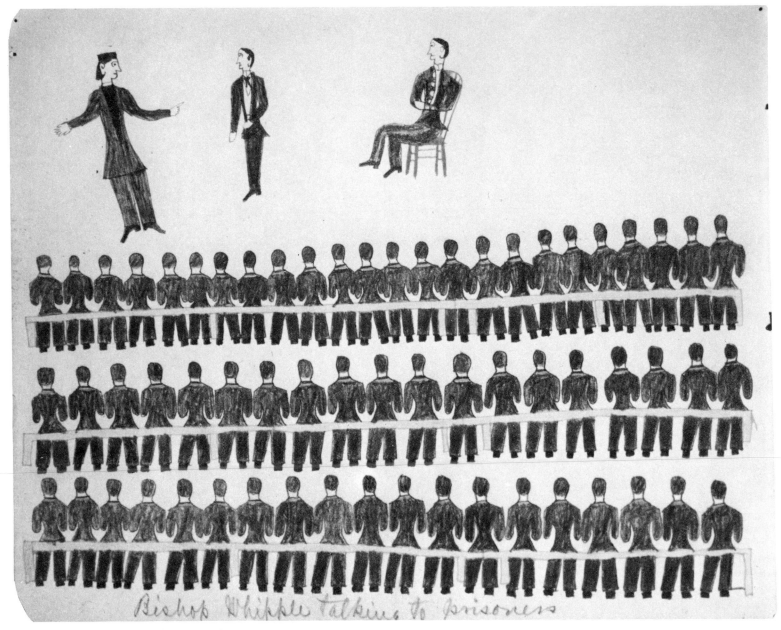

Fig. 19. Bear's Heart (Cheyenne).
Bishop Whipple talking to prisoners, c. 1875.
16.4 x 20.7 cm. Graphite and Crayon on Paper. 20/6231.

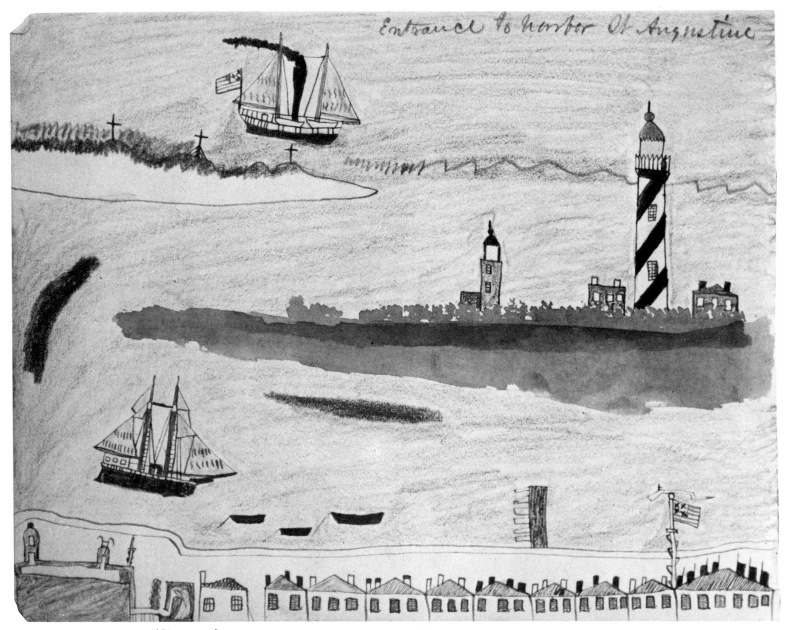

Fig. 20. Bear's Heart (Cheyenne).
Entrance to harbor St. Augustine, c. 1875.
16.4 x 20.7 cm. Graphite, Crayon on Paper. 20/6231.

Bear's Heart was a prolific artist while he was imprisoned at Fort Marion. The two pages shown here are from a book of drawings in which he recorded some of the events that happened at the fort and St. Augustine scenery that he caught glimpses of during his incarceration.

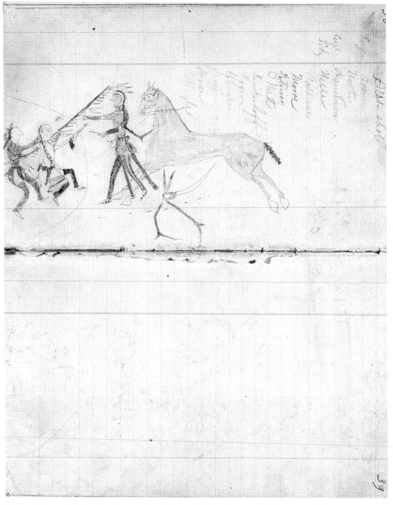

This roster book was originally kept by a U.S. Cavalry officer named Sergeant Brown who was at the Battle of the Little Big Horn in General Custer's command. He was killed in the fight and the book was taken from him by a Northern Cheyenne, possibly High Bull himself. High Bull and his friends filled many of the pages with drawings of their exploits. On the pages shown, Brown recorded the names of the "best shots" in his squad -- Sergeants Brown and Northig, Corporal Hammon, Privates Wells, Wallace, Moore, Petring, O'Niel, Brinkerhoff, Rogers, Shanahan, Seafferman, Dose, and Kilfoyle. The drawing shows Little Sun counting coup on two Shoshones who are entrenched behind a barricade. Little Sun has dismounted from his horse and discarded his weapon to strike the enemies with his lance.

The book was recaptured by the Cavalry on November 26, 1876 by General Mackenzie's troop while attacking the village where High Bull was staying.

Fig. 21. High Bull and others (Northern Cheyenne).
"Double Trophy Roster" book, 1876. 11.5 x 18.9 cm.
Graphite, Crayon on Paper. 10/8725.

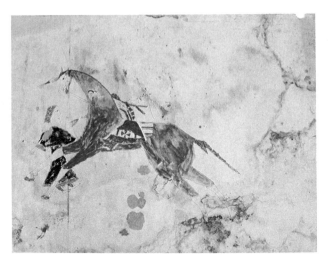

Fig. 22. Artist unknown (possibly Assiniboin).
Man on horseback shooting a woman.
22.7 x 28.8 cm. Graphite and Watercolor
on Paper. 10/9640.

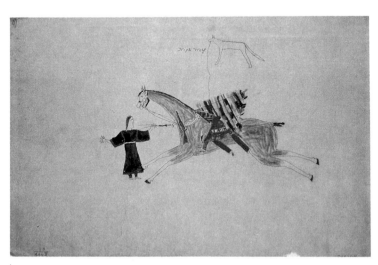

Fig. 23. Possibly Yellow Nose (Cheyenne).
High Wolf counting coup on a woman, c. 1880.
25.5 x 38 cm. Graphite, Crayon, Ink on Paper.
23/4463.

Women were often present and killed at battles between warring Plains Indian groups, but it is uncommon to find these events recorded pictographically. Many elements in both of these drawings are remarkably similar, in addition to the subject matter itself. Both women wear blue dresses with red trim, and the men's shirts, vests, skirts, moccasins, and horses are virtually identical.

It is tempting to draw a relationship between the two drawings because of the puzzling origin of the works identified as being by Yellow Nose and the scanty documentation on the other. Although it seems obvious that these drawings were done by different hands, perhaps both recount the event of High Wolf "killing" a particular woman.

Fig. 24. Earnest Spybuck (Shawnee).
"War Dance Gathering Scene." 44 x 63.5 cm.
Graphite, Watercolor, Crayon on Paperboard. 2/5614.

Traditional dances are still performed today by Native Americans across the United States. The Shawnee War Dance pictured here probably took place in the early 1900s. Spybuck's colorful and vital portrayal of this scene reminds us that dances such as this are important social events participated in and enjoyed by many people. The careful details of the figures make it likely that Spybuck worked on this painting and others with the aid of photographs.

Fig. 25. Johnny John (Shawnee).
 "Going Home From the Dance on High Lope,"
 23.2 x 28 cm. Graphite, Crayon, Ink on Paper.
 7/3505D.

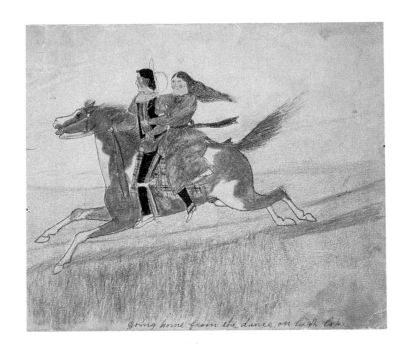

Although it is not uncommon for American Indian artists to combine western elements into their work, Johnny John has done so with talent and charm in these two drawings. That he apparently studied European drawing styles is evident from the careful attention to detail, realism, and the poses of his human figures.

The couple spiritedly galloping home from a dance wear western and Indian clothing. The card-playing scene is drawn in such a candid, personal way that one suspects that the artist was drawing an event with which he was well aquainted.

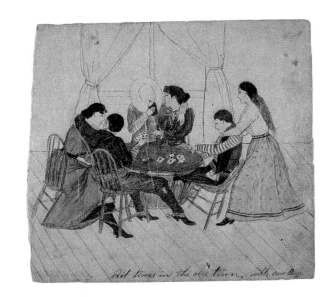

Fig. 26. Johnny John (Shawnee).
 "Hot Times in the Old Town with Cowboys,"
 23 x 24.9 cm. Graphite, Crayon, Ink on Paper.
 7/3505B.

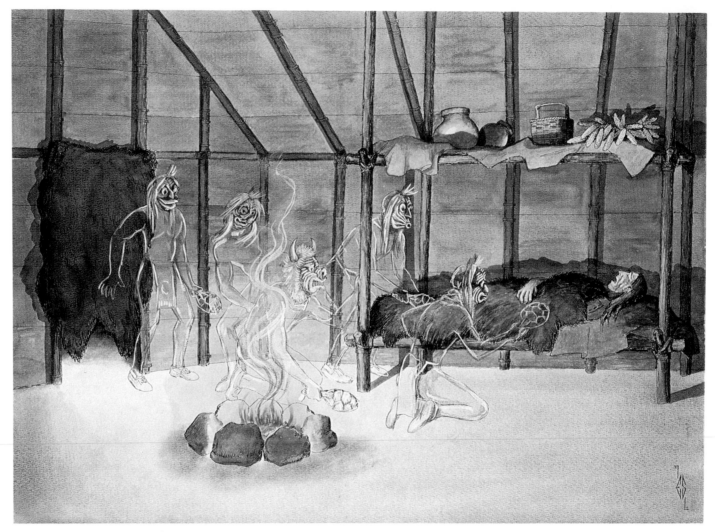

Fig. 27. Ernest Smith (Seneca).
 "A Man's Vision of the False Face Society," 1972.
 53 x 66.5 cm. Watercolor, Ink on Paper. 24/8847.

Smith uses light and color dramatically to create this haunting scene of False Face spirits visiting a man while he sleeps.

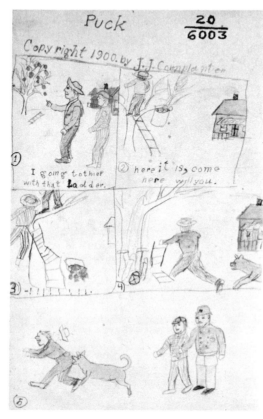

Fig. 28.　Jesse Cornplanter (Seneca).
"Puck," 1900. 18.4 x 11.5 cm.
Graphite, Watercolor on Paper.
20/6003.

Jesse Cornplanter and his sister Carrie were children when they made these drawings. It seems that they practiced drawing and writing together. Jesse frequently copied words and pictures from Puck *magazine, as shown here. Carrie's drawing of a Cornhusk Dance shows ladies in Victorian dress wearing cornhusk masks with an audience of non-Indians looking on.*

Fig. 29.　Carrie Cornplanter (Seneca).
"Indian Cornhusk Dance". 30.4 x 24 cm.
Graphite, Watercolor on Paper. 16/5334.

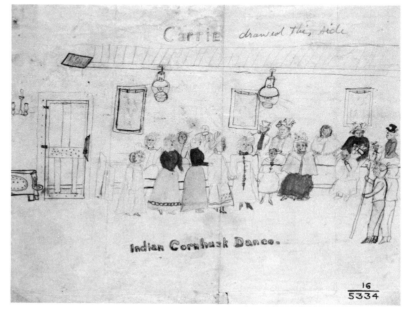

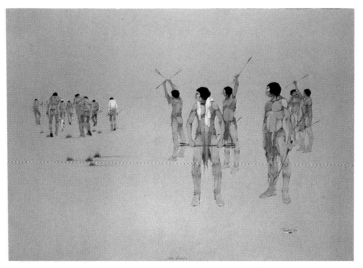

Fig. 30. Jerome Tiger (Creek/Seminole). "The Victors,"
1967. 40.5 x 56.0 cm. Opaque Watercolor on
Paperboard. 25/1125.

Jerome Tiger's innovative style of painting has placed him as one of the most respected Native American painters. "The Victors" won him his last major show award for the best painting in the 1967 All-American Indian Days exhibit at Sheridan, Wyoming. "The Intruders" is one of Tiger's finest portrayals of mood and distance in the Everglades setting.

Fig. 31. Jerome Tiger (Creek/Seminole). "The Intruders,"
1966. 40.5 x 50.9 cm. Opaque Watercolor on
Paperboard. 23/6992.

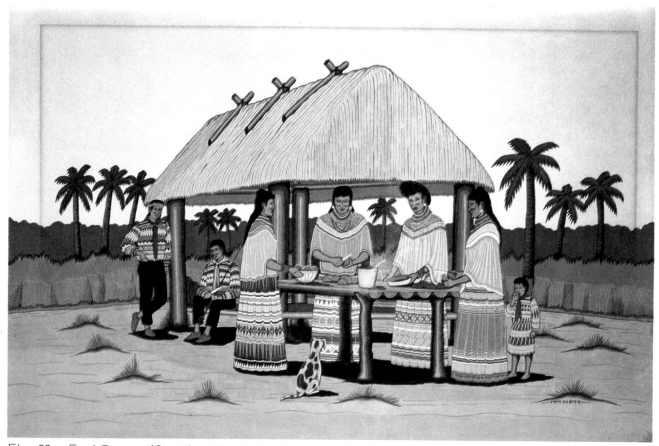

Fig. 32. Fred Beaver (Creek). "Seminoles Preparing Food," 1949.
45.5 x 66.7 cm. Opaque Watercolor on Paper. 23/8383.

The Seminoles in this scene are shown wearing the elaborately appliqued clothing that is their traditional dress. Beaver's formal style contrasts with the setting featuring a relaxed, everyday activity.

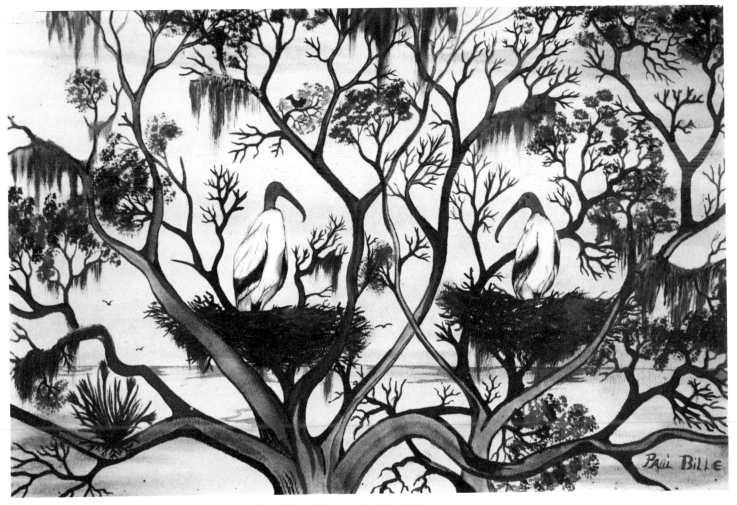

Fig. 33. Paul Billie (Mikasuki Seminole). "Two Cranes in Nests,"
1973. 30.2 x 45.5 cm. Watercolor on Paper. 25/51.

Although Billie is not a well-known artist, his work stands as an example of contemporary Native American painting. This tranquil Everglades scene suggests the lush, hidden life that abounds there.

Fig. 34. Dick West (Cheyenne).
 "Dark Dance of the Little People," 1948.
 30.5 x 45.8 cm. Opaque Watercolor on Paper. 23/8382.

The subject matter of many of Dick West's paintings involve ceremonies that were traditional among the Cheyenne and other American Indian groups. It was often necessary for him to obtain permission from tribal elders to depict sacred scenes or portray legends and stories.

Fig. 35.
Artist unknown (Eskimo).
Book of drawings. 18.6 x 28.5 cm.
Graphite, Crayon on Paper. 11/1731.

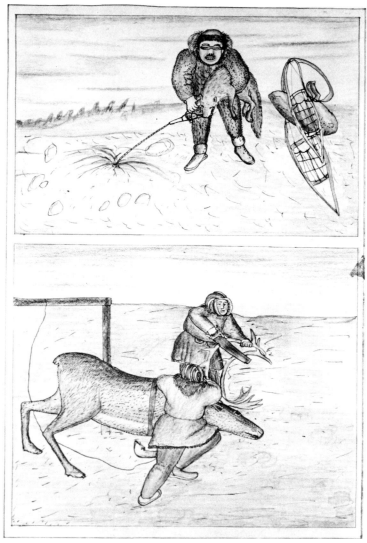

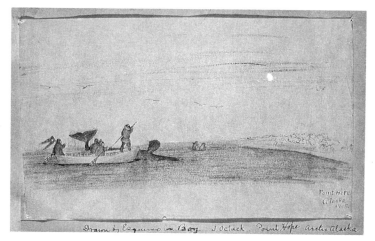

Fig. 37. J. Octuck (Eskimo).
Whale hunting, 1905. 13.0 x 20.5 cm.
Graphite, Crayon, Ink on Paper. 22/4490.

Fig. 36. Artist unknown (Eskimo).
Book of drawings. 18.6 x 28.5 cm.
Graphite, Crayon on Paper. 11/1731.

Drawings by Alaskan Eskimos from this period are extremely rare.
examples, the themes and executions are irrefutably Eskimo in effect.
scenes add to our knowledge of ethnography in this area.

While European conventions are apparent in these
The fine details that are captured in these hunting

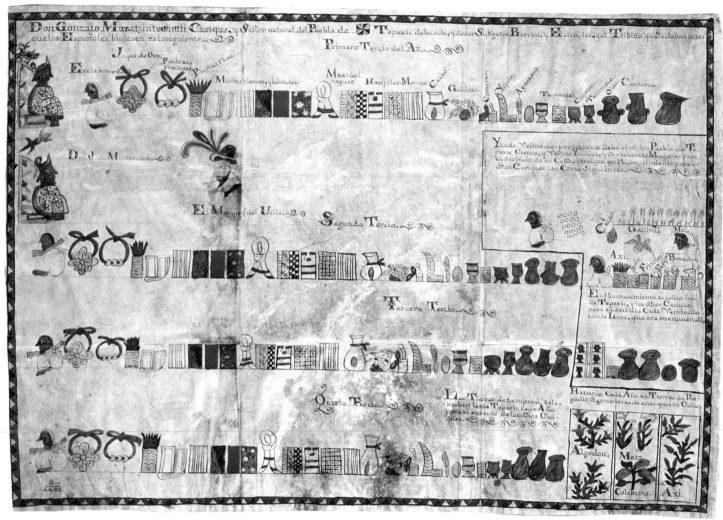

Fig. 38. Artist unknown (possibly Nahua).
Tribute record, c.1600. 41.5 x 58 cm.
Graphite, Watercolor, Ink on Parchment. 8/4482.

This tribute record was executed in the late sixteenth century, decades after the Spanish conquest of Mexico. It shows pictographically, with Spanish or Nahuatl captions, the types of items paid under the Aztec system of tribute to highly placed government and village officials. Included are slaves, gold ornaments, precious stones, colorful feathers which often had the quills filled with gold dust, lengths of plain and ornamented cloth, loincloths, shirts, cocoa, hens, avocados, chairs, gourd cups, and varieties of pottery vessels.

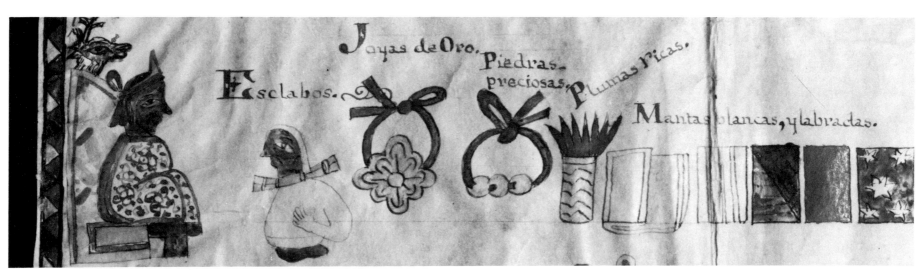

Detail of Fig. 38.

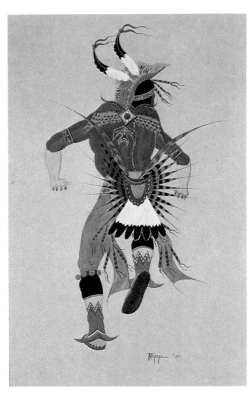

Fig. 39. Stephen Mopope (Kiowa).
 "Butterfly Dancer," 1930.
 8.3 x 18 cm.
 Watercolor on Paper. 22/8619.

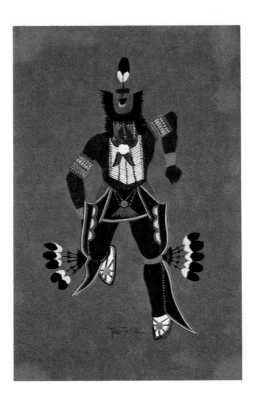

Fig. 40. Monroe Tsatoke (Kiowa).
 "Advancing Warrior,"
 25.8 x 16.3 cm.
 Watercolor on Paper. 23/6048.

Shown here are examples of the work of each of the Five Kiowas. The artists, working together at the University of Oklahoma, developed individual styles that included the consistent use of bright color, flat application of paint, and similar subject matter.

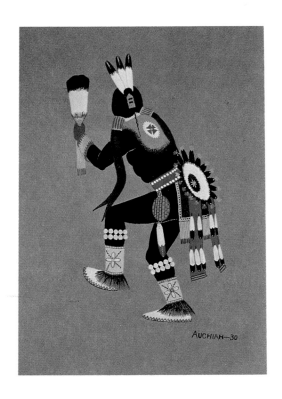

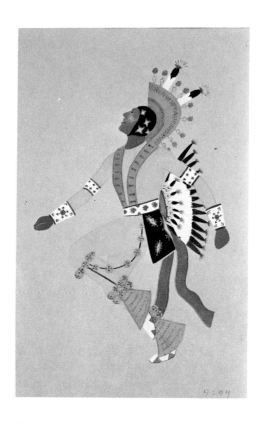

Fig. 41. James Auchiah (Kiowa).
Dancer with bustle, 1930.
27.5 x 19.5 cm.
Watercolor on Paper. 22/8615.

Fig. 42. Jack Hokeah (Kiowa).
"Drummer."
24.8 x 17.7 cm.
Watercolor on Paper. 22/8614.

Fig. 43. Spencer Asah (Kiowa).
War dancer with bustle.
33 x 20 cm.
Watercolor on Paper. 22/8613.

Fig. 44. Woody Crumbo (Creek/Potowatomi).
"Three Eagle Dancers," c. 1935.
50.5 x 66.0 cm. Watercolor on Paper. 23/1261.

This painting clearly demonstrates the influence that the style of the Five Kiowas, shown on the preceding pages, played on Crumbo's early work. The bulk of his later paintings mark his change of style toward that being developed at The Studio in Santa Fe.

Fig. 45. Louis Gonzales (San Ildefonso). Christmas card.
9.5 x 14.5 cm. Ink, Watercolor on Paper. 23/3358.

Wo-Peen (Louis Gonzales) here has hand-tinted a printed version of his own painting for a holiday message, a fine example of the commercial aspect of works on paper. Many artists painted small greeting cards that sold for pennies each.

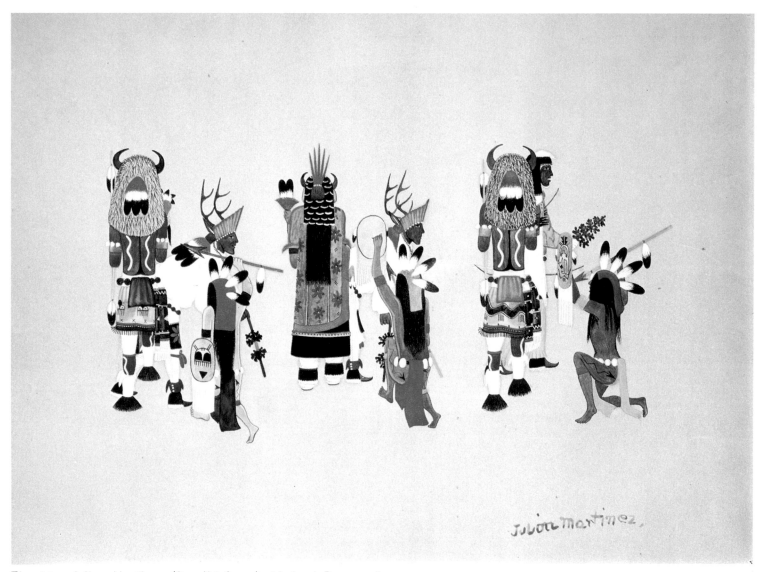

Fig. 46. Julian Martinez (San Ildefonso). "Animal Dancers."
 35.4 x 47.9 cm. Watercolor, Graphite, Ink on Paper. 22/8584.

Julian Martinez, husband of the well-known potter, Maria, was one of the early painters in the Southwest. In addition to painting familiar pottery designs on paper, he also created abstractions in vivid colors and many dance scenes, such as this one depicting animal dancers.

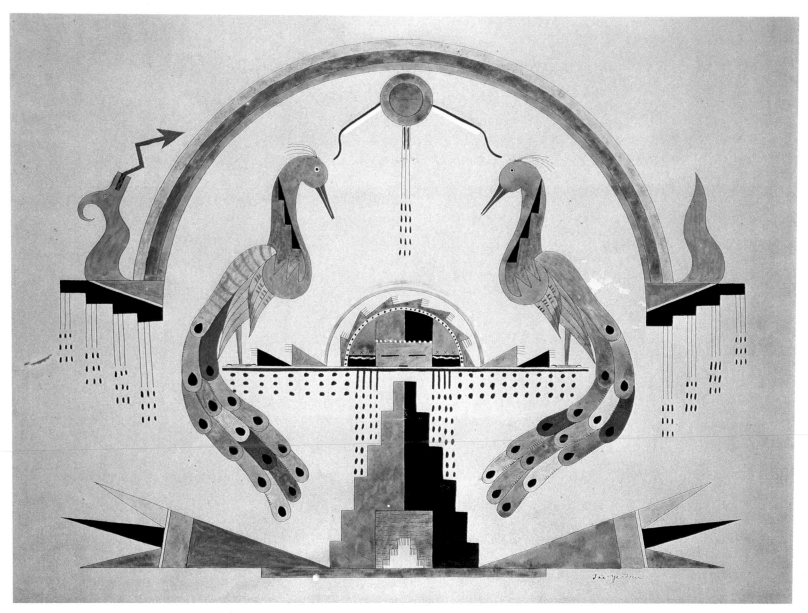

Fig. 47. Tse Ye Mu (San Ildefonso).
Stylized birds and rainbow, c. 1930.
56.7 x 69.8 cm. Ink Wash on Paper. 25/1129.

Tse Ye Mu (Romando Vigil) painted with ink during this period, as did Awa Tsireh and Julian Martinez. Combining Southwestern motifs with imported ones, such as the peacocks here, this artist created abstract designs that were often very elaborate.

Fig. 48. Awa Tsireh (San Ildefonso).
Mother skunk and young, c. 1930.
20.6 x 26.7 cm. Printed on Paper. 22/7876.

Awa Tsireh's inspiration for this design comes from a Mimbres bowl now at the Museum of Northern Arizona. The skunk motif is an old one at San Ildefonso and is here created in a highly abstract form typical of the artist's later painting.

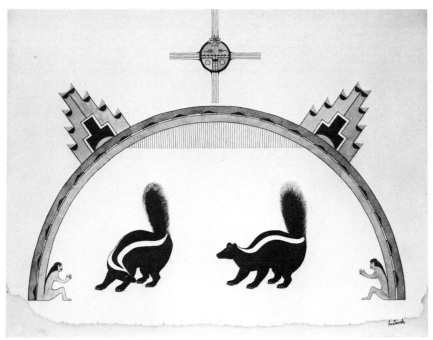

Fig. 49. Awa Tsireh (San Ildefonso).
"Rain Symbols and Skunks," c. 1930.
27.7 x 35.4 cm. Ink Wash on Paperboard. 22/8589.

The artist has again used skunks, but they are realistically painted with much more animation. Such forms, combined with the abstract rainbow, were created by Awa Tsireh before his painting became totally abstract.

Fig. 50. Fred Kabotie (Hopi).
 Shalako and Hahai-i Wuqti kachinas.
 1927. 38.1 x 31.7 cm.
 Watercolor on Paper. 18/2058.

This painting is one of many in a Kabotie portfolio commissioned for the Museum by John Louw Nelson in 1927. Kabotie painted traditional ceremonies to preserve them. The Shalakos pictured here were revived at Hopi in 1944, owing in part to Kabotie's influence.

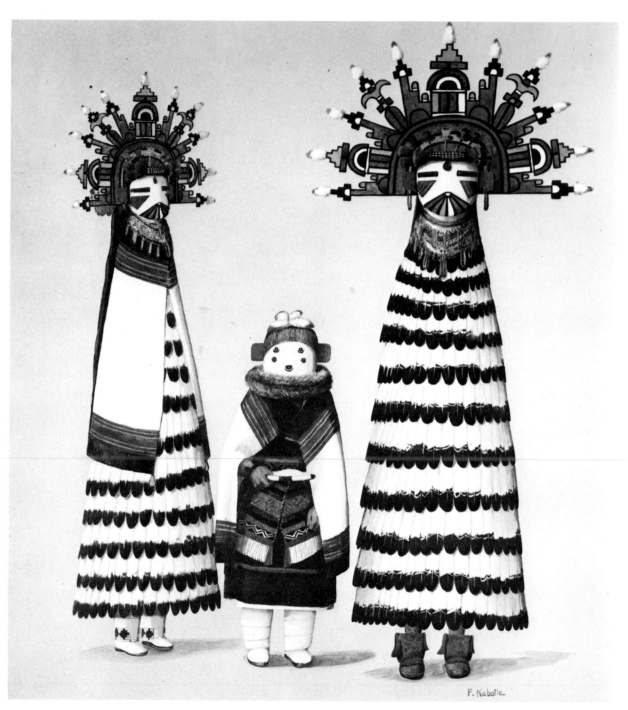

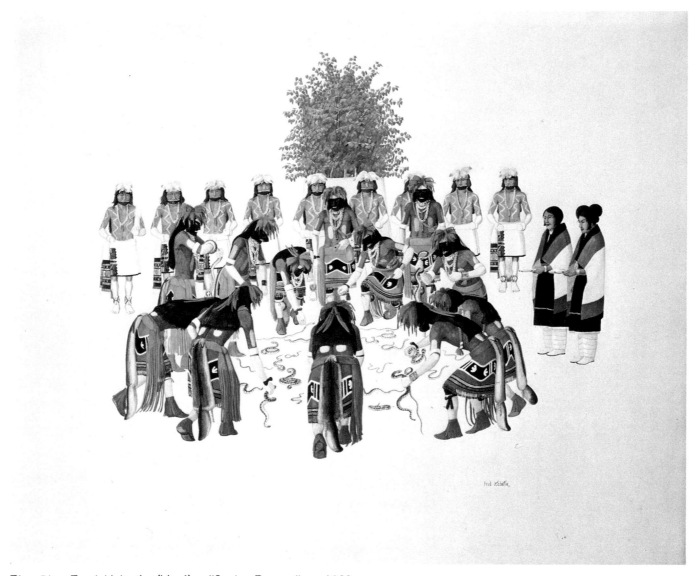

Fig. 51. Fred Kabotie (Hopi). "Snake Dance," c. 1930.
 48.0 x 57.5 cm. Watercolor, Graphite on Paper. 22/8647.

This painting is a standard version of several works that Kabotie completed depicting the Hopi Snake Dance. Here the gathering of the snakes is shown.

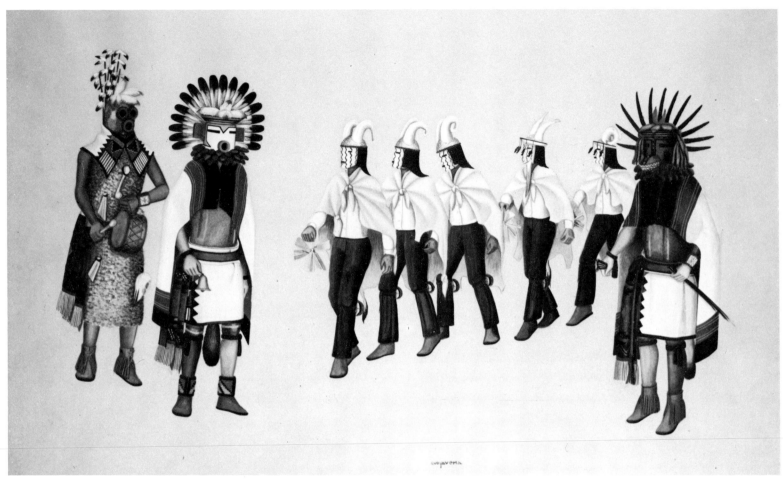

Fig. 52. Riley Quoyavema (Hopi). Kachinas, c. 1935.
 45.6 x 61.0 cm. Opaque Watercolor on Paper. 22/8601.

Quoyavema, although highly influenced by other Hopi painters, such as Fred Kabotie and Otis Polelonema, was strongly affected by the Kiowa style of painting. Here he depicts Hopi kachinas, (from left to right) Masauu, Nuvak, a group of Two-horn Society priests, and Honau.

Fig. 53. Waldo Mootzka (Hopi). Three Tatangaya kachinas.
c. 1930. 30.5 x 45.7 cm.
Opaque Watercolor on Paper. 23/3450.

*Mootzka remains somewhat of a mystery among Hopi
painters. This work is one of the only formative paintings
of his anywhere and clearly indicates artistic talent.
Other early works by Mootzka in the Museum's collection
may help to determine more clearly the development of
this artist. He is said to have died around 1940.*

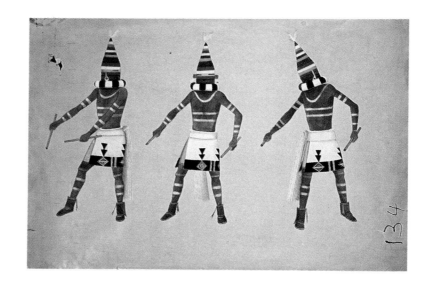

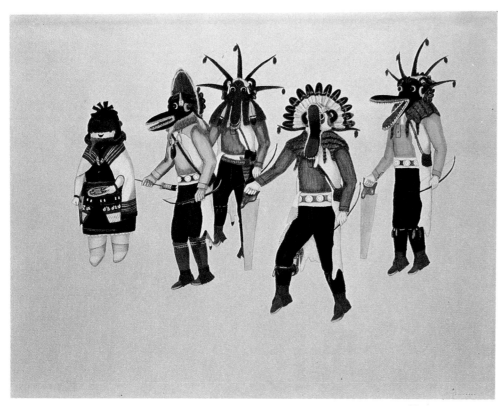

Fig. 54. T. Tomossee (Hopi).
Five Natashka kachinas,
c. 1930. 38.1 x 48.0 cm.
Watercolor, Graphite on Paper. 18/2067.

*Tomossee was commissioned by John L.
Nelson to paint kachinas, most often as
single figures. This unusual grouping
depicts the Natashka group and includes
(left to right) Hahi (mother of the rest),
Qumavnatashka-tahaam, Palamchana, Qut-
chamchova, and Qumavnatashka.*

55

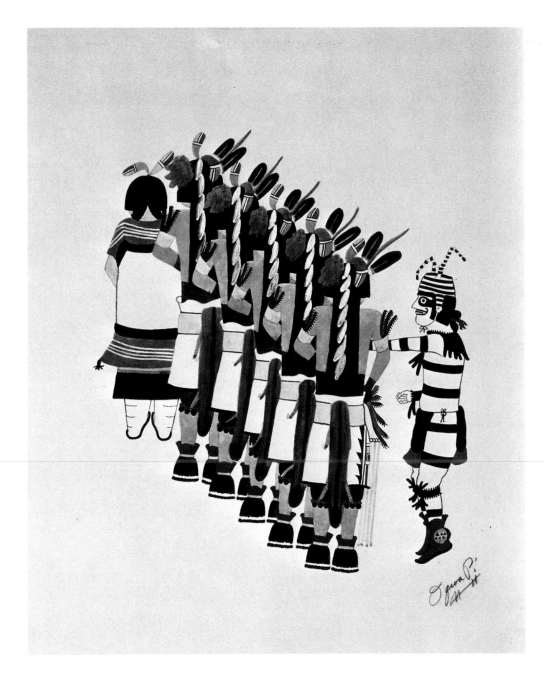

Fig. 55. Oqwa Pi (San Ildefonso).
"Turtle Dancers," c.1935. 38.0 x 28.0 cm.
Watercolor, Graphite on Paper. 22/8585.

This painting of turtle dancers shows the final development of one of the earlier painters from realistic portrayals to attractive and highly stylized works that have movement and charm.

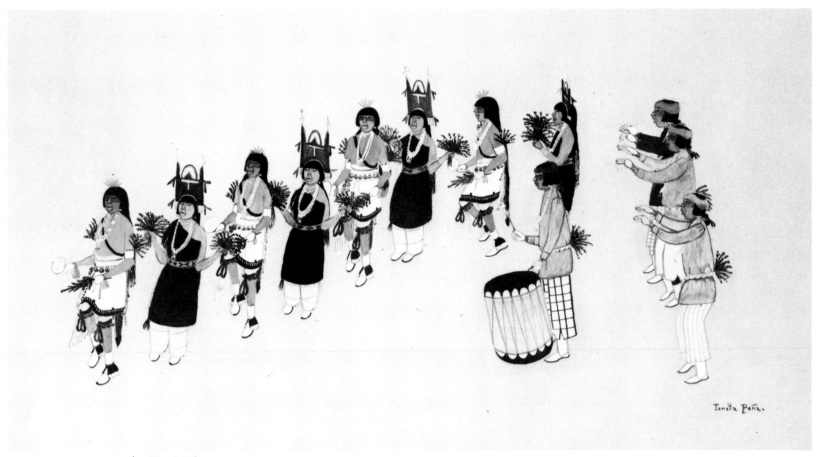

Fig. 56. Tonita Peña (Cochiti).
"Corn Dance with Singers and Drummer," c. 1945. 35.5 x 55.8 cm.
Opaque Watercolor on Paperboard. 22/8610.

This scene was often painted by this artist, the only female among the early painters and the mother of artist Joe Herrera. It is obviously a later work because the line of dancers is at an angle, not straight. She was also experimenting here with a blotting technique which was not done earlier.

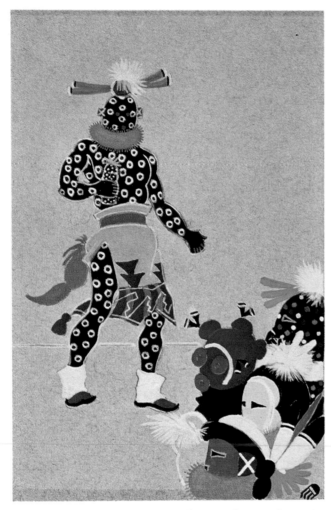

Fig. 57. James M. Byrnes (Acoma/Laguna)
 "Little Fire God and Others,"
 c. 1960. 17.4 x 11.5 cm.
 Watercolor, Graphite on Paper. 23/7650.

This painting, typical of this artist and post-Studio painting, includes a sharpness, white form lines, a horizon line, and well-formed figures. An art-deco influence is apparent in the work.

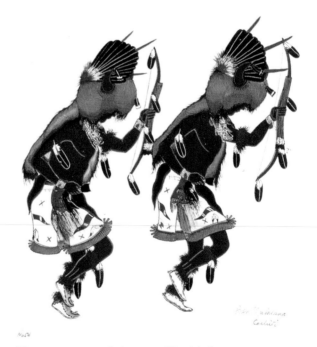

Fig. 58. Ben Quintana (Cochiti).
 Buffalo dancers, c. 1940.
 37.8 x 30.3 cm. Watercolor on Paper.
 24/8199.

Quintana did not paint after 1942. This fine work shows the mature style he had already achieved in his late teens. He died in 1944 at the age of twenty-one.

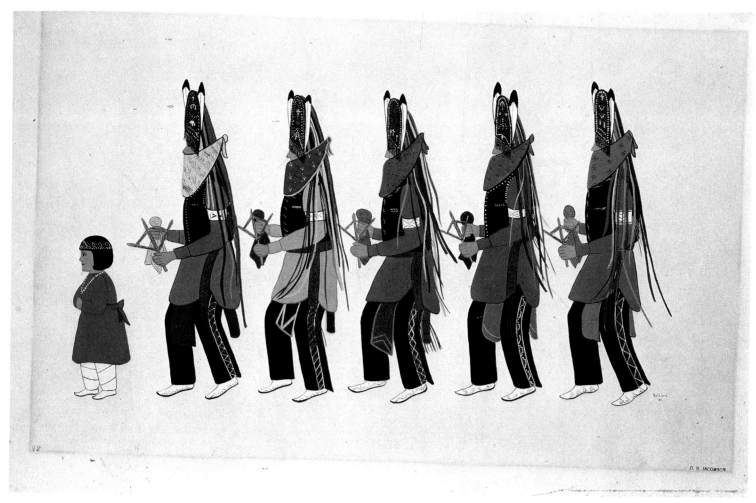

Fig. 59. Geronima Cruz Montoya (San Juan).
"Matachina Dance," 1942. 31.6 x 48.2 cm.
Opaque Watercolor on Paper. 23/6028.

Montoya was Dorothy Dunn's teaching assistant at The Studio and directed the Art Department at the Santa Fe Indian School from the late 1930s until the early 1960s. This scene depicts the Matachina Dance which reenacts the conquest of Mexico. The little girl on the left represents Cortez's guide. This dance, the only masked dance in the Rio Grande pueblos, ends with a bullfight.

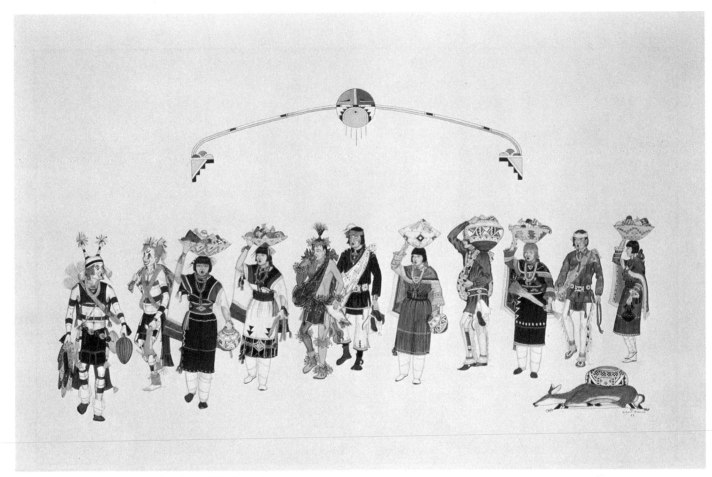

Fig. 60. Gilbert Atencio (San Ildefonso).
 "The Food Bearers," 1959. 49.0 x 52.4 cm.
 Watercolor on Paper. 23/1266.

Atencio, a nephew of Maria Martinez, was a contemporary of Ben Quintana, Joe Herrera, and Geronima Cruz Montoya. In a move away from The Studio, he often reverted to the styles of the self-taught painters. Painting with lightened colors, the balance of figures in Atencio's works is sometimes awkward, but the realism of the forms especially resemble early Hopi painting.

Fig. 61. Charles Vicenti (Zuni). "Home Life," 1955.
 21.7 x 28.0 cm. Opaque Watercolor on Paper. 23/1489.

Painting and other arts at Zuni were revived by Clara Gonzales at Zuni Day School in the 1940s. Painters often supplemented their income with lapidary work. This painting by Charles Vicenti is clean and sharp with vivid color contrasts. The diagonal shape is a typical Zuni form.

Fig. 62. Ignatius Palmer (Mescalero Apache).
"Three Bears," 1962. 30.7 x 25.5 cm.
Opaque Watercolor on Paper. 23/2926.

This painting by Ignatius Palmer has roots in
The Studio with its flat colors and outlined
forms. The more realistic environment and
bright colors, however, are indications of later
development. Palmer is also known for
paintings of Apache dancers (see Fig. 70).

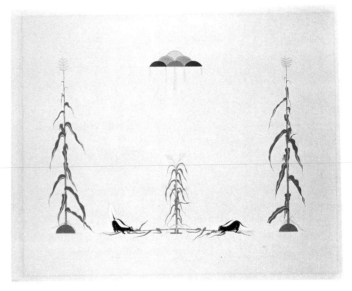

Fig. 63. Ben Quintana (Cochiti). "Skunks in Corn,"
c. 1939. 50.7 x 61.4 cm.
Opaque Watercolor on Paper. 23/1262.

Studio styles are obvious in this painting with the
stylized cloud form, playful skunks, and lack of a
well-defined horizon. The definition of the corn
plants indicates the talent of this young artist, who
was killed in World War II.

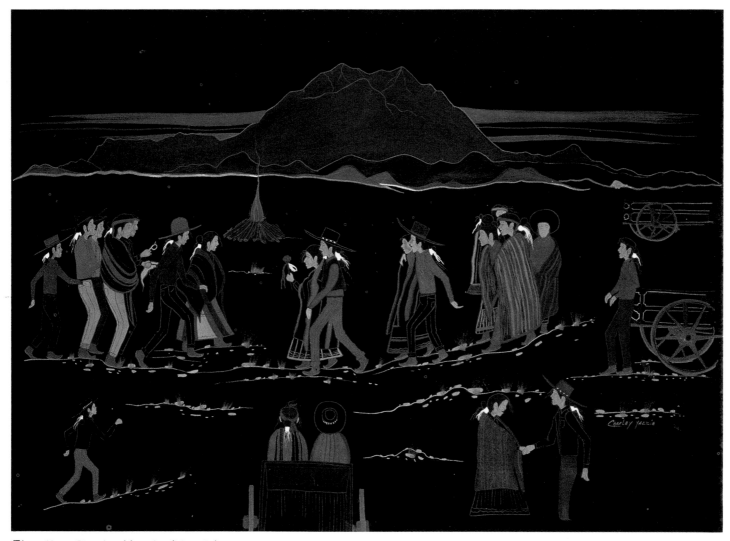

Fig. 64. Charley Yazzie (Navajo).
 "Navajo Squaw Dance," c. 1965. 55.7 x 76.0 cm.
 Watercolor on Paperboard. 25/1127.

This unfinished work is an example of contemporary Navajo painting, and is especially similar to that of Andy Tsinajinnie and Robert Chee. The black background and the forms, many of which are traced, have been typical since the 1950s.

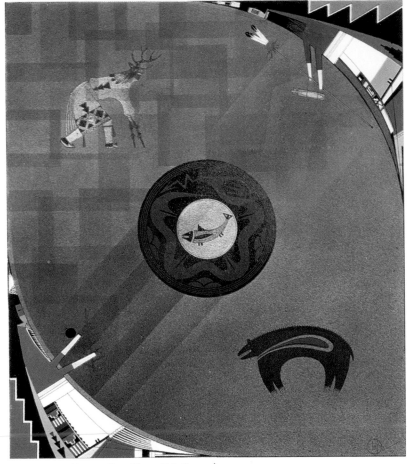

Fig. 65. Tony Da (San Ildefonso).
"The Sacred Water Serpent," 1967. 58.3 x 51.0 cm.
Watercolor on Paper. 23/9301.

This painting by Tony Da, grandson of Julian and Maria Martinez, uses a spattering technique introduced by Raymond Jonson at the University of New Mexico. Composition is calculated with a compass and design forms draw on Mimbres styles (fish) and early painting motifs (dancer, upper left).

Fig. 66. Joe Herrera (Cochiti).
Mural figure, c. 1950. 28.5 x 19.4 cm.
Opaque Watercolor on Construction Paper. 23/1248.

Based on a petroglyph near Santa Fe, this painting was part of a series of works undertaken while Herrera was a graduate student at the University of New Mexico from 1950 until 1952. The spattering technique later used by Tony Da was first employed here by Herrera.

Fig. 67.

Quincy Tahoma (Navajo).
"First Furlough," 1943. 45.7 x 37.7 cm.
Watercolor on Paperboard. 23/6014.

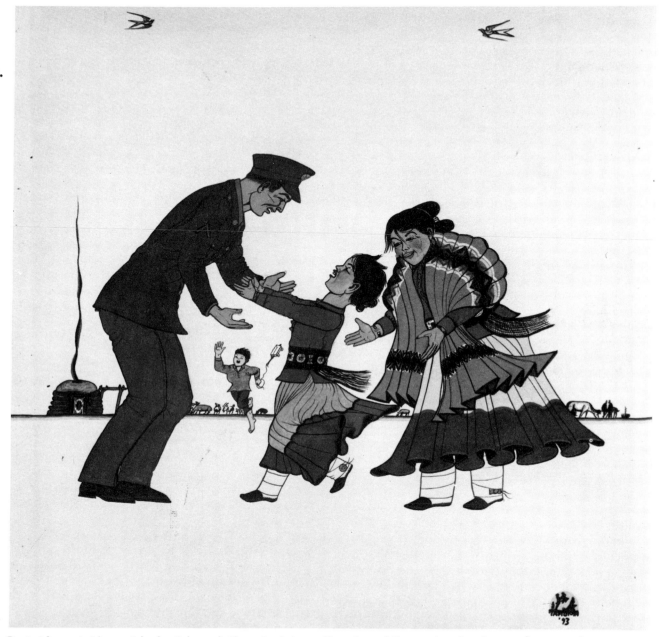

Probably autobiographical, this painting depicts a Navajo soldier returning home from active duty in World War II; the artist was one of the famous code-talkers. The silhouette signature is typical of Tahoma about 1941. The two swooping birds are characteristic of fellow Navajo artist Beatien Yazz. The pleated skirt style was first undertaken by Gerald Nailor at the Santa Fe Indian School and employed by Tahoma here. After the war Tahoma's painting took on a more violent aspect.

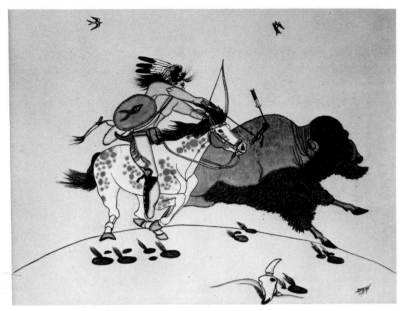

Fig. 68. Beatien Yazz (Navajo).
"Mounted Buffalo Hunter," c. 1944.
28.0 x 38.0 cm. Watercolor on Paper. 23/6803.

This scene and particularly the two birds are typical of Yazz. A nostalgic Indian theme, the hunter and the buffalo are clearly not of a Studio style in that they are fully formed, with the action of the scene depicting the violence of the hunt. Yazz gained notoriety through the biography Spin a Silver Dollar.

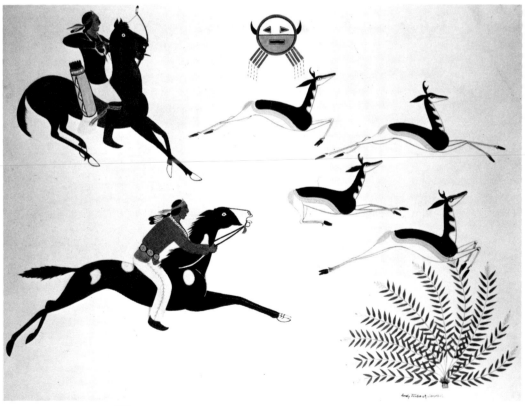

Fig. 69. Andy Tsinajinnie (Navajo).
"Deerhunt on Horseback," c. 1938.
50.6 x 64.9 cm.
Watercolor on Paperboard. 22/8649.

The hunt is more pastoral here in Tsinajinnie's Studio-style painting. The stylized figures are painted in flat colors, while the graceful deer leap in space with no suggestion of an environment except for the stylized plant. A traditional-style horned figure is typically centered at the top of the painting.

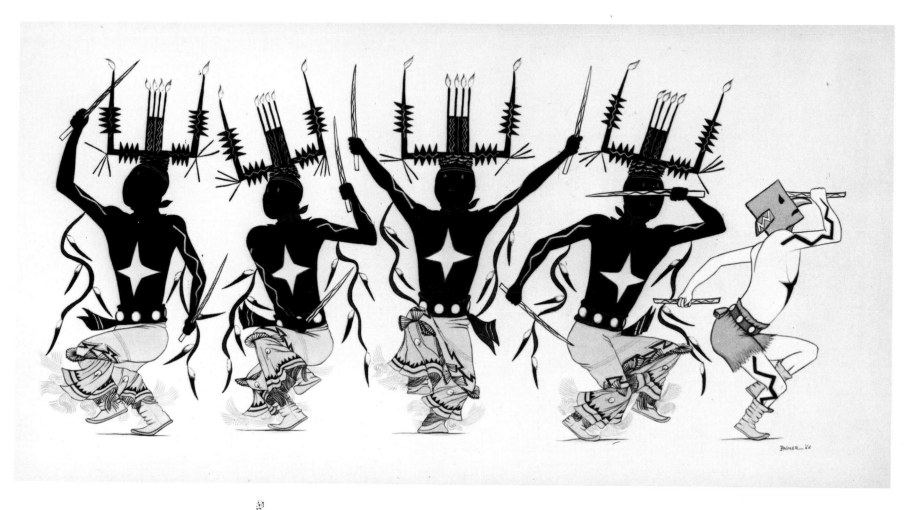

Fig. 70. Ignatius Palmer (Mescalero Apache).
 "Dance of the Mountain Gods," 1962.
 33.5 x 63.9 cm. Watercolor on Paperboard. 23/2925.

This is one of four or five standard renditions by Palmer of the Mountain Spirits Dance. The clown at the right is wearing an unusual mask while the other four figures perform the traditional dance. Palmer won second prize at the 1962 New Mexico State Fair with this painting.

Fig. 71. Maxine Gachupin (Jemez). "Deer," 1963.
 35.5 x 45.7 cm. Watercolor on Paperboard. 23/4132.

This painting was entered in the 1964 annual competition at the Philbrook Art Center, one of several major competitions for Native Americans. The patterns, reminiscent of textile designs, are typical of the Jemez Day School.

LIST OF THE COLLECTION

The following is a list of all of the paintings and drawings in the collection of the Museum of the American Indian. The list is grouped by culture in alphabetical order and by artist within that group. All measurements are given as height by width in centimeters.

CULTURE UNKNOWN

TWO MEN, WOMAN & CHILD, 1821
Watercolor on Paper. 18.5 x 17.0
Anonymous Collection, 8/8209
Artist Unknown

JESUS
Watercolor on Paper. 12.5 x 17.7
Joseph Imhof Collection, 23/3358D
Artist Unknown

DANCER
Ink on Paper. 15.9 x 10.8
Joseph Imhof Collection, 23/3358E
Artist Unknown

SUN DANCER
Watercolor on Paper. 15.2 x 10.1
Joseph Imhof Collection, 23/3388
Artist Unknown

BUFFALO DANCER
Watercolor, Ink on Paper. 14.0 x 9.8
Joseph Imhof Collection, 23/3389
Artist Unknown

WOMAN KNEELING
Watercolor, Ink, Graphite on Paper. 10.3 x 13.1
Joseph Imhof Collection, 23/3390
Artist Unknown

BATTLE SCENE
Graphite, Colored Pencil on Paper. 43.0 x 55.7
Anonymous Collection, 25/1109
Artist Unknown

INDIAN GIRL, 1953
Construction Paper on Paper. 35.4 x 37.5
Anonymous Collection, 25/1110
Artist Unknown

KACHINA MASKS, 1964
Graphite on Paper. 44.5 x 30.2
Anonymous Collection, 25/1123
Artist Unknown

MAN ON BUCKING HORSE
Graphite, Crayon on Paper. 22.4 x 15.0
Anonymous Collection, 25/1124A
Artist Unknown

HORSE AND THROWN RIDER
Graphite, Crayon on Paper. 22.4 x 15.0
Anonymous Collection, 25/1124B
Artist Unknown

WOMAN AND GIRL WITH DOG TRAVOIS
Graphite, Crayon on Paper. 22.4 x 14.7
Anonymous Collection, 25/1124C
Artist Unknown

LANDSCAPE
Graphite, Crayon on Paper. 14.9 x 22.5
Anonymous Collection, 25/1124D
Artist Unknown

SEATED MEN AND DANCERS
Graphite, Crayon on Paper. 14.7 x 22.5
Anonymous Collection, 25/1124F
Artist Unknown

COUPLES DANCING, MEN CONVERSING, WOMEN SEATED
Graphite, Crayon on Paper. 15.0 x 22.4
Anonymous Collection, 25/1124G
Artist Unknown

WOMEN AND MEN STANDING
Graphite, Crayon on Paper. 15.0 x 22.5
Anonymous Collection, 25/1124H
Artist Unknown

MEN SHOOTING ARROWS AT MEN ON HORSEBACK, 1933
Oil on Board. 31.2 x 46.0
Daniel Carter Beard Collection, 20/2344
Levi Blackbear

NAVAJO TRADER, 1929
Ink on Paper. 29.0 x 27.7
Anonymous Collection, 25/1130
De

GEOMETRIC BIRD
Watercolor, Graphite on Paper. 20.3 x 15.1
Anonymous Collection, 25/1084
Lolita E.

BEAR
Ink on Paper. 91.0 x 60.0
Anonymous Collection, 25/1106
C.B. Greul

BEAR WITH EAGLE ON HEAD
Ink on Paper. 91.0 x 60.0
Anonymous Collection, 25/1107
C.B. Greul

EAGLE
Ink on Paper. 63.0 x 96.0
Anonymous Collection, 25/1108
C.B. Greul

HOUSE AND DOCK WITH BOATS
Crayon, Graphite on Paper. 49.0 x 45.5
Anonymous Collection, 25/1092
Jane H. Hornbrook

CEREMONY
Graphite, Crayon on Paper. 50.7 x 63.5
Anonymous Collection, 25/1114
Annie Little Warrior

FEAST
Graphite, Crayon on Paper. 39.0 x 56.4
Anonymous Collection, 25/1115
Annie Little Warrior

WOMEN LEADING HORSES WITH TRAVOIS
Graphite, Crayon on Paper. 31.5 x 50.5
Anonymous Collection, 25/1116
Annie Little Warrior

BUFFALO HERD FOLLOWED BY MEN ON HORSEBACK
Crayon, Graphite on Paper. 42.8 x 61.5
Anonymous Collection, 25/1117
Annie Little Warrior

CEREMONY
Crayon, Graphite on Paper. 35.9 x 56.2
Anonymous Collection, 25/1118
Annie Little Warrior

WILD BOAR LEAPING A CACTUS
Ink on Board. 25.4 x 25.8
Byron Harvey Collection, 23/7604
Wallace Rice

FIGURE
Graphite, Crayon on Paper. 14.7 x 22.5
Anonymous Collection, 25/1124E
Annie Viulew

FACES
Oil on Wood. 30.5 x 68.0
Wa Wa Chaw Collection, 25/1151
Bonita Wa Wa Calachaw Nunez (1885-)

MAN AND WOMAN EMBRACING CHILD
Oil on Wood. 84.5 x 62.0
Wa Wa Chaw Collection, 25/1152
Bonita Wa Wa Calachaw Nunez (1885-)

WOMAN WITH HAIR ORNAMENT
Oil on Wood. 90.5 x 59.5
Wa Wa Chaw Collection, 25/1153
Bonita Wa Wa Calachaw Nunez (1885-)

FACES WITH DOVE
Oil on Canvas. 92.3 x 103.3
Wa Wa Chaw Collection, 25/1154
Bonita Wa Wa Calachaw Nunez (1885-)

COUPLE EMBRACING
Oil on Fabric. 132.4 x 60.3
Wa Wa Chaw Collection, 25/1155
Bonita Wa Wa Calachaw Nunez (1885-)

FACES AND FELINE FIGURE
Oil on Wood. 111.0 x 124.4
Wa Wa Chaw Collection, 25/1156
Bonita Wa Wa Calachaw Nunez (1885-)

PEOPLE EMBRACING
Oil on Canvas. 73.5 x 59.3
Wa Wa Chaw Collection, 25/1157
Bonita Wa Wa Calachaw Nunez (1885-)

ABSTRACT FORMS
Oil on Wood. 116.0 x 113.0
Wa Wa Chaw Collection, 25/1158
Bonita Wa Wa Calachaw Nunez (1885-)

WOMEN EMBRACING
Oil on Wood. 137.2 x 72.4
Wa Wa Chaw Collection, 25/1159
Bonita Wa Wa Calachaw Nunez (1885-)

WOMAN HOLDING FLOWERS
Oil on Canvas. 133.5 x 62.3
Wa Wa Chaw Collection, 25/1160
Bonita Wa Wa Calachaw Nunez (1885-)

PEOPLE WITH EAGLE
Oil on Canvas. 124.0 x 125.0
Wa Wa Chaw Collection, 25/1161
Bonita Wa Wa Calachaw Nunez (1885-)

TWO HANDS
Oil on Canvas. 57.4 x 36.3
Wa Wa Chaw Collection, 25/1162
Bonita Wa Wa Calachaw Nunez (1885-)

PORTRAIT OF MAN
Oil on Wood. 64.2 x 46.0
Wa Wa Chaw Collection, 25/1163
Bonita Wa Wa Calachaw Nunez (1885-)

PORTRAIT OF WOMAN
Oil on Wood. 74.3 x 33.0
Wa Wa Chaw Collection, 25/1164
Bonita Wa Wa Calachaw Nunez (1885-)

WOMAN EMBRACING CHILD
Oil on Wood. 87.5 x 48.8
Wa Wa Chaw Collection, 25/1165
Bonita Wa Wa Calachaw Nunez (1885-)

MAN EMBRACING TWO WOMEN
Oil on Canvas. 84.0 x 60.3
Wa Wa Chaw Collection, 25/1166
Bonita Wa Wa Calachaw Nunez (1885-)

MAN AND WOMAN WITH ANIMALS
Oil on Wood. 111.0 x 90.5
Wa Wa Chaw Collection, 25/1167
Bonita Wa Wa Calachaw Nunez (1885-)

PORTRAIT OF WOMAN
Oil on Canvas. 88.2 x 47.3
Wa Wa Chaw Collection, 25/1168
Bonita Wa Wa Calachaw Nunez (1885-)

PORTRAIT OF WOMAN
Oil on Canvas. 84.0 x 60.4
Wa Wa Chaw Collection, 25/1169
Bonita Wa Wa Calachaw Nunez (1885-)

WOMEN WITH ANIMALS
Oil on Wood. 113.3 x 108.7
Wa Wa Chaw Collection, 25/1170
Bonita Wa Wa Calachaw Nunez (1885-)

WOMEN AND MEN
Oil on Wood. 137.5 x 72.0
Wa Wa Chaw Collection, 25/1171
Bonita Wa Wa Calachaw Nunez (1885-)

PORTRAIT OF WOMAN
Oil on Fabric. 111.0 x 64.2
Wa Wa Chaw Collection, 25/1172
Bonita Wa Wa Calachaw Nunez (1885-)

PEOPLE EMBRACING
Oil on Canvas. 101.5 x 47.1
Wa Wa Chaw Collection, 25/1173
Bonita Wa Wa Calachaw Nunez (1885-)

PRIEST WITH A CAT AND PEOPLE
Oil on Canvas. 133.5 x 94.2
Wa Wa Chaw Collection, 25/1174
Bonita Wa Wa Calachaw Nunez (1885-)

PORTRAIT OF WOMAN
Oil on Wood. 112.4 x 68.5
Wa Wa Chaw Collection, 25/1175
Bonita Wa Wa Calachaw Nunez (1885-)

MAN AND MANY HANDS
Oil on Canvas. 83.5 x 60.4
Wa Wa Chaw Collection, 25/1176
Bonita Wa Wa Calachaw Nunez (1885-)

WOMAN AND TWO MEN
Oil on Canvas. 83.0 x 61.0
Wa Wa Chaw Collection, 25/1177
Bonita Wa Wa Calachaw Nunez (1885-)

ACOMA-LAGUNA

NAWISH KATSINA, 1964
Lithograph. 35.5 x 25.3
Byron Harvey III Collection, 23/3902
J. Michael Byrnes

MUDHEADS AND OTHER KATSINAS, 1964
Lithograph. 35.5 x 25.3
Byron Harvey III Collection, 23/3903
J. Michael Byrnes (1938-)

BURIAL SCENE, 1964
Lithograph. 22.3 x 30.4
Byron Harvey III Collection, 23/3904
J. Michael Byrnes (1938-)

CURING RITUAL, 1964
Lithograph. 35.4 x 28.0
Byron Harvey III Collection, 23/3905
J. Michael Byrnes (1938-)

CURING RITUAL, 1964
Lithograph. 25.2 x 35.6
Byron Harvey III Collection, 23/3906
J. Michael Byrnes (1938-)

TSATIA HOCHENI AND ALTAR, 1964
Lithograph. 22.9 x 35.7
Byron Harvey III Collection, 23/3907
J. Michael Byrnes (1938-)

LAGUNA BRIDE, 1964
Lithograph. 35.5 x 25.3
Byron Harvey III Collection, 23/3908
J. Michael Byrnes (1938-)

ACOMA MEDICINE MAN, 1964
Lithograph. 33.0 x 25.3
Byron Harvey III Collection, 23/3909
J. Michael Byrnes (1938-)

ACOMA KATSINA INITIATION, 1964
Lithograph. 32.9 x 25.4
Byron Harvey III Collection, 23/3910
J. Michael Byrnes (1938-)

KACHINAS
Watercolor, Ink on Board. 50.5 x 40.5
Byron Harvey Collection, 23/7629
J. Michael Byrnes (1938-)

LITTLE FIRE GOD AND OTHERS
Watercolor, Graphite on Board. 17.4 x 11.5
Byron Harvey Collection, 23/7650
J. Michael Byrnes

KACHINA SCENE, 1964
Lithograph. 32.9 x 25.4
Byron Harvey Collection, 23/7660A
J. Michael Byrnes (1938-)

HEALING SCENE, 1964
Lithograph. 25.2 x 35.6
Byron Harvey Collection, 23/7660B
J. Michael Byrnes (1938-)

LAGUNA BRIDE, 1964
Lithograph. 35.5 x 25.3
Byron Harvey Collection, 23/7660C
J. Michael Byrnes (1938-)

CURING RITUAL, 1964
Lithograph. 35.4 x 28.0
Byron Harvey Collection, 23/7660D
J. Michael Byrnes (1938-)

MUDHEADS AND OTHER KACHINAS, 1964
Lithograph. 35.5 x 25.3
Byron Harvey Collection, 23/7660E
J. Michael Byrnes (1938-)

BURIAL SCENE, 1964
Lithograph. 22.3 x 30.4
Byron Harvey Collection, 23/7660F
J. Michael Byrnes (1938-)

NAWISH KATSINA, 1964
Lithograph. 35.5 x 25.3
Byron Harvey Collection, 23/7660G
J. Michael Byrnes (1938-)

ACOMA MEDICINE MAN, 1964
Lithograph. 33.0 x 25.3
Byron Harvey Collection, 23/7660H
J. Michael Byrnes (1938-)

APACHE

MAN, 1964
Watercolor, Graphite on Paper. 30.3 x 22.9
Byron Harvey III Collection, 23/3893
Montie Nosie

DEVIL DANCERS, 1964
Watercolor on Paper. 37.8 x 27.6
Byron Harvey III Collection, 23/6161
Denis P. Pinto

MESCALERO APACHE

DESERT PEACE, 1967
Watercolor on Board. 50.8 x 40.8
Philbrook Art Center Annual, 23/9303
Bernadette Little (1948-)

GANS DANCER, 1961
Watercolor on Board. 28.5 x 23.9
William Michalsky Collection, 23/2922
Ignatius Palmer

GANS DANCER, 1962
Watercolor on Board. 21.6 x 16.7
William Michalsky Collection, 23/2923
Ignatius Palmer

GANS DANCER, 1962
Watercolor on Board. 21.7 x 16.6
William Michalsky Collection, 23/2924
Ignatius Palmer

DANCE OF THE MOUNTAIN GODS, 1962
Watercolor on Board. 33.5 x 63.9
William Michalsky Collection, 23/2925
Ignatius Palmer

THREE BEARS, 1962
Watercolor on Board. 30.7 x 25.5
William Michalsky Collection, 23/2926
Ignatius Palmer

TWO DEER, 1961
Watercolor on Board. 28.8 x 24.0
William Michalsky Collection, 23/2927
Ignatius Palmer

THE BASKET WEAVER, 1962
Watercolor on Board. 30.5 x 25.8
William Michalsky Collection, 23/2928
Ignatius Palmer

BUFFALO HUNTER, 1962
Watercolor on Board. 23.1 x 28.6
William Michalsky Collection, 23/2929
Ignatius Palmer

TWO DEER, 1948
Watercolor on Paper. 21.7 x 28.4
Oscar B. Jacobson Collection, 23/6035
Rudolph Treas

SAN CARLOS APACHE

APACHE GAHN DANCER, c.1960
Watercolor on Paper. 38.6 x 28.5
Lorenzo Hubbell Collection, 24/3921
Daniel Nash

ARAPAHO

OKLAHOMA DANCERS
Oil on Fabric. 33.4 x 63.0
Joseph Imhof Collection, 23/3357
Carl Sweezy (c.1881-1953)

THREE CHEYENNE WARRIORS
Watercolor on Board. 32.6 x 56.8
Oscar B. Jacobson Collection, 23/6037
Carl Sweezy (c.1881-1953)

WARRIORS
Watercolor, Graphite on Paper. 34.0 x 46.0
Jeanne O. Snodgrass Collection, 24/8189
Carl Sweezy (c.1881-1953)

ASSINIBOIN

TWO MEN ON FOOT WITH GUNS
Graphite, Watercolor on Lined Paper. 22.6 x 28.6
Frank H. Cushing Collection, 10/9641
Artist Unknown

MAN ON HORSEBACK SHOOTING A WOMAN(?)
Graphite, Watercolor on Paper. 22.7 x 28.8
F.H. Cushing Collection, 10/9640
Artist Unknown

BLACKFEET

LEDGER BOOK
Ink, Colored Pencil on Lined Paper. 14.7 x 17.8
Dr. Walter A. Stevens Collection, 14/3394
Artist Unknown

BLACKFOOT WARRIOR, 1943
Oil on Canvas. 45.2 x 31.2
Margo Kokott Collection, 24/4243
Margo Kokott

BURNING BUSH, 1982
Watercolor on Paper. 57.5 x 76.0
King Kuka Collection, 25/1126
King Kuka (1946-)

STOLEN HORSES, 1981
Oil on Canvas. 177.4 x 143.2
King Kuka Collection, 25/1184
King Kuka (1946-)

MAN ON HORSEBACK
Ink on Paper. 22.7 x 30.3
Mr. & Mrs. Joseph Van Vleck Jr. Collection, 22/8913
Lone Wolf (-1879)

BUNGI

LEDGER BOOK OF CEREMONIES
Graphite, Colored Pencil on Lined Paper. 16.8 x 11.0
Donald Cadzow Collection, 14/2512
Artist Unknown

CHEROKEE

A CHEROKEE DOCTOR
Watercolor, Graphite on Paper. 26.7 x 21.5
Oscar B. Jacobson Collection, 23/6050
Cecil Dick (1915- date unknown)

CHEROKEE-POTAWATOMI

THE HUNTER'S KILL
Watercolor on Paper. 41.4 x 33.6
Anonymous Collection, 24/8192
Franklin Gritts (1941-)

CHEYENNE

BATTLE SCENE, c.1870
Graphite, Ink, Watercolor on Paper. 57.7 x 80.7
James Rowan O'Beirne Collection, 11/1705
Little Chief(?)

SUN DANCE, c.1870
Graphite, Ink, Watercolor on Paper. 59.5 x 65.8
James Rowan O'Beirne Collection, 11/1706
Little Chief(?)

DOUBLE TROPHY ROSTER, 1876
Graphite, Colored Pencil on Lined Paper. 19.0 x 12.5
Mrs. John Jay White Collection, 10/8725
High Bull

MAN LEADING HORSE, 1886
Ink, Graphite, Crayon on Paper. 26.3 x 40.5
George Terasaki Collection, 23/5998
Roman Nose

THE DREAMER, 1970
Watercolor on Board. 33.1 x 44.5
Frederick J. Dockstader Collection, 24/3724
Edward Stands Alone

WHERE CAN WE GO NOW?, 1970
Watercolor on Board. 35.0 x 46.6
Frederick J. Dockstader Collection, 24/3725
Edward Stands Alone

DARK DANCE OF THE LITTLE PEOPLE, c.1948
Watercolor on Paper. 30.5 x 45.8
Jeanne O. Snodgrass Collection, 23/8382
Dick West (1912-)

THE FLUTE PLAYER, 1938
Watercolor on Paper. 33.7 x 23.2
Anonymous Collection, 24/8191
Dick West (1912-)

350 tracings and drawings including portraits, battle
scenes, courtship scenes and ceremonies.
Graphite, Ink, Watercolor on Paper, 25.5 x 38.0
Major John Gregory Bourke Collection
23/4251-23/4599B, 24/1045-24/1052
Possibly Yellow Nose

LEDGER BOOK BY SEVERAL ARTISTS, c.1875
Ink, Graphite, Crayon on Lined Paper. 15.4 x 10.0
Frank G. Speck Collection, 16/4352

COCHITI

MURAL FIGURE, 1948
Watercolor on Paper. 28.5 x 19.4
Charles and Ruth DeYoung Elkus Collection, 23/1248
Joe H. Herrera (1923-)

KOSHARE CLOWN DANCING, c.1940
Watercolor on Paper. 18.0 x 12.6
Joseph Imhof Collection, 23/3349
Joe H. Herrera (1923-)

FEMALE DANCER
Watercolor, Graphite on Paper. 33.9 x 24.2
Oscar B. Jacobson Collection, 23/6032
Joe H. Herrera (1923-)

OLDEN TIME BUTTERFLY DANCE
Watercolor on Paper. 28.8 x 18.0
Oscar B. Jacobson Collection, 23/6033
Joe H. Herrera (1923-)

A DANCE
Watercolor on Paper. 27.6 x 14.3
Oscar B. Jacobson Collection, 23/6034
Joe H. Herrera (1923-)

KOSHARY, 1955
Watercolor on Paper. 25.6 x 20.2
Byron Harvey Collection, 23/1497
Justino Herrera (1920-)

KOSHARY EATING MELON, 1955
Watercolor on Paper. 30.5 x 23.0
Anonymous Collection, 23/1498
Justino Herrera (1920-)

EAGLE DANCER
Watercolor on Paper. 23.9 x 32.8
Joseph Imhof Collection, 23/3329
Justino Herrera (1920-)

RED BUFFALO DANCE
Watercolor on Paper. 34.5 x 25.3
Oscar B. Jacobson Collection, 23/6029
Justino Herrera (1920-)

RETURNING HOME FROM BEAR HUNT, c.1940
Watercolor on Paper. 35.0 x 58.3
Oscar B. Jacobson Collection, 23/6030
Justino Herrera (1920-)

THREE DANCERS, c.1950
Watercolor on Board. 38.9 x 42.9
Charles and Ruth DeYoung Elkus Collection, 23/1236
Victor Herrera

DEER DANCE
Watercolor on Paper. 54.5 x 38.5
Byron Harvey Collection, 25/1185
Ray Melchior

CORN DANCE WITH SINGERS AND DRUMMER
Watercolor on Board. 35.5 x 55.8
Henry Craig Fleming Collection, 22/8610
Tonita Peña (1895-1949)

DRUMMERS
Watercolor on Paper. 17.9 x 11.8
Joseph Imhof Collection, 23/3359
Tonita Peña (1895-1949)

DRUMMER
Watercolor on Paper. 17.9 x 11.8
Joseph Imhof Collection, 23/3360
Tonita Peña (1895-1949)

DRUMMER
Watercolor on Paper. 17.7 x 11.9
Joseph Imhof Collection, 23/3361
Tonita Peña (1895-1949)

SKUNKS IN CORN, c.1939
Watercolor on Paper. 50.7 x 61.4
Charles and Ruth DeYoung Elkus Collection, 23/1262
Ben Quintana (1923-1944)

BUFFALO DANCE
Watercolor on Paper. 37.8 x 30.3
Oscar B. Jacobson Collection, 24/8199
Ben Quintana (1923-1944)

BUFFALO DANCER, 1961
Watercolor on Canvas. 43.0 x 36.0
Jeanne O. Snodgrass Collection, 23/8381
Theodore Suina (1918-)

GIRL HARVEST DANCER
Watercolor on Board. 25.4 x 18.0
Oscar B. Jacobson Collection, 24/8188
Theodore Suina (1918-)

BOY DEER DANCER
Watercolor, Graphite on Paper. 35.6 x 20.5
Oscar B. Jacobson Collection, 23/6031
Andy Trujillo

COLLAS-AYMARA (Bolivia)

DANCERS AND POSITIONS
Watercolor on Lined Paper. 16.1 x 84.0
A.H. Verrill Collection, 15/8309
Artist Unknown

COMANCHE

LOST, 1960
Watercolor on Board. 41.5 x 34.0
Philbrook Art Center Annual, 23/6995
Rance Hood (1941-)

BULL ROBE PRAYS TO 'NICKUNI', 1960
Oil on Canvas. 55.5 x 75.5
Anne Hyatt Huntington Collection, 25/1178
Dan Taulbee (1924-)

THE LAST LOOK, 1958
Oil on Canvas. 55.3 x 70.5
Anne Hyatt Huntington Collection, 25/1179
Dan Taulbee (1924-)

WHITE MAN, WHERE ARE OUR BUFFALO?, 1960
Oil on Canvas. 40.0 x 50.5
Anne Hyatt Huntington Collection, 25/1180
Dan Taulbee (1924-)

THE LAST HUNTERS, 1961
Oil on Canvas. 45.4 x 60.8
Anne Hyatt Huntington Collection, 25/1181
Dan Taulbee (1924-)

THE AMERICAN BOW MAKER, 1961
Oil on Canvas. 40.2 x 50.5
Anne Hyatt Huntington Collection, 25/1182
Dan Taulbee (1924-)

BEFORE THE HORSE CAME, 1960
Oil on Canvas. 60.6 x 76.0
Anne Hyatt Huntington Collection, 25/1183
Dan Taulbee (1924-)

COMANCHE GIRL, 1938
Watercolor on Paper. 29.3 x 21.6
Oscar B. Jacobson Collection, 23/6049
Marian Terasaz (1916-)

CREEK

FLORIDA SEMINOLES PREPARING FOOD, 1949
Watercolor on Board. 45.4 x 66.5
Jeanne O. Snodgrass Collection, 23/8383
Fred Beaver (1911-)

CREEK-CHEROKEE

MISSISSIPPIAN STYLE WARRIOR, 1964
Watercolor on Paper. 76.5 x 56.4
Philbrook Art Center Annual, 23/4134
Joan Hill (1930-)

CREEK-POTAWATOMI

DEER
Ink on Paper. 19.0 x 14.2
Charles and Ruth DeYoung Elkus Collection, 23/1259
Woody Crumbo (1912-)

WILD PINTO
Ink on Paper. 19.1 x 14.1
Charles and Ruth DeYoung Elkus Collection, 23/1260
Woody Crumbo (1912-)

THREE EAGLE DANCERS
Watercolor, Graphite on Vellum. 50.5 x 66.0
Charles and Ruth DeYoung Elkus Collection, 23/1261
Woody Crumbo (1912-)

THE FLUTE DANCER
Lithograph. 32.9 x 26.5
Anonymous Collection, 25/1131
Woody Crumbo (1912-)

MEDICINE SONG
Lithograph. 32.9 x 26.5
Anonymous Collection, 25/1132
Woody Crumbo (1912-)

THE DEER DANCE
Lithograph. 32.9 x 26.5
Anonymous Collection, 25/1133
Woody Crumbo (1912-)

THE EAGLE DANCE
Lithograph. 32.9 x 26.5
Anonymous Collection, 25/1134
Woody Crumbo (1912-)

THE EAGLE DANCE
Lithograph. 32.9 x 26.5
Anonymous Collection, 25/1135
Woody Crumbo (1912-)

THE CROW DANCE
Lithograph. 32.9 x 26.5
Anonymous Collection, 25/1136
Woody Crumbo (1912-)

THE BUFFALO DANCE
Lithograph. 32.9 x 26.5
Anonymous Collection, 25/1137
Woody Crumbo (1912-)

CREEK-SEMINOLE

THE INTRUDERS, 1966
Watercolor on Board. 40.7 x 51.0
Philbrook Art Center Annual, 23/6992
Jerome Tiger (1941-1967)

SEMINOLE MOTHER, 1967
Watercolor on Board. 14.1 x 18.5
Jeanne O. Snodgrass Collection, 23/8387
Jerome Tiger (1941-1967)

TOWARD HOME, 1966
Watercolor on Board. 19.2 x 25.3
Jeanne O. Snodgrass Collection, 24/8193
Jerome Tiger (1941-1967)

FIRST SHOT, 1967
Watercolor, Graphite on Board. 35.5 x 49.4
Philbrook Art Center Annual, 25/1081
Jerome Tiger (1941-1967)

COLD NO MORE, 1967
Watercolor, Graphite on Board. 25.2 x 15.1
Philbrook Art Center Annual, 25/1102
Jerome Tiger (1941-1967)

LAST VISIT, 1967
Watercolor, Graphite on Board. 20.2 x 30.3
Philbrook Art Center Annual, 25/1103
Jerome Tiger (1941-1967)

EVERGLADE TERROR, 1967
Watercolor, Graphite on Board. 35.7 x 48.2
Philbrook Art Center Annual, 25/1104
Jerome Tiger (1941-1967)

THE VICTORS, 1967
Graphite, Watercolor on Board. 40.6 x 55.9
Philbrook Art Center Annual, 25/1125
Jerome Tiger (1941-1967)

FAMILY REMOVAL, 1965
Watercolor on Board. 13.9 x 25.6
Jerome Tiger Collection, 23/6112
Jerome Tiger (1941-1967)

COLD JOURNEY HOME, 1965
Watercolor on Board. 17.8 x 26.7
Jerome Tiger Collection, 23/6113
Jerome Tiger (1941-1967)

YESTERDAY THEY RODE, 1967
Watercolor on Board. 30.4 x 40.9
Jerome Tiger Collection, 24/0746
Jerome Tiger (1941-1967)

CUNA (Panama)

ILLUSTRATIONS OF MEDICINE AND CEREMONIAL SONGS
Graphite, Colored Pencil on Lined Paper. 21.5 x 11.0
David B. Stout Collection, 20/4539
Artist Unknown

VILLAGE SCENE
Graphite, Crayon on Paper. 56.9 x 72.7
David B. Stout Collection, 20/4549
Artist Unknown

DELAWARE-CHEROKEE

DELAWARE MISI'NG DANCER, 1967
Watercolor on Board. 51.0 x 41.0
Philbrook Art Center Annual, 23/9302
Ruthe Blalock Jones (1939-)

ESKIMO

MAN & WOMAN
Graphite, Crayon on Paper. 21.0 x 28.0
Purchase, 10/8678
Artist Unknown

PICTOGRAPHIC LETTER, 1907
Graphite on Board. 9.3 x 51.6
Anonymous Collection, 12/7455
Artist Unknown

DEER, 1953
Graphite on Paper. 22.6 x 30.2
Anonymous Collection, 25/1111
Mike

CARIBOU DRIVE, 1936
Ink on Hide. 25.0 x 30.0
Purchase, 19/1654
George Agupuk

FISHING SCENE, 1956
Ink on Hide. 25.3 x 30.1
Purchase, 19/1655
George Agupuk

CARIBOU ROUNDUP
Ink on Hide. 20.0 x 25.2
J.A.L. Moller Collection, 21/5688
George Agupuk

VILLAGE SCENE
Ink on Caribou Skin. 44.0 x 89.2
George Terasaki Collection, 23/8578
George Agupuk

IGLOO, FIGURES AND SLED, 1953
Watercolor, Construction Paper on Paper. 24.0 x 28.0
Anonymous Collection, 25/1113
Louis Lapluma

MASK-FACE WITH FISH, 1960
Watercolor on Construction Paper. 40.1 x 29.9
Jeanne O. Snodgrass Collection, 23/8392
Gabriel Monignok (-1965)

HUNTING WHALE, 1905
Graphite, Crayon, Ink on Paper. 14.0 x 20.5
Frederick J. Dockstader Collection, 22/4489
J. Ocktuck

HUNTING WHALE, 1905
Graphite, Crayon, Ink on Paper. 13.0 x 20.5
Frederick J. Dockstader Collection, 22/4490
J. Ocktuck

GROS VENTRES

THE BULL DANCE
Watercolor, Crayon, Ink on Paper. 43.0 x 55.8
Mrs. P.F. Cochrane Collection, 4/2446B
Artist Unknown

THE EXPLOITS OF POOR WOLF
Crayon, Watercolor, Ink on Paper. 43.0 x 56.1
Mrs. P.F. Cochrane Collection, 4/2446A
Artist Unknown

HAIDA

CYCLES, 1979
Ink on Paper. 25.3 x 25.4
Robert Davidson Collection, 25/0861
Robert Davidson (1946-)

RAVEN STEALING THE MOON, 1977
Ink on Paper. 58.3 x 26.5
Robert Davidson Collection, 25/1150
Robert Davidson (1946-)

BOOK OF DESIGNS, 1892
Graphite on Paper. 24.7 x 38.1
Purchase, 11/6948
John Robinson

DOGFISH DRAWN ON A MAP
Paint, Crayon on Lined Paper. 78.0 x 52.1
Purchase, 15/8613
Jon Robson

I SEE BIG FISH
Graphite, Ink, Crayon on Paper. 20.0 x 26.0
Purchase, 15/8614
Jon Robson

GOT- EAGLE
Graphite, Ink, Crayon on Paper. 26.0 x 19.9
Purchase, 15/8615
Jon Robson

HOOTS- GRIZZLY BEAR
Graphite, Crayon, Ink on Paper. 26.0 x 20.3
Purchase, 15/8616
Jon Robson

HOOIYA- RAVEN
Graphite, Ink, Crayon on Paper. 24.5 x 20.1
Purchase, 15/8617
Jon Robson

GHY-YA- SCULPIN
Graphite, Crayon, Ink on Paper. 23.7 x 19.3
Purchase, 15/8618
Jon Robson

GAN-GO-STAN- FROG
Graphite, Ink, Crayon on Paper. 26.0 x 20.3
Purchase, 15/8619
Jon Robson

HOPI

KACHINA
Watercolor on Paper. 41.0 x 27.3
Lorenzo Hubbell Collection, 22/4468
Artist Unknown

ANTELOPE SOCIETY DANCER, c.1945
Watercolor on Paper. 31.9 x 18.0
Lorenzo Hubbell Collection, 22/4480
Artist Unknown

KACHINA DANCER AND KACHINA MAIDEN
Watercolor on Paper. 25.1 x 25.6
John L. Nelson Collection, 23/3452
Artist Unknown

KACHINA GROUP, c.1945
Watercolor, Graphite on Paper. 23.0 x 30.5
Anonymous Collection, 23/3777
Artist Unknown

KOKOPOLO MANA
Watercolor on Paper. 27.4 x 19.6
Byron Harvey III Collection, 23/3955
Artist Unknown

KACHINA
Watercolor on Paper. 27.9 x 17.4
Byron Harvey III Collection, 23/7581
Artist Unknown

KACHINA AND TURKEY
Watercolor on Paper. 30.7 x 41.2
Byron Harvey III Collection, 23/7659
Artist Unknown

CLOUD KACHINA
Watercolor on Paper. 42.4 x 26.5
Lorenzo Hubbell Collection, 24/3910
Artist Unknown

COW KACHINA
Watercolor on Board. 38.0 x 19.0
Lorenzo Hubbell Collection, 24/3911
Artist Unknown

ROLE OF KACHINAS IN HOPI LIFE
Crayon, Graphite on Board. 11.5 x 22.0
Anonymous Collection, 25/1138
Artist Unknown

KACHINAS IN KIVA
Crayon, Graphite on Board. 11.5 x 22.0
Anonymous Collection, 25/1139
Artist Unknown

MUDHEADS DANCING IN VILLAGE
Crayon, Graphite on Board. 11.5 x 22.0
Anonymous Collection, 25/1140
Artist Unknown

THE NIMAN KACHINAS
Crayon, Graphite on Board. 11.5 x 22.0
Anonymous Collection, 25/1141
Artist Unknown

NIMAN KACHINA ON KIVA
Crayon, Graphite on Board. 11.5 x 22.0
Anonymous Collection, 25/1142
Artist Unknown

PERSON TENDING FIRE IN KIVA
Crayon, Graphite on Board. 11.5 x 22.0
Anonymous Collection, 25/1143
Artist Unknown

MUDHEAD & SERPENT
Watercolor on Board. 26.0 x 26.0
Lorenzo Hubbell Collection, 24/3908
Calvin Akima

CHIRO KACHINA
Watercolor on Paper. 30.4 x 22.8
Lorenzo Hubbell Collection, 22/4447
Victor H. Coochwatewa

TASAP KACHINA
Watercolor on Paper. 35.7 x 28.3
Lorenzo Hubbell Collection, 22/4448
Victor H. Coochwatewa

HEHEYA KACHINA
Watercolor on Paper. 30.5 x 22.8
Lorenzo Hubbell Collection, 24/3918
Victor H. Coochwatewa

CHAVEYO KACHINA
Watercolor on Paper. 30.3 x 22.8
Lorenzo Hubbell Collection, 24/3919
Victor H. Coochwatewa

HOTOTO & SAIASTASAKA, 1965
Watercolor on Board. 38.4 x 34.7
Oscar B. Jacobson Collection, 23/6149
Neal David

THREE BUFFALO DANCERS, 1965
Watercolor on Board. 36.5 x 54.5
Byron Harvey Collection, 23/6150
Neal David

TEWA YAH-NE-WAH DANCERS, 1965
Watercolor on Board. 25.4 x 45.0
Byron Harvey III Collection, 23/6426
Neal David

PROUD KACHINA
Watercolor on Board. 41.8 x 27.5
Byron Harvey III Collection, 23/3957
Henry Fred

THREE KACHINAS, 1965
Watercolor on Paper. 43.5 x 46.5
Byron Harvey III Collection, 23/6154
Lee Roy Gaseoma

MARAO MANA, 1965
Watercolor on Board. 38.5 x 26.5
Oscar B. Jacobson Collection, 23/6155
Lee Roy Gaseoma

KACHINA DANCER, 1961
Watercolor on Paper. 24.5 x 20.2
Byron Harvey III Collection, 23/3776
Art Holmes

HORSES, 1945
Watercolor on Paper. 31.7 x 48.5
Oscar B. Jacobson Collection, 23/6007
Gordon Holmes

ABSTRACT DESIGN, c.1965
Marker on Paper. 60.0 x 43.5
Byron Harvey III Collection, 23/7584
Delbridge Honanie

KACHINAS & MUDHEAD
Watercolor on Board. 38.0 x 50.5
Byron Harvey III Collection, 23/7585
Delbridge Honanie

AHOTE KACHINA
Oil on Board. 37.9 x 28.7
Lorenzo Hubbell Collection, 22/4446
Eric Humatewa

MORNING STAR KACHINA
Watercolor on Board. 33.8 x 24.5
Oscar B. Jacobson Collection, 23/6000
James R. Humetewa Jr. (1926-)

PUEBLO ON MESA TOP, c.1945
Watercolor on Paper. 24.0 x 31.8
Isabel Schroeter Collection, 22/4885
E.H.K.

PUEBLO ON A MESA TOP, c.1945
Crayon, Graphite on Paper. 22.3 x 30.1
Isabel Schroeter Collection, 22/4898
E.H.K.

KOHONIN KACHINAS, c.1927
Watercolor, Crayon on Paper. 35.0 x 26.2
John L. Nelson Collection, 18/2033
Fred Kabotie (1900-)

KOWAKO (ROOSTER) KACHINA DANCERS, c.1927
Watercolor on Paper. 36.5 x 27.5
John L. Nelson Collection, 18/2034
Fred Kabotie (1900-)

KACHINA DANCERS APPEARING IN ANKNWA, c.1927
Watercolor on Paper. 36.4 x 27.5
John L. Nelson Collection, 18/2035
Fred Kabotie (1900-)

PAYIKALO KACHINA DANCERS, c.1927
Watercolor, Chalk on Paper. 35.2 x 26.2
John L. Nelson Collection, 18/2036
Fred Kabotie (1900-)

DANCERS (HAVASUPAI?), c.1927
Watercolor on Paper. 39.5 x 27.2
John L. Nelson Collection, 18/2037
Fred Kabotie (1900-)

HO-HO-LO DANCE, c.1927
Watercolor on Paper. 38.2 x 27.7
John L. Nelson Collection, 18/2038
Fred Kabotie (1900-)

TALANAI (DAWN) KACHINA DANCERS, c.1927
Watercolor on Paper. 38.2 x 27.8
John L. Nelson Collection, 18/2039
Fred Kabotie (1900-)

MORNING KACHINAS, c.1927
Watercolor on Paper. 38.0 x 28.0
John L. Nelson Collection, 18/2044
Fred Kabotie (1900-)

NAVAJO KACHINAS, c.1927
Watercolor on Paper. 38.0 x 26.0
John L. Nelson Collection, 18/2045
Fred Kabotie (1900-)

LINE OF BUFFALO KACHINA DANCERS, c.1927
Watercolor on Paper. 38.0 x 27.5
John L. Nelson Collection, 18/2046
Fred Kabotie (1900-)

KACHINA DANCER, c.1927
Watercolor on Paper. 38.0 x 25.5
John L. Nelson Collection, 18/2051
Fred Kabotie (1900-)

HUNTING KACHINA, c.1927
Watercolor, Crayon on Paper. 38.0 x 25.2
John L. Nelson Collection, 18/2052
Fred Kabotie (1900-)

MOM KACHINA DANCER, c.1927
Watercolor, Crayon on Paper. 38.0 x 27.5
John L. Nelson Collection, 18/2053
Fred Kabotie (1900-)

FIRST MESA, c.1927
Crayon, Watercolor on Paper. 38.0 x 27.5
John L. Nelson Collection, 18/2054
Fred Kabotie (1900-)

QOMAUSHIPIKNE TAKA KACHINA, c.1927
Watercolor on Paper. 38.4 x 27.5
John L. Nelson Collection, 18/2055
Fred Kabotie (1900-)

KACHINA DANCERS, c.1927
Watercolor, Crayon on Paper. 38.0 x 31.8
John L. Nelson Collection, 18/2058
Fred Kabotie (1900-)

TEBASHUI NAVAJO DANCE, c.1927
Watercolor, Chalk on Paper. 38.0 x 30.4
John L. Nelson Collection, 18/2059
Fred Kabotie (1900-)

AVATCH-HAYA KACHINAS, c.1927
Watercolor on Paper. 39.0 x 30.5
John L. Nelson Collection, 18/2060
Fred Kabotie (1900-)

HUMIS KACHINA DANCE, c.1927
Watercolor on Paper. 36.5 x 32.2
John L. Nelson Collection, 18/2061
Fred Kabotie (1900-)

CROW MOTHER AND FLOGGERS, c.1927
Watercolor, Chalk on Paper. 38.5 x 30.4
John L. Nelson Collection, 18/2062
Fred Kabotie (1900-)

HO-LEA KACHINAS, c.1927
Watercolor, Chalk on Paper. 38.0 x 31.2
John L. Nelson Collection, 18/2063
Fred Kabotie (1900-)

HEALIHA- FERN DANCE, c.1927
Watercolor, Chalk on Paper. 34.3 x 37.6
John L. Nelson Collection, 18/2064
Fred Kabotie (1900-)

SNAKE DANCE SCENE, c.1927
Watercolor on Paper. 38.0 x 48.4
John L. Nelson Collection, 18/2068
Fred Kabotie (1900-)

EAGLE DANCERS AND MUDHEADS, c.1927
Watercolor on Paper. 35.2 x 55.6
John L. Nelson Collection, 18/2072
Fred Kabotie (1900-)

MARAO KACHINA, 1965
Watercolor on Board. 49.5 x 38.2
Oscar B. Jacobson Collection, 23/6153
Wilmer Kaye

MUDHEADS AND KACHINA
Watercolor on Board. 37.7 x 51.3
Byron Harvey III Collection, 23/7590
Wilmer Kaye

KACHINA DANCER
Watercolor on Board. 35.5 x 28.2
Byron Harvey III Collection, 22/4875
C.T. Kelhoyoma

BUFFALO DANCER, 1964
Watercolor on Board. 33.5 x 26.0
Byron Harvey III Collection, 23/6152
Leroy Kewanyama (1922-)

MANANGYA KACHINA
Watercolor, Graphite on Paper. 37.9 x 27.9
Lorenzo Hubbell Collection, 24/3888
Leroy Kewanyama (1922-)

BUFFALO DANCER
Watercolor on Paper. 37.1 x 27.9
Lorenzo Hubbell Collection, 24/3889
Leroy Kewanyama (1922-)

LAGAN KACHINA
Watercolor on Paper. 37.1 x 27.8
Lorenzo Hubbell Collection, 24/3890
Leroy Kewanyama (1922-)

TURTLE KACHINA, c.1940
Watercolor on Paper. 37.1 x 27.6
Lorenzo Hubbell Collection, 24/3891
Leroy Kewanyama (1922-)

MAGIC MUDHEAD
Watercolor on Paper. 37.2 x 27.8
Lorenzo Hubbell Collection, 24/3892
Leroy Kewanyama (1922-)

TACAP KACHINA
Watercolor on Paper. 36.9 x 27.7
Lorenzo Hubbell Collection, 24/3893
Leroy Kewanyama (1922-)

KWEWUU KACHINA
Watercolor on Paper. 37.0 x 27.7
Lorenzo Hubbell Collection, 24/3894
Leroy Kewanyama (1922-)

MONGWII KACHINA
Watercolor on Paper. 30.4 x 22.8
Lorenzo Hubbell Collection, 24/3895
Leroy Kewanyama (1922-)

CHAKWAINA
Watercolor on Paper. 30.5 x 22.5
Lorenzo Hubbell Collection, 24/3896
Leroy Kewanyama (1922-)

MAK KACHINA
Watercolor on Paper. 37.4 x 27.8
Lorenzo Hubbell Collection, 24/3897
Leroy Kewanyama (1922-)

HO-HI KACHINA
Watercolor on Paper. 37.9 x 27.8
Lorenzo Hubbell Collection, 24/3898
Leroy Kewanyama (1922-)

KONA KACHINA
Watercolor on Paper. 37.9 x 27.7
Lorenzo Hubbell Collection, 24/3899
Leroy Kewanyama (1922-)

ABSTRACT DESIGN WITH CORN, c.1950
Watercolor on Paper. 45.6 x 50.8
Charles and Ruth DeYoung Elkus Collection, 23/1263
Otellie Loloma (c.1922-)

SILAKAFHONTAKA KACHINAS, 1964
Watercolor on Paper. 61.0 x 48.5
Byron Harvey III Collection, 23/3956
Marshall Lomakema (1935-)

KACHINA BASKET DANCERS, 1964
Watercolor on Paper. 38.6 x 35.4
Byron Harvey III Collection, 23/4124
Marshall Lomakema (1935-)

MARAU DANCERS IN WAUHETOKA CEREMONY, 1964
Watercolor on Paper. 35.4 x 42.3
Byron Harvey III Collection, 23/4125
Marshall Lomakema (1935-)

MARAU CEREMONY WITH CHATIMAKA PERFORMER, 1964
Watercolor on Paper. 34.8 x 31.1
Byron Harvey III Collection, 23/4126
Marshall Lomakema (1935-)

WAWASH KACHINA, 1964
Watercolor on Paper. 35.0 x 28.0
Byron Harvey III Collection, 23/4127
Marshall Lomakema (1935-)

POK'CHINA, THE DOG KACHINA, 1964
Watercolor on Paper. 35.1 x 28.1
Byron Harvey III Collection, 23/4128
Marshall Lomakema (1935-)

KWAINA KACHINA
Watercolor on Paper. 24.4 x 20.2
Byron Harvey III Collection, 23/3774
N. Lomayaktuva (1946-)

LANGANTOINAKA KACHINA
Watercolor on Paper. 24.4 x 20.2
Byron Harvey III Collection, 23/3775
N. Lomayaktuva (1946-)

TONEINILI KACHINA, 1964
Watercolor on Paper. 40.0 x 30.4
Byron Harvey III Collection, 23/6151
N. Lomayaktuva (1946-)

SNAKE CATCHER KACHINA
Watercolor on Paper. 30.7 x 23.8
Byron Harvey III Collection, 24/8196
Louis Lomayesva (c.1925-)

HOPI WATER BIRD DANCER
Watercolor on Paper. 30.4 x 24.3
Byron Harvey III Collection, 24/8197
Louis Lomayesva (c.1925-)

YELLOW RAIN KACHINA
Watercolor on Paper. 30.1 x 24.2
Byron Harvey III Collection, 24/8198
Louis Lomayesva (c.1925-)

CHAKWAINA KACHINA
Watercolor on Paper. 30.4 x 18.3
Lorenzo Hubbell Collection, 22/4449
Waldo Mootzka (1903-1941)

TALAVAI KACHINA, c.1930
Watercolor on Paper. 38.0 x 29.2
Lorenzo Hubbell Collection, 22/4450
Waldo Mootzka (1903-1941)

KACHINA AND PUEBLO SCENE
Watercolor on Paper. 47.0 x 30.0
Lorenzo Hubbell Collection, 22/4451
Waldo Mootzka (1903-1941)

WAWASH KACHINAS AND MEN
Watercolor, Graphite on Paper. 29.1 x 41.8
John L. Nelson Collection, 23/3348
Waldo Mootzka (1903-1941)

WOMAN IN CEREMONIAL COSTUME, c.1935
Watercolor on Paper. 30.4 x 20.4
John L. Nelson Collection, 23/3444
Waldo Mootzka (1903-1941)

EOTOTO KACHINA, c.1935
Watercolor on Paper. 36.9 x 29.0
John L. Nelson Collection, 23/3447
Waldo Mootzka (1903-1941)

ANGAKCHINA DANCERS, c.1930
Watercolor on Paper. 30.0 x 48.4
John L. Nelson Collection, 23/3449
Waldo Mootzka (1903-1941)

THREE TATANGAYA KACHINAS
Watercolor on Paper. 30.5 x 45.7
John L. Nelson Collection, 23/3450
Waldo Mootzka (1903-1941)

SNAKE DANCER
Watercolor on Paper. 15.3 x 10.5
Indianapolis Children's Museum Collection, 23/8410
Waldo Mootzka (1903-1941)

KACHINA DANCER
Watercolor on Paper. 15.3 x 10.5
Indianapolis Children's Museum Collection, 23/8411
Waldo Mootzka (1903-1941)

TALAVAI KACHINA
Watercolor, Graphite on Paper. 30.1 x 20.4
Lorenzo Hubbell Collection, 24/3875
Waldo Mootzka (1903-1941)

CHAVEYO KACHINA
Watercolor on Paper. 29.3 x 18.4
Lorenzo Hubbell Collection, 24/3876
Waldo Mootzka (1903-1941)

PAWIK KACHINA
Watercolor on Paper. 29.4 x 19.1
Lorenzo Hubbell Collection, 24/3877
Waldo Mootzka (1903-1941)

CHOP KACHINA WITH BACKGROUND
Watercolor on Paper. 32.0 x 22.1
Lorenzo Hubbell Collection, 24/3878
Waldo Mootzka (1903-1941)

SUPAI DANCER, 1956
Watercolor on Paper. 25.4 x 20.4
Byron Harvey Collection, 23/1496
Raymond Naha (1933-1975)

CORN DANCE, 1964
Watercolor on Board. 42.5 x 43.6
Byron Harvey III Collection, 23/4129
Raymond Naha (1933-1975)

ZUNI CORN DANCERS, 1964
Watercolor on Board. 38.0 x 51.7
Philbrook Art Center Annual, 23/4130
Raymond Naha (1933-1975)

MIXED KACHINA DANCE, 1964
Watercolor on Board. 49.3 x 61.4
Philbrook Art Center Annual, 23/4131
Raymond Naha (1933-1975)

MIXED KACHINA DANCE, 1964
Watercolor on Board. 49.3 x 61.4
Philbrook Art Center Annual, 23/4931
Raymond Naha (1933-1975)

KACHINA DOLL CARVER, 1966
Watercolor on Board. 54.9 x 41.5
Philbrook Art Center Annual, 23/6993
Raymond Naha (1933-1975)

DOLLS AND SPROUTING CORN IN THE KIVA, 1966
Watercolor on Board. 49.8 x 32.0
Philbrook Art Center Annual, 23/6994
Raymond Naha (1933-1975)

WHITE BEAR KACHINA, 1964
Watercolor, Graphite on Paper. 32.7 x 24.1
Byron Harvey III Collection, 23/3520
Grifford Narningha

WO-E KACHINAS
Watercolor on Paper. 28.9 x 38.0
Byron Harvey III Collection, 23/3959
A.M. Nova

KACHINA, c.1940
Watercolor, Graphite on Paper. 35.6 x 30.5
Lorenzo Hubbell Collection, 22/4461
George Outie (1926-)

ANAKCHINA
Watercolor on Paper. 35.8 x 28.1
Lorenzo Hubbell Collection, 22/4462
George Outie (1926-)

BEARDED KACHINA
Watercolor, Graphite on Paper. 30.1 x 22.5
Byron Harvey III Collection, 23/7577
Ray P.

KACHINA WITH CROOK AND RATTLE
Watercolor, Graphite on Paper. 30.1 x 22.5
Byron Harvey III Collection, 23/7578
Ray P.

TALAVAI KACHINA
Watercolor, Graphite on Paper. 30.2 x 22.6
Byron Harvey III Collection, 23/7579
Ray P.

KACHINA
Watercolor on Paper. 28.0 x 18.6
Byron Harvey III Collection, 23/7580
Ray P.

DEER KACHINA, 1965
Crayon, Ink, Graphite on Paper. 30.4 x 22.9
Byron Harvey III Collection, 23/7594
T. Pavatea

QOIN KACHINA
Watercolor, Graphite on Paper. 30.4 x 21.6
Lorenzo Hubbell Collection, 24/3907
Robert Pentewa

CHICKEN HAWK KACHINA DANCER, 1930
Watercolor on Board. 31.8 x 21.9
Charles and Ruth DeYoung Elkus Collection, 23/1245
Otis Polelonema (1902-1981)

RAIN WATER DANCE, c.1930
Watercolor on Paper. 48.5 x 35.6
Charles and Ruth DeYoung Elkus Collection, 23/1246
Otis Polelonema (1902-1981)

STANDING FIGURE (ALOSAKA), c.1930
Watercolor on Paper. 48.3 x 30.5
Charles and Ruth DeYoung Elkus Collection, 23/1247
Otis Polelonema (1902-1981)

POWAMU CEREMONY
Watercolor on Paper. 27.3 x 18.5
Oscar B. Jacobson Collection, 23/6005
Otis Polelonema (1902-1981)

ELK SOCIAL DANCER, 1965
Watercolor, Chalk on Paper. 33.3 x 20.3
Byron Harvey III Collection, 23/7596
Otis Polelonema (1902-1981)

HOME DANCE
Watercolor on Paper. 29.3 x 20.2
Countryman Collection, 24/2708
Otis Polelonema (1902-1981)

TONENILI KACHINA
Watercolor on Paper. 29.2 x 19.2
Countryman Collection, 24/2709
Otis Polelonema (1902-1981)

HOPI FARMER, c.1935
Watercolor, Graphite on Paper. 37.7 x 45.6
Byron Harvey III Collection. 25/1087
Otis Polelonema (1902-1981)

WUPAMO KACHINA, c.1960
Watercolor on Paper. 33.9 x 21.0
Byron Harvey III Collection, 23/7597
Tyler R. Polelonema (1940-)

AHOTE KACHINA
Watercolor on Paper. 39.0 x 24.6
Byron Harvey III Collection, 23/7598
Tyler R. Polelonema (1940-)

WUYAKTAIOWA KACHINA
Watercolor on Paper. 35.2 x 27.5
Byron Harvey III Collection, 23/7599
Tyler R. Polelonema (1940-)

MUDHEAD DANCER
Watercolor on Paper. 31.3 x 21.0
Byron Harvey III Collection, 23/7600
Tyler R. Polelonema (1940-)

TASHAP KACHINA
Watercolor on Paper. 39.7 x 27.2
Byron Harvey III Collection, 23/7601
Tyler R. Polelonema (1940-)

SINGER KACHINA DANCE
Watercolor on Paper. 35.8 x 20.4
Lorenzo Hubbell Collection, 24/3904
E.D. Poleyestewa

MAALO KACHINA
Watercolor on Paper. 35.6 x 17.1
Lorenzo Hubbell Collection, 24/3905
E.D. Poleyestewa

SOYOK WUQTI OR SOYOK WUET KACHINA, 1946
Watercolor on Paper. 30.0 x 19.7
Lorenzo Hubbell Collection, 22/4458
Raymond Poseyesva

TUNWUP TAHAMU KACHINA
Watercolor on Paper. 30.5 x 22.8
Lorenzo Hubbell Collection, 22/4459
Raymond Poseyesva

QAO KACHINA
Watercolor on Paper. 30.3 x 24.1
Lorenzo Hubbell Collection, 22/4460
Raymond Poseyesva

HOLOLO KACHINA
Watercolor on Paper. 38.7 x 26.5
Lorenzo Hubbell Collection, 22/4467
Raymond Poseyesva

TUNEI-NILI KACHINA
Watercolor on Paper. 29.4 x 20.3
Lorenzo Hubbell Collection, 22/4469
Raymond Poseyesva

SIKIACHANTAQA
Watercolor on Paper. 40.7 x 26.8
Lorenzo Hubbell Collection, 22/4470
Raymond Poseyesva

SIPIKNI KACHINA
Watercolor on Paper. 40.8 x 26.8
Lorenzo Hubbell Collection, 22/4471
Raymond Poseyesva

HILILI KACHINA
Watercolor on Paper. 44.2 x 29.1
Lorenzo Hubbell Collection, 22/4472
Raymond Poseyesva

PAHIALA KACHINA
Watercolor on Paper. 38.7 x 25.6
Lorenzo Hubbell Collection, 22/4473
Raymond Poseyesva

MOSAIRU OR COCHA MAZURA KACHINA
Watercolor on Paper. 36.9 x 25.1
Lorenzo Hubbell Collection, 22/4474
Raymond Poseyesva

KOROSTA KACHINA
Watercolor on Paper. 43.1 x 25.9
Lorenzo Hubbell Collection, 22/4475
Raymond Poseyesva

HAKTO KACHINA
Watercolor, Graphite on Paper. 42.0 x 24.3
Lorenzo Hubbell Collection, 22/4476
Raymond Poseyesva

SAKA AYA KACHINA
Watercolor, Graphite on Paper. 43.1 x 25.1
Lorenzo Hubbell Collection, 22/4477
Raymond Poseyesva

NUVAK KACHINA
Watercolor on Paper. 35.7 x 21.6
Lorenzo Hubbell Collection, 22/4478
Raymond Poseyesva

AHOTE KACHINA, c.1945
Oil on Board. 42.5 x 30.5
Lorenzo Hubbell Collection, 22/4479
Raymond Poseyesva

LAQAN KACHINA
Watercolor on Paper. 40.6 x 26.7
Lorenzo Hubbell Collection, 22/4481
Raymond Poseyesva

POLISIO HUMIS KACHINA
Oil on Board. 41.0 x 30.3
Lorenzo Hubbell Collection, 22/4482
Raymond Poseyesva

BUTTERFLY DANCER, c.1935
Watercolor on Paper. 39.6 x 23.5
Lorenzo Hubbell Collection, 22/4483
Raymond Poseyesva

CHIRO KACHINA, 1930
Watercolor on Board. 45.3 x 24.0
Lorenzo Hubbell Collection, 22/4452
Raymond Poseyesva

PIOKOT OR HS-HS-AH KACHINA, c.1940
Watercolor on Paper. 25.9 x 15.3
Lorenzo Hubbell Collection, 22/4453
Raymond Poseyesva

KWASUS ALEKTAQA KACHINA
Watercolor on Paper. 35.7 x 28.0
Lorenzo Hubbell Collection, 22/4454
Raymond Poseyesva

TUVIK ANAKCHINA
Watercolor on Paper. 32.9 x 18.7
Lorenzo Hubbell Collection, 22/4455
Raymond Poseyesva

KACHINA
Watercolor on Paper. 30.4 x 24.1
Lorenzo Hubbell Collection, 22/4456
Raymond Poseyesva

KACHINA
Watercolor on Paper. 35.1 x 28.1
Lorenzo Hubbell Collection, 22/4457
Raymond Poseyesva

SOYOK WUQTI OR SOYOK WUET KACHINA, 1946
Watercolor on Paper. 30.0 x 19.7
Lorenzo Hubbell Collection, 22/4458
Raymond Poseyesva

TUNWUP TAHAMU KACHINA
Watercolor on Paper. 30.5 x 22.8
Lorenzo Hubbell Collection, 22/4459
Raymond Poseyesva

QAO KACHINA
Watercolor on Paper. 30.3 x 24.1
Lorenzo Hubbell Collection, 22/4460
Raymond Poseyesva

HOLOLO KACHINA
Watercolor on Paper. 38.7 x 26.5
Lorenzo Hubbell Collection, 22/4467
Raymond Poseyesva

TUNEI-NILI KACHINA
Watercolor on Paper. 29.4 x 20.3
Lorenzo Hubbell Collection, 22/4469
Raymond Poseyesva

SIKIACHANTAQA
Watercolor on Paper. 40.7 x 26.8
Lorenzo Hubbell Collection, 22/4470
Raymond Poseyesva

SIPIKNI KACHINA
Watercolor on Paper. 40.8 x 26.8
Lorenzo Hubbell Collection, 22/4471
Raymond Poseyesva

HILILI KACHINA
Watercolor on Paper. 44.2 x 29.1
Lorenzo Hubbell Collection, 22/4472
Raymond Poseyesva

PAHIALA KACHINA
Watercolor on Paper. 38.7 x 25.6
Lorenzo Hubbell Collection, 22/4473
Raymond Poseyesva

MOSAIRU OR COCHA MAZURA KACHINA
Watercolor on Paper. 36.9 x 25.1
Lorenzo Hubbell Collection, 22/4474
Raymond Poseyesva

KOROSTA KACHINA
Watercolor on Paper. 43.1 x 25.9
Lorenzo Hubbell Collection, 22/4475
Raymond Poseyesva

HAKTO KACHINA
Watercolor, Graphite on Paper. 42.0 x 24.3
Lorenzo Hubbell Collection, 22/4476
Raymond Poseyesva

SAKA AYA KACHINA
Watercolor, Graphite on Paper. 43.1 x 25.1
Lorenzo Hubbell Collection, 22/4477
Raymond Poseyesva

NUVAK KACHINA
Watercolor on Paper. 35.7 x 21.6
Lorenzo Hubbell Collection, 22/4478
Raymond Poseyesva

AHOTE KACHINA, c.1945
Oil on Board. 42.5 x 30.5
Lorenzo Hubbell Collection, 22/4479
Raymond Poseyesvn

LAQAN KACHINA
Watercolor on Paper. 40.6 x 26.7
Lorenzo Hubbell Collection, 22/4481
Raymond Poseyesva

POLISIO HUMIS KACHINA
Oil on Board. 41.0 x 30.3
Lorenzo Hubbell Collection, 22/4482
Raymond Poseyesva

BUTTERFLY DANCER, c.1935
Watercolor on Paper. 39.6 x 23.5
Lorenzo Hubbell Collection, 22/4483
Raymond Poseyesva

FEMALE DANCER, c.1935
Watercolor on Paper. 37.3 x 25.3
Lorenzo Hubbell Collection, 22/4484
Raymond Poseyesva

YUCHE KACHINA, c.1935
Watercolor on Paper. 34.0 x 23.1
Lorenzo Hubbell Collection, 22/4485
Raymond Poseyesva

KACHINA DANCER, 1935
Watercolor on Paper. 38.8 x 29.1
Byron Harvey Collection, 23/1499
Raymond Poseyesva

LONG HAIR, c.1945
Watercolor on Paper. 35.6 x 27.8
Oscar B. Jacobson Collection, 23/6006
Raymond Poseyesva

WAWASH KACHINA BORROWED FROM ZUNI
Watercolor on Paper. 31.5 x 25.4
Lorenzo Hubbell Collection, 24/3879
Raymond Poseyesva

HOPI RATTLE KACHINA
Watercolor on Paper. 30.4 x 24.1
Lorenzo Hubbell Collection, 24/3880
Raymond Poseyesva

HEE-LI-LI KACHINA, c.1945
Watercolor on Paper. 30.5 x 24.2
Lorenzo Hubbell Collection, 24/3881
Raymond Poseyesva

HO-JAH-NIE KACHINA
Watercolor on Paper. 30.8 x 24.0
Lorenzo Hubbell Collection, 24/3882
Raymond Poseyesva

HE-HAY-AH KACHINA
Watercolor on Paper. 30.5 x 22.8
Lorenzo Hubbell Collection, 24/3883
Raymond Poseyesva

HOTOTO KACHINA
Watercolor on Paper. 30.5 x 24.1
Lorenzo Hubbell Collection, 24/3884
Raymond Poseyesva

APACHE KACHINA, 1946
Watercolor on Paper. 30.2 x 22.1
Lorenzo Hubbell Collection, 24/3885
Raymond Poseyesva

QUIVI KACHINA
Watercolor on Paper. 35.5 x 23.5
Lorenzo Hubbell Collection, 24/3886
Raymond Poseyesva

HOJIN KACHINA
Watercolor on Paper. 23.5 x 14.7
Lorenzo Hubbell Collection, 24/3887
Raymond Poseyesva

QUIVI KACHINA, c.1945
Watercolor on Paper. 35.7 x 21.6
Lorenzo Hubbell Collection, 24/3912
Raymond Poseyesva

BAREFOOT LONG HAIR DANCER
Watercolor on Paper. 41.1 x 24.1
Lorenzo Hubbell Collection, 24/3913
Raymond Poseyesva

HU KACHINA
Watercolor on Paper. 43.0 x 27.4
Lorenzo Hubbell Collection, 24/3914
Raymond Poseyesva

AYA KATCHINA
Watercolor on Paper. 43.1 x 22.1
Lorenzo Hubbell Collection, 24/3915
Raymond Poseyesva

TUNEINILI KACHINA, c.1945
Watercolor on Paper. 36.7 x 21.8
Lorenzo Hubbell Collection, 24/3916
Raymond Poseyesva

KAWAIKA KACHINA
Watercolor on Paper. 29.2 x 20.3
Lorenzo Hubbell Collection, 22/4464
Robert Qotskuyva

TASAP MANA KACHINA
Watercolor on Paper. 26.0 x 17.3
Lorenzo Hubbell Collection, 22/4465
Robert Qotskuyva

SAIASTASA KACHINA
Watercolor on Paper. 29.8 x 20.4
Lorenzo Hubbell Collection, 22/4466
Robert Qotskuyva

KENE KACHINA
Watercolor on Paper. 24.5 x 20.4
Lorenzo Hubbell Collection, 24/3906
Robert Qotskuyva

MUDHEAD, 1965
Watercolor on Board. 40.5 x 29.4
Byron Harvey Collection, 23/6148
Redford Quamahongnewa

KACHINAS, c.1935
Watercolor on Paper. 45.6 x 61.0
Henry Craig Fleming Collection, 22/8600
Riley Quoyavema

KACHINAS AND GROUP OF TWO-HORN SOCIETY PRIESTS
Watercolor on Paper. 45.2 x 60.8
Henry Craig Fleming Collection, 22/8601
Riley Quoyavema

LIGHTNING SHOOTER KACHINA, c.1935
Watercolor on Paper. 30.4 x 20.4
John L. Nelson Collection, 23/3445
Riley Quoyavema

CLOWNS ON RAINBOW, 1965
Watercolor on Board. 27.9 x 35.6
Byron Harvey III Collection, 23/7595
A. Sakeva

HEHEYA KACHINA
Watercolor on Paper. 30.4 x 20.4
John L. Nelson Collection, 23/3451
Harry Sakyesva (1921-)

NAVAJO MAIDEN DANCER, c.1938
Watercolor on Paper. 27.7 x 19.0
James Economos Collection, 24/7481
Harry Sakyesva (1921-)

BUTTERFLY DANCER
Watercolor on Paper. 29.7 x 23.2
Oscar B. Jacobson Collection, 23/6002
H. Shelton

HOPI SHALAKO
Watercolor on Board. 50.7 x 40.5
Oscar B. Jacobson Collection, 23/6003
Peter H. Shelton, Jr.

MUDHEAD CEREMONY
Watercolor on Board. 34.3 x 44.7
Oscar B. Jacobson Collection, 23/6004
Peter H. Shelton, Jr.

CHAVEYO KACHINA WITH TWO KOYEMSI, 1951
Watercolor on Paper. 37.7 x 45.2
Kathleen Peters Collection, 24/3730
Gibson Talahytewa (1934-)

FLOGGER OR TUNGUP KACHINA
Watercolor, Ink on Board. 30.4 x 24.1
John L. Nelson Collection, 16/5283
T. Tomosee

YELLOW AHOTE
Watercolor, Ink on Board. 30.6 x 24.0
John L. Nelson Collection, 16/5284
T. Tomosee

BLACK KACHINA (FIRST MESA)
Watercolor, Graphite on Board. 35.4 x 25.4
John L. Nelson Collection, 16/5285
T. Tomosee

WITCH
Watercolor on Board. 35.6 x 25.0
John L. Nelson Collection, 16/5286
T. Tomosee

PAWIK THE DUCK
Watercolor, Graphite on Board. 36.0 x 25.2
John L. Nelson Collection, 16/5287
T. Tomosee

RATTLESNAKE
Watercolor, Ink on Paper. 37.8 x 25.2
John L. Nelson Collection, 16/5288
T. Tomosee

BEAR
Watercolor, Graphite on Paper. 37.8 x 25.3
John L. Nelson Collection, 16/5289
T. Tomosee

BEARDED KACHINA
Watercolor, Graphite on Paper. 37.9 x 25.2
John L. Nelson Collection, 16/5290
T. Tomosee

HEHEA
Watercolor, Graphite, Pen on Paper. 38.0 x 25.3
John L. Nelson Collection, 16/5291
T. Tomosee

SUN
Watercolor, Graphite, Ink on Paper. 37.6 x 25.4
John L. Nelson Collection, 16/5292
T. Tomosee

MONSTER
Watercolor, Ink on Paper. 37.9 x 25.5
John L. Nelson Collection, 16/5293
T. Tomosee

DEATH
Watercolor, Ink on Paper. 38.0 x 25.2
John L. Nelson Collection, 16/5294
T. Tomosee

BLUE AHOTE
Watercolor, Ink on Paper. 37.2 x 25.2
John L. Nelson Collection, 16/5295
T. Tomosee

WITCH FROM AWATOBI
Watercolor on Paper. 36.8 x 25.3
John L. Nelson Collection, 16/5296
T. Tomosee

KEME
Watercolor, Graphite on Paper. 37.8 x 25.3
John L. Nelson Collection, 16/5297
T. Tomosee

WHITE NATASHKA
Watercolor, Graphite, Ink on Paper. 37.8 x 25.3
John L. Nelson Collection, 16/5298
T. Tomosee

EAGLE
Watercolor on Paper. 37.9 x 25.3
John L. Nelson Collection, 16/5299
T. Tomosee

DAWN
Watercolor, Graphite on Paper. 38.0 x 25.4
John L. Nelson Collection, 16/5300
T. Tomosee

RACER
Watercolor on Paper. 37.9 x 25.1
John L. Nelson Collection, 16/5301
T. Tomosee

BEARDED MAIDENS
Watercolor, Ink on Paper. 37.7 x 25.7
John L. Nelson Collection, 16/5302
T. Tomosee

TURQUOISE EARRINGED KACHINA
Watercolor, Graphite on Paper. 37.8 x 25.7
John L. Nelson Collection, 16/5303
T. Tomosee

BUFFALO
Watercolor, Ink on Paper. 38.1 x 25.5
John L. Nelson Collection, 16/5304
T. Tomosee

RAINBOW
Watercolor on Paper. 37.7 x 25.5
John L. Nelson Collection, 16/5305
T. Tomosee

SUN FORM
Watercolor, Ink on Paper. 37.7 x 25.3
John L. Nelson Collection, 16/5306
T. Tomosee

HAVASUPAI KACHINA
Watercolor on Paper. 38.0 x 25.1
John L. Nelson Collection, 16/5307
T. Tomosee

TUNGUP THE FLOGGER
Watercolor on Paper. 37.9 x 25.2
John L. Nelson Collection, 16/5308
T. Tomosee

CORN
Watercolor on Paper. 38.0 x 25.5
John L. Nelson Collection, 16/5309
T. Tomosee

WHITE MAIDEN
Watercolor, Graphite on Paper. 37.7 x 25.3
John L. Nelson Collection, 16/5310
T. Tomosee

CACTUS
Watercolor, Graphite on Paper. 38.0 x 25.5
John L. Nelson Collection, 16/5311
T. Tomosee

THE BOOGIE MAN
Watercolor, Graphite on Paper. 37.7 x 25.4
John L. Nelson Collection, 16/5312
T. Tomosee

SNOW
Watercolor on Paper. 37.6 x 25.5
John L. Nelson Collection, 16/5313
T. Tomosee

MUNGWA KACHINA
Watercolor, Graphite, Ink on Paper. 37.8 x 25.3
John L. Nelson Collection, 16/5314
T. Tomosee

GREEN LIZARD
Watercolor, Graphite on Paper. 38.0 x 25.5
John L. Nelson Collection, 16/5315
T. Tomosee

SHITOTO KACHINA
Watercolor on Paper. 38.0 x 25.0
John L. Nelson Collection, 16/5316
T. Tomosee

ANCIENT KACHINA
Watercolor, Graphite on Paper. 38.2 x 25.4
John L. Nelson Collection, 16/5317
T. Tomosee

BURR
Watercolor, Graphite on Paper. 37.8 x 25.3
John L. Nelson Collection, 16/5318
T. Tomosee

ONE ARM PAINTED KACHINA
Watercolor, Graphite on Paper. 38.0 x 25.3
John L. Nelson Collection, 16/5319
T. Tomosee

KACHINA FROM TE CLAN
Watercolor on Paper. 37.8 x 25.3
John L. Nelson Collection, 16/5320
T. Tomosee

RACING KACHINA
Watercolor, Graphite on Paper. 37.8 x 25.0
John L. Nelson Collection, 16/5321
T. Tomosee

CORN FORM
Watercolor, Graphite on Paper. 38.3 x 25.4
John L. Nelson Collection, 16/5322
T. Tomosee

WUWUYOMO
Watercolor on Paper. 36.8 x 25.0
John L. Nelson Collection, 16/5323
T. Tomosee

TASHAT OF NAVAJO
Watercolor, Ink on Paper. 37.9 x 25.5
John L. Nelson Collection, 16/5324
T. Tomosee

YEBETCHAI KACHINA
Watercolor, Ink on Paper. 37.8 x 25.0
John L. Nelson Collection, 16/5325
T. Tomosee

TUNAILILI OF NAVAJO
Watercolor, Graphite on Paper. 37.8 x 25.1
John L. Nelson Collection, 16/5326
T. Tomosee

ZUNI FIREBRINGER
Watercolor, Graphite on Paper. 37.8 x 25.0
John L. Nelson Collection, 16/5327
T. Tomosee

MUDHEADS OF ZUNI
Watercolor, Ink on Paper. 37.9 x 25.2
John L. Nelson Collection, 16/5328
T. Tomosee

PANTIWA OF ZUNI
Watercolor, Graphite, Ink on Paper. 38.0 x 25.2
John L. Nelson Collection, 16/5329
T. Tomosee

UNCLE OF CORN KACHINA
Watercolor, Graphite, Ink on Paper. 38.8 x 25.3
John L. Nelson Collection, 16/5330
T. Tomosee

HAKTO OF ZUNI
Watercolor, Ink on Board. 30.6 x 23.1
John L. Nelson Collection, 16/5331
T. Tomosee

SHIABASHANA
Watercolor, Ink on Board. 30.8 x 23.5
John L. Nelson Collection, 16/5332
T. Tomosee

KACHINA DOLLS
Watercolor, Graphite on Paper. 37.9 x 25.2
John L. Nelson Collection, 18/2028
T. Tomosee

KACHINAS
Watercolor, Graphite on Paper. 37.8 x 25.4
John L. Nelson Collection, 18/2029
I. Tomosee

NATASHKA KACHINAS
Watercolor, Graphite on Paper. 38.1 x 48.0
John L. Nelson Collection, 18/2067
T. Tomosee

HOLOLO KACHINA IN COSTUME
Watercolor on Printed Board. 30.5 x 22.5
John L. Nelson Collection, 23/3446
T. Tomosee

THE HEMEZ KATCHIN SCREEN, 1941
Watercolor on Board. 50.8 x 40.5
Lorenzo Hubbell Collection, 24/3909
Kyrate Tuvahuema (1914-1942)

NIMAN KACHINA AND MATE
Ink on Paper. 43.1 x 29.2
Anonymous Collection, 25/1148
Kyrate Tuvahuema (1914-1942)

HOTAE KACHINA
Ink on Paper. 43.1 x 29.2
Anonymous Collection, 25/1149
Kyrate Tuvahuema (1914-1942)

ILLUSTRATIONS FOR 'BOOK OF THE HOPI'
Watercolor on Paper.
Frank Waters Collection, 23/6398
White Bear

HEHEA KACHINA, 1941
Watercolor on Paper. 38.0 x 30.0
Lorenzo Hubbell Collection, 22/4463
Earl Y.

HOO-TEH KACHINA
Watercolor on Paper. 45.7 x 35.0
Lorenzo Hubbell Collection, 24/3902
Earl Yowytewa

TUKWUNANGWU KACHINA
Watercolor on Paper. 44.8 x 28.9
Lorenzo Hubbell Collection, 24/3903
Earl Yowytewa

Collection of 270 paintings in a portfolio assembled by Byron Harvey III and published in Ritual in Pueblo Art: Hopi Life in Hopi Painting, Museum of the American Indian, New York, 1970. Five artists are

represented: Marshall Lomakema, Arlo Nuvayouma,
Narron Lomayaktewa, Leroy Kewanyama, and Melvin
Nuvayouma.
Graphite, Watercolor on Paper.
Byron Harvey III Collection, 23/7301-23/7570

IROQUOIS

MAN LIGHTING A PIPE, 1973
Watercolor on Paper. 30.0 x 22.5
William F. Stiles Collection, 24/8846
Chew

MAN SMOKING, 1972
Watercolor on Paper. 30.2 x 22.5
Mrs. McNamara Collection, 24/9376
Chew

ISLETA

CLOWNS, 1955
Watercolor on Paper. 22.5 x 30.2
Byron Harvey III Collection, 23/1495
E. Jojola

LINE OF DANCERS
Watercolor on Paper. 55.5 x 75.0
Byron Harvey III Collection, 23/3140
Jose Bartolo Lente

LINE OF KACHINA DANCERS
Watercolor on Paper. 56.5 x 75.6
Purchase, 22/5662
Jose Bartolo Lente

JEMEZ

CEREMONIAL FIGURE, 1958
Watercolor on Paper. 23.6 x 18.0
Jeanne O. Snodgrass Collection, 23/8385
Lawrence Chinana

DEER IN FOREST, 1920
Watercolor on Cardboard. 25.5 x 38.0
Byron Harvey Collection, 23/1492
Juan Gachupin

DEER, 1963
Watercolor on Board. 35.5 x 45.7
Philbrook Art Center Annual, 23/1492
Maxine Gachupin (1948-)

STYLIZED TURTLE, c.1965
Watercolor, Graphite on Board. 40.5 x 30.3
Byron Harvey Collection, 23/7586
Stella Loretto

PECOS BULL DANCE, 1965
Watercolor on Board. 36.0 x 46.0
Byron Harvey Collection, 23/6146
Nora Alice Lucero

TURTLE, 1965
Watercolor on Board. 46.0 x 35.9
Byron Harvey Collection, 23/6147
Nora Alice Lucero

MAN HUNTING BUFFALO, 1937
Watercolor on Paper. 27.2 x 21.3
Oscar B. Jacobson Collection, 23/6019
Jose Toledo (1915-)

DEER DANCER
Watercolor, Graphite, on Paper. 28.1 x 19.2
Henry Craig Fleming Collection, 22/8637
Jose Maria Toya

DEER DANCER
Watercolor, Graphite, on Paper. 27.3 x 18.3
Henry Craig Fleming Collection, 22/8638
Jose Maria Toya

SHEEP DANCER
Watercolor, Graphite, on Paper. 28.1 x 18.9
Henry Craig Fleming Collection, 22/8639
Jose Maria Toya

BUFFALO DANCER
Watercolor, Graphite, on Paper. 28.2 x 19.4
Henry Craig Fleming Collection, 22/8640
Jose Maria Toya

BUFFALO DANCERS
Watercolor, Graphite, on Paper. 25.4 x 35.3
Henry Craig Fleming Collection, 22/8641
Jose Maria Toya

SANTIAGO DANCER ON HORSEBACK, c.1935
Watercolor, Graphite, on Paper. 25.3 x 28.8
Henry Craig Fleming Collection, 22/8642
Jose Maria Toya

JEMEZ BULL DANCE, 1956
Watercolor on Paper. 27.9 x 35.8
Byron Harvey III Collection, 23/1493
Johnny Toya

KIOWA

SCHOOL CHILDREN'S DRAWINGS, c.1895
Graphite, Crayon, on Paper. 20.0 x 13.9
Margaret Cronk Collection, 23/1620
Artist Unknown

WOMAN ELK DANCER, c.1895
Graphite, Colored Pencil, Ink on Paper. 27.7 x 20.3
Margaret Cronk Collection, 23/1621
Artist Unknown

MALE ELK DANCER, c.1895
Graphite, Colored Pencil, Ink on Paper. 27.7 x 20.3
Margaret Cronk Collection, 23/1622
Artist Unknown

MAN IN A PRAIRIE DOG TOWN, c.1895
Graphite, Colored Pencil on Paper. 20.1 x 27.6
Margaret Cronk Collection, 23/1623
Artist Unknown

KIOWA WAR DANCER
Watercolor on Construction Paper. 33.0 x 20.0
Henry Craig Fleming Collection, 22/8613
Spencer Asah (c.1905-1954)

MOUNTED WARRIOR
Watercolor on Construction Paper. 31.2 x 26.6
Oscar B. Jacobson Collection, 23/6040
Spencer Asah (c.1905-1954)

WAR DANCE FIGURE, 1930
Watercolor on Construction Paper. 27.5 x 19.5
Henry Craig Fleming Collection, 22/8615
James Auchiah (1906-1974)

KIOWA MOURNERS, 1930
Watercolor on Construction Paper. 26.9 x 18.1
Henry Craig Fleming Collection, 22/8625
James Auchiah (1906-1974)

KIOWA PEYOTE FEATHER, c.1930
Watercolor on Construction Paper. 11.8 x 40.1
Charles and Ruth DeYoung Elkus Collection, 23/1252
James Auchiah (1906-1974)

THE NEWLYWEDS, 1924
Watercolor on Construction Paper. 24.0 x 16.3
Oscar B. Jacobson Collection, 23/6038
James Auchiah (1906-1974)

COMANCHE BUFFALO DANCE, 1929
Watercolor on Construction Paper. 27.2 x 15.9
Oscar B. Jacobson Collection, 23/6039
James Auchiah (1906-1974)

LEDGER BOOK, 1876
Graphite, Crayon on Paper. 16.5 x 20.7
Eleanor Sherman Fitch Collection, 20/6231
Bear's Heart

LINE OF MEN AND WOMEN, c.1875
Graphite, Crayon on Lined Paper. 20.5 x 31.0
General John Porter Hatch Collection, 11/8347
Big Bow (1845-1901)

KIOWA PEYOTE CHIEF, 1960
Watercolor on Board. 51.0 x 38.0
Byron Harvey III Collection, 23/7607
Woody Big Bow (1914-)

KIOWA PEYOTE CHIEF
Graphite on Paper. 30.4 x 45.4
Byron Harvey III Collection, 23/7608
Woody Big Bow (1914-)

KIOWA WARRIOR
Watercolor on Board. 50.5 x 38.0
Byron Harvey III Collection, 23/7609
Woody Big Bow (1914-)

KIOWA WARRIOR, 1956
Graphite on Paper. 60.0 x 45.3
Byron Harvey III Collection, 23/7610
Woody Big Bow (1914-)

KIOWA PEYOTE WOMAN, 1960
Watercolor on Board. 50.5 x 38.0
Byron Harvey III Collection, 23/7611
Woody Big Bow (1914-)

KIOWA PEYOTE WOMAN
Graphite on Paper. 45.3 x 29.0
Byron Harvey III Collection, 23/7612
Woody Big Bow (1914-)

WOMAN IN ROBE, 1948
Graphite on Paper. 59.7 x 45.3
Byron Harvey III Collection, 23/7613
Woody Big Bow (1914-)

TWO SEATED MEN
Graphite on Paper. 45.4 x 60.0
Byron Harvey III Collection, 23/7614
Woody Big Bow (1914-)

MOUNTED HUNTER, 1948
Graphite on Paper. 60.0 x 45.3
Byron Harvey III Collection, 23/7615
Woody Big Bow (1914-)

MAN ON BICYCLE
Graphite on Paper. 45.3 x 60.0
Byron Harvey III Collection, 23/7616
Woody Big Bow (1914-)

SEATED FIGURE
Graphite on Paper. 45.4 x 28.0
Byron Harvey III Collection, 23/7617
Woody Big Bow (1914-)

TWO KIOWAS
Graphite on Paper. 45.4 x 32.0
Byron Harvey III Collection, 23/7618
Woody Big Bow (1914-)

FIGURE IN HAT
Graphite on Paper. 45.4 x 29.3
Byron Harvey III Collection, 23/7619
Woody Big Bow (1914-)

WOMAN ON HORSEBACK, 1959
Graphite on Paper. 45.3 x 60.0
Byron Harvey III Collection, 23/7620
Woody Big Bow (1914-)

FIGURE STANDING BY A HILL
Graphite on Paper. 45.4 x 29.4
Byron Harvey III Collection, 23/7621
Woody Big Bow (1914-)

WARRIOR ON HORSEBACK, 1959
Graphite on Paper. 45.3 x 60.0
Byron Harvey III Collection, 23/7622
Woody Big Bow (1914-)

MAN IN BLANKET, 1950
Watercolor on Board. 22.6 x 20.5
Jeanne O. Snodgrass Collection, 23/8386
Woody Big Bow (1914-)

KIOWA SINGER
Watercolor on Construction Paper. 24.8 x 17.7
Henry Craig Fleming Collection, 22/8614
Jack Hokeah (1902-1969)

KIOWA MEDICINE MAN
Watercolor on Construction Paper. 26.8 x 21.0
Oscar B. Jacobson Collection, 23/6042
Jack Hokeah (1902-1969)

KIOWA MEDICINE MAN
Watercolor on Construction Paper. 27.1 x 14.9
Oscar B. Jacobson Collection, 23/6043
Jack Hokeah (1902-1969)

PORTRAIT, c.1935
Watercolor on Paper. 15.2 x 10.2
Joseph Imhof Collection, 23/3377
George Campbell Keahbone (1916-)

CHOCTAW BALL PLAYER
Watercolor on Paper. 15.3 x 10.3
Joseph Imhof Collection, 23/3378
George Campbell Keahbone (1916-)

HORSE AND RIDER
Watercolor, Ink on Paper. 10.2 x 15.3
Joseph Imhof Collection, 23/3379
George Campbell Keahbone (1916-)

LANCE DANCE
Watercolor on Vellum. 26.0 x 18.1
Oscar B. Jacobson Collection, 23/6041
Alfred Kodaseet

MOUNTAIN SPIRITS DANCE, 1958
Watercolor on Board. 75.5 x 55.7
Jeanne O. Snodgrass Collection, 23/8390
Al Momaday (1913-1981)

CHIEF AND SQUAW, 1930
Watercolor on Board. 28.4 x 20.0
Henry Craig Fleming Collection, 22/8587
Stephen Mopope (1900-1974)

EAGLE DANCER, 1930
Watercolor on Paper. 27.5 x 17.2
Henry Craig Fleming Collection, 22/8588
Stephen Mopope (1900-1974)

INDIAN PEYOTE PRIEST, 1929
Watercolor on Construction Paper. 27.0 x 17.0
Henry Craig Fleming Collection, 22/8616
Stephen Mopope (1900-1974)

DANCER WITH BUSTLE, 1929
Watercolor on Paper. 27.7 x 17.8
Henry Craig Fleming Collection, 22/8617
Stephen Mopope (1900-1974)

SEATED MEN AND EAGLE DANCER, 1929
Watercolor on Construction Paper. 18.7 x 27.5
Henry Craig Fleming Collection, 22/8618
Stephen Mopope (1900-1974)

BUTTERFLY DANCE, 1930
Watercolor on Construction Paper. 28.3 x 18.0
Henry Craig Fleming Collection, 22/8619
Stephen Mopope (1900-1974)

CADDO DRUMMER, 1930
Watercolor on Construction Paper. 24.0 x 16.2
Henry Craig Fleming Collection, 22/8620
Stephen Mopope (1900-1974)

EAGLE DANCE, 1929
Watercolor on Construction Paper. 17.5 x 28.3
Henry Craig Fleming Collection, 22/8621
Stephen Mopope (1900-1974)

PEYOTE MEETING, 1930
Watercolor on Construction Paper. 26.0 x 17.4
Henry Craig Fleming Collection, 22/8622
Stephen Mopope (1900-1974)

THE SACRED ARROWS, 1930
Watercolor on Construction Paper. 26.8 x 17.9
Henry Craig Fleming Collection, 22/8623
Stephen Mopope (1900-1974)

APACHE DEVIL DANCE, 1929
Watercolor on Paper. 20.0 x 42.3
Henry Craig Fleming Collection, 22/8648
Stephen Mopope (1900-1974)

MOUNTED MAN WITH WOMAN
Ink on Paper. 37.7 x 2.8
Oscar B. Jacobson Collection, 25/1120
Stephen Mopope (1900-1974)

KIOWA-APACHE WARRIOR
Watercolor on Construction Paper. 24.2 x 13.4
Oscar B. Jacobson Collection, 23/6044
Bougetah Smokey (1907-1981)

MOTHER AND BABE
Watercolor on Paper. 23.9 x 13.5
Oscar B. Jacobson Collection, 24/8195
Bougetah Smokey (1907-1981)

LEDGER BOOK, 1886
Graphite, Crayon on Lined Paper. 34.5 x 21.5
Purchase, 19/8126
To-oan

CADDO WOMAN, 1960
Watercolor on Board. 25.5 x 21.5
Philbrook Art Center Annual, 23/1482
Lee Tsatoke (1929-)

EVENING SING, 1960
Watercolor on Board. 34.4 x 31.3
Philbrook Art Center Annual, 23/1483
Lee Tsatoke (1929-)

EVENING BY THE LAKE, 1960
Watercolor on Board. 38.0 x 25.4
Philbrook Art Center Annual, 23/1485
Lee Tsatoke (1929-)

END OF THE TRAIL, 1960
Watercolor on Board. 38.0 x 25.4
Philbrook Art Center Annual, 23/1485
Lee Tsatoke (1929-)

PORTRAIT OF A CROW, c.1930
Watercolor on Construction Paper. 22.8 x 19.0
Charles and Ruth DeYoung Elkus Collection, 23/1249
Monroe Tsatoke (1904-1937)

PEYOTE BIRD VISION
Watercolor on Construction Paper. 17.9 x 24.4
Oscar B. Jacobson Collection, 23/6045
Monroe Tsatoke (1904-1937)

DECORATING A WARRIOR
Watercolor on Construction Paper. 14.8 x 19.2
Oscar B. Jacobson Collection, 23/6046
Monroe Tsatoke (1904-1937)

THE KIOWA FLUTE PLAYER
Watercolor, Graphite on Construction Paper. 17.5 x 17.9
Oscar B. Jacobson Collection, 23/6047
Monroe Tsatoke (1904-1937)

ADVANCING WARRIOR
Watercolor, Graphite on Construction Paper. 25.8 x 16.3
Oscar B. Jacobson Collection, 23/6048
Monroe Tsatoke (1904-1937)

FLUTE PLAYER, 1929
Watercolor on Paper. 20.0 x 20.0
Oscar B. Jacobson Collection, 24/8194
Monroe Tsatoke (1904-1937)

MAN WITH SPEAR, 1935
Watercolor, Graphite on Paper. 30.2 x 22.5
Anonymous Collection, 25/1080
Monroe Tsatoke (1904-1937)

GENERAL GRIERSON MEETING KIOWAS, c.1875
Graphite, Crayon on Paper. 19.8 x 26.3
Eleanor Sherman Fitch Collection, 20/6232
Paul Zotom (1853-1913)

KIOWA SOLDIER DANCE, c.1875
Graphite, Crayon on Paper. 19.8 x 26.3
Eleanor Sherman Fitch Collection, 20/6233
Paul Zotom (1853-1913)

NAVAHOS, c.1875
Graphite, Crayon on Paper. 19.8 x 26.3
Eleanor Sherman Fitch Collection, 20/6234
Paul Zotom (1853-1913)

LINES OF DANCERS, c.1875
Graphite, Crayon on Paper. 19.8 x 26.3
Eleanor Sherman Fitch Collection, 20/6235
Paul Zotom (1853-1913)

NAVAHOS/RAILROAD TRAIN, c.1875
Graphite, Crayon on Paper. 19.8 x 26.3
Eleanor Sherman Fitch Collection, 20/6236
Paul Zotom (1853-1913)

MEXICAN TRADERS/ANASTASIA ISLAND LIGHTHOUSE, c.1875
Graphite, Crayon on Paper. 19.8 x 26.3
Eleanor Sherman Fitch Collection, 20/6237
Paul Zotom (1853-1913)

OSAGE WAR DANCE/BOATING ST. AUGUSTINE, c.1875
Graphite, Crayon on Paper. 19.8 x 26.3
Eleanor Sherman Fitch Collection, 20/6238
Paul Zotom (1853-1913)

KIOWAS, c.1875
Graphite, Crayon on Paper. 19.8 x 26.3
Eleanor Sherman Fitch Collection, 20/6239
Paul Zotom (1853-1913)

BUFFALO HEAP GOOD, c.1875
Graphite, Watercolor, Crayon on Paper. 21.6 x 58.0
Eleanor Sherman Fitch Collection, 20/6240
Paul Zotom (1853-1913)

KIOWA APACHE

WAR DANCER, 1971
Watercolor on Board. 51.0 x 40.5
Joe Rivera Collection, 24/9384
David Williams (1933-)

KWAKIUTL

HUNTING SCENE
Graphite, Crayon on Lined Paper. 26.3 x 20.7
D.F. Tozier Collection, 7/1166A
Artist Unknown

DESIGNS
Graphite, Crayon on Lined Paper. 26.5 x 20.9
D.F. Tozier Collection, 7/1166B
Artist Unknown

DESIGN
Graphite, Crayon on Lined Paper. 26.0 x 20.5
D.F. Tozier Collection, 7/1166C
Artist Unknown

DESIGN
Graphite, Crayon on Lined Paper. 25.8 x 20.8
D.F. Tozier Collection, 7/1166D
Artist Unknown

FISH
Graphite on Lined Paper. 25.5 x 20.8
D.F. Tozier Collection, 7/1166E
Artist Unknown

EAGLE & WHALES
Graphite, Crayon on Lined Paper. 25.4 x 20.8
D.F. Tozier Collection, 7/1166F
Artist Unknown

EAGLE & WHALE
Graphite on Lined Paper. 25.3 x 20.9
D.F. Tozier Collection, 7/1166G
Artist Unknown

MEN FIGHTING DRAGON
Graphite on Lined Paper. 26.5 x 20.7
D.F. Tozier Collection, 7/1166H
Artist Unknown

EAGLES, WHALES & OTHERS
Graphite, Crayon on Lined Paper. 26.3 x 20.8
D.F. Tozier Collection, 7/1166I
Artist Unknown

DESIGN
Graphite, Crayon on Lined Paper. 26.2 x 20.8
D.F. Tozier Collection, 7/1166J
Artist Unknown

THUNDERBIRD, 1965
Ink on Board. 45.5 x 45.3
The Quest Gallery, 23/6054
Douglas Cranmer

BEAVER, 1965
Ink on Paper. 45.5 x 45.5
The Quest Gallery, 23/6055
Douglas Cranmer

BEAR, 1965
Ink on Paper. 46.9 x 58.9
The Quest Gallery, 23/6056
Douglas Cranmer

MICMAC

LEDGER BOOK WRITTEN IN MICMAC ALPHABET
Ink on Lined Paper. 17.7 x 11.4
Wilson D. Wallis Collection, 3/2409
Artist Unknown

MIKASUKI SEMINOLE

CRANES IN NESTS, 1973
Watercolor on Paper. 30.2 x 45.5
Mrs. Oneone Thomas Collection, 25/0051
Paul Billie

HERON AT THE EDGE OF LAGOON, 1973
Watercolor on Paper. 35.5 x 42.3
William F. Stiles Collection, 25/0052
Paul Billie

SEMINOLE FAMILY, 1973
Watercolor on Paper. 45.0 x 30.4
William F. Stiles Collection, 25/0053
Paul Billie

MOHAWK

NIGHT SCENE WITH SPIRIT, 1950
Watercolor on Paper. 45.2 x 30.5
William F. Stiles Collection, 21/7312
Frank Roberts

MAN WITH DOOR KEEPER'S MASK, 1951
Watercolor, Graphite on Paper. 45.5 x 30.5
William F. Stiles Collection, 21/7313
Frank Roberts

NAHUA (Mexico)

TRIBUTE RECORD, c.1800
Graphite, Ink, Watercolor on Parchment. 41.5 x 58.0
James B. Ford Collection, 8/4482
Artist Unknown

NAVAJO

FLOWERS IN A VASE, c.1945
Watercolor, Graphite on Paper. 22.7 x 19.7
Isabel Schroeter Collection, 22/4886
Artist Unknown

DESERT SCENE, c.1945
Watercolor on Paper. 25.4 x 34.6
Isabel Schroeter Collection, 22/4887
Artist Unknown

BOY AND GIRL, c.1945
Crayon, Graphite on Paper. 30.4 x 45.6
Isabel Schroeter Collection, 22/4896
Artist Unknown

HORSES AND HOGAN, c.1945
Crayon, Graphite on Paper. 30.2 x 45.8
Isabel Schroeter Collection, 22/4897
Artist Unknown

BUTTES, c.1945
Crayon on Paper. 22.7 x 30.8
Isabel Schroeter Collection, 22/4899
Artist Unknown

ERODED CANYON WALLS, c.1945
Crayon on Paper. 26.5 x 44.0
Isabel Schroeter Collection, 22/4901
Artist Unknown

HORSES AND BUTTES, c.1945
Crayon, Graphite on Paper. 22.7 x 32.3
Isabel Schroeter Collection, 22/4902
Artist Unknown

FRIENDS ON THE DESERT
Crayon, Graphite on Paper. 21.0 x 31.0
Isabel Schroeter Collection, 22/4903
Artist Unknown

MOONLIGHT ON MOUNTAINS, c.1945
Chalk on Paper. 22.5 x 30.4
Isabel Schroeter Collection, 22/4904
Artist Unknown

RUNNING HORSE, c.1945
Crayon on Paper. 17.8 x 28.2
Isabel Schroeter Collection, 22/4905
Artist Unknown

BOOK OF DRAWINGS, c.1945
Crayon, Graphite, Yarn on Paper. 30.5 x 46.0
Isabel Schroeter Collection, 22/4909
Artist Unknown

PREPARING FOR NIGHT CHANT, c.1935
Watercolor on Paper. 25.3 x 23.5
Oscar B. Jacobson Collection, 23/6012
Narciso Platero Abeyta (1918-)

HARVEST
Watercolor on Board. 22.3 x 29.5
Oscar B. Jacobson Collection, 23/6013
Narciso Platero Abeyta (1918-)

CHANGEABLE WEREWOLF
Watercolor, Graphite on Board. 69.0 x 51.3
Purchase, 25/1086
Narciso Platero Abeyta (1918-)

STUDY OF A PLAINS INDIAN WARRIOR, 1963
Wax on Canvas . 24.9 x 20.8
Byron Harvey III Collection, 23/6162
Frank Austin (1938-)

NAVAJO MASKED DANCER
Watercolor on Board. 39.5 x 23.8
Byron Harvey III Collection, 23/7602
H. Begay

YEIBICHAI DANCERS, 1960
Watercolor on Board. 50.8 x 38.2
Byron Harvey III Collection, 23/7603
H. Begay

WOMEN PICKING CORN, c.1940
Watercolor on Paper. 36.6 x 29.4
Oscar B. Jacobson Collection, 23/6011
Harrison Begay (1917-)

HERDING THE SHEEP
Watercolor on Board. 50.7 x 63.5
Philbrook Art Center Annual, 23/6991
Harrison Begay (1917-)

NAVAJO BOY STARTING OUT FOR A HUNT
Watercolor on Paper. 29.2 x 24.3
Jeanne O. Snodgrass Collection, 24/8190
Harrison Begay (1917-)

ANTELOPE HOUSE, c.1936
Watercolor, Graphite on Paper. 23.8 x 29.0
Charles and Ruth DeYoung Elkus Collection, 25/1112
Harrison Begay (1917-)

NIGHT CHANT GODS
Watercolor on Paper. 28.1 x 25.2
Charles and Ruth DeYoung Elkus, 25/1119
Harrison Begay (1917-)

THE NOONDAY NAP, c.1945
Crayon on Paper. 28.5 x 45.8
Isabel Schroeter Collection, 22/4892
Babe Billy

NAVAJO FIRE DANCER, c.1960
Watercolor on Board. 42.7 x 50.6
Ernest S. Carter Collection, 24/4476
Robert Chee (1938-)

NAVAJO GIRL WITH PET, c.1960
Watercolor on Board. 24.3 x 20.2
Ernest S. Carter Collection, 24/4477
Robert Chee (1938-)

AMONG THE MOUNTAINS, c.1960
Watercolor on Board. 32.9 x 25.0
Ernest S. Carter Collection, 24/4478
Robert Chee (1938-)

THE TRAGEDY, 1964
Print. 14.0 x 18.9
Jeanne O. Snodgrass Collection, 23/8388
R.C. Gorman (1933-)

NAVAJO MOTHER, 1964
Print. 16.5 x 20.2
Jeanne O. Snodgrass Collection, 23/8389
R.C. Gorman (1933-)

NAVAJO WOMAN, 1973
Pastel on Paper. 73.6 x 58.7
R.C. Gorman Collection, 24/8344
R.C. Gorman (1933-)

NAVAJO WOMAN, 1973
Pastel on Paper. 72.6 x 58.6
R.C. Gorman Collection, 24/8345
R.C. Gorman (1933-)

THREE YEI FIGURES, 1975
Print. 76.5 x 56.5
R.C. Gorman Collection, 25/1082
R.C. Gorman (1933-)

KNEELING WOMAN HOLDING POT, 1973
Print. 76.5 x 56.7
R.C. Gorman Collection, 25/1083
R.C. Gorman (1933-)

WOMAN ON HORSEBACK, c.1945
Crayon, Graphite on Paper. 30.5 x 45.7
Isabel Schroeter Collection, 22/4900
Gene H.

SKETCHBOOK AND TEXT OF NAVAJO LIFE, c.1945
Crayon, Watercolor, Graphite on Paper. 30.9 x 45.5
Isabel Schroeter Collection, 22/4908
J. H.

DESERT SCENE, 1945
Watercolor on Paper. 21.4 x 30.2
Isabel Schroeter Collection, 22/4884
J. Holgate

SUNSET, c.1945
Crayon on Paper. 22.6 x 28.4
Isabel Schroeter Collection, 22/4890
Richard Jackson

DESERT TREES AND CLOUDS, c.1945
Crayon, Graphite on Paper. 22.9 x 30.4
Isabel Schroeter Collection, 22/4893
Fred Joe

FLOWERS, c.1945
Watercolor on Paper. 25.7 x 15.4
Isabel Schroeter Collection, 22/4907
James Johnson

DESERT AND BUTTES, c.1945
Crayon on Cork Board.. 19.8 x 27.0
Isabel Schroeter Collection, 22/4895
E.H.K.

MAN AND WOMAN NEAR HOGAN
Watercolor on Paper. 32.5 x 38.0
Byron Harvey III Collection, 23/7582
Betty J. Lee

BRAVE AND SQUAW, c.1965
Watercolor on Paper. 40.0 x 50.0
Byron Harvey III Collection, 23/7583
Betty J. Lee

WOMAN TENDING FLOCK
Watercolor on Board. 35.5 x 55.6
Byron Harvey III Collection, 23/7587
Frank Lee

NAVAJO RIDERS
Watercolor, Graphite on Paper. 45.4 x 63.5
Oscar B. Jacobson Collection, 23/6008
Charlie Lee (1926-)

HORSE RACE, c.1940
Watercolor, Ink on Paper. 39.0 x 55.9
Oscar B. Jacobson Collection, 23/6009
Charlie Lee (1926-)

BUTTES AND DISTANT MOUNTAINS, c.1945
Crayon on Paper. 22.2 x 30.4
Isabel Schroeter Collection, 22/4888
Jim Man

NAVAJO MAN, c.1945
Crayon on Paper. 45.4 x 30.4
Isabel Schroeter Collection, 22/4894
Hugh Paddock

TREES AND DISTANT HILLS, c.1945
Crayon on Paper. 19.9 x 34.4
Isabel Schroeter Collection, 22/4891
Robert Peaches

NAVAJO DANCER, 1961
Watercolor on Board. 31.5 x 30.5
Byron Harvey III Collection, 23/7605
H.R. Shorty

BOY ON HORSEBACK CHASING RABBIT
Watercolor on Board. 39.9 x 48.7
Byron Harvey Collection, 23/7606
H.R. Shorty

FIRST FURLOUGH, 1943
Watercolor on Board. 45.7 x 37.7
Oscar B. Jacobson Collection, 23/6014
Quincy Tahoma (1920-1956)

WARRIORS ON HORSEBACK, c.1940
Watercolor on Board. 49.5 x 66.0
George Terasaki Collection, 23/6114
Quincy Tahoma (1920-1956)

WARRIOR ON HORSEBACK, c.1940
Watercolor on Board. 15.0 x 9.9
Kenneth C. Miller Collection, 24/4350
Quincy Tahoma (1920-1956)

DANCER, c.1937
Watercolor, Graphite on Paper. 28.0 x 19.0
Henry Craig Fleming Collection, 22/8626
Andrew Van Tsinajinnie (1916-)

FLUTE DANCER, c.1935
Watercolor on Paper. 28.1 x 19.1
Henry Craig Fleming Collection, 22/8627
Andrew Van Tsinajinnie (1916-)

DEER, 1938
Watercolor on Paper. 19.0 x 28.1
Henry Craig Fleming Collection, 22/8628
Andrew Van Tsinajinnie (1916-)

DEER HUNT ON HORSEBACK
Watercolor on Board. 50.6 x 64.9
Henry Craig Fleming Collection, 22/8649
Andrew Van Tsinajinnie (1916-)

TWO MEN CARRYING A BOY
Ink on Paper. 32.0 x 38.3
James Economos Collection, 24/7752
Andrew Van Tsinajinnie (1916-)

BOY WITH HORSE AT WATER HOLE, c.1960
Watercolor on Paper. 28.0 x 38.8
James Economos Collection, 24/7753
Andrew Van Tsinajinnie (1916-)

TWO WOMEN ON BURRO, c.1960
Watercolor on Paper. 36.3 x 29.4
James Economos Collection, 24/7754
Andrew Van Tsinajinnie (1916-)

THE GHOST HORSES
Watercolor on Board. 50.9 x 76.4
Douglas Ruhe Collection, 24/9386
Andrew Van Tsinajinnie (1916-)

BUTTES AND TREES, c.1945
Crayon on Paper. 27.3 x 30.5
Isabel Schroeter Collection, 22/4889
Harry Tsosie

MUSICIANS OF TUBA, 1948
Graphite on Paper. 45.6 x 30.5
Isabel Schroeter Collection, 22/4906
Fred Warner

BEFORE SUNSET, c.1950
Watercolor on Board. 40.5 x 46.2
Charles and Ruth DeYoung Elkus Collection, 23/1237
Beatien Yazz (1928-)

NAVAJO BY CAMPFIRE, c.1950
Watercolor on Board. 32.0 x 26.0
Charles and Ruth DeYoung Elkus Collection, 23/1238
Beatien Yazz (1928-)

NAVAJO DANCERS, c.1949
Watercolor on Board. 40.3 x 28.5
Charles and Ruth DeYoung Elkus Collection, 23/1239
Beatien Yazz (1928-)

YEI DANCER, c.1940
Watercolor on Board. 33.3 x 21.4
Charles and Ruth DeYoung Elkus Collection, 23/1240
Beatien Yazz (1928-)

NAVAJO FIRE DANCER, c.1949
Watercolor on Board. 24.1 x 18.0
Charles and Ruth DeYoung Elkus Collection, 23/1241
Beatien Yazz (1928-)

TREE, c.1950
Watercolor, Ink on Paper. 28.8 x 18.9
Charles and Ruth DeYoung Elkus Collection, 23/1242
Beatien Yazz (1928-)

FRIGHTENED ANTELOPES
Watercolor, Ink on Paper. 30.1 x 45.4
Oscar B. Jacobson Collection, 23/6010
Beatien Yazz (1928-)

MOUNTED BUFFALO HUNTER, c.1944
Watercolor on Paper. 28.0 x 38.0
Thomas Trippodo Collection, 23/6803
Beatien Yazz (1928-)

MESSENGER AND PATIENT-MOUNTAIN CHANT, c.1948
Watercolor on Paper. 41.0 x 41.6
Byron Harvey III Collection, 23/7588
Beatien Yazz (1928-)

EVERGREEN DANCE, c.1947
Watercolor on Paper. 36.0 x 33.5
Byron Harvey III Collection, 23/7589
Beatien Yazz (1928-)

BOY HERDING SHEEP
Watercolor on Board. 40.0 x 38.0
Lorenzo Hubbell Collection, 24/3901A
Beatien Yazz (1928-)

WOMAN
Watercolor on Board. 40.9 x 38.0
Lorenzo Hubbell Collection, 24/3901B
Beatien Yazz (1928-)

NIGHT SCENE WITH BIRDS AND HOGAN
Watercolor on Board. 45.7 x 56.2
Anonymous Collection, 25/0989
Beatien Yazz (1928-)

TWO DEER
Watercolor on Board. 36.6 x 48.3
Lorenzo Hubbell Collection, 24/3900
Charley Yazzie

THE BUFFALO HUNTER, c.1960
Watercolor on Board. 43.8 x 38.0
The Hubbell-Kinsolving Collection, 24/3920
Charley Yazzie

PROCESSION AROUND FIRE
Graphite, Watercolor on Board. 55.7 x 76.0
Anonymous Collection, 25/1127
Charley Yazzie

OMAHA

MAN ON HORSEBACK CHASING A BUFFALO, 1883
Graphite, Watercolor on Paper. 24.6 x 31.7
DeCost Smith Collection, 20/1621
Lightening

MEN ON HORSEBACK ENGAGED IN BATTLE, 1882
Graphite, Watercolor on Paper. 17.6 x 24.1
DeCost Smith Collection, 20/1622
Meet-Me-In-The-Night

ONONDAGA

LEGEND OF THE SPIRIT OF THE ANIMALS
Watercolor, Graphite on Board. 49.7 x 35.5
Purchase, 21/1549
Tom Dorsey (1920-)

CORN POUNDING SCENE
Watercolor, Graphite on Board. 49.7 x 35.5
Purchase, 21/1550
Tom Dorsey (1920-)

STALKING A DEER BY A LAKE
Watercolor, Graphite on Board. 49.7 x 33.5
Purchase, 21/1551
Tom Dorsey (1920-)

BUSHYHEAD DANCER, 1963
Watercolor, Graphite on Paper. 25.5 x 18.7
William F. Stiles Collection, 23/3789
Celson S. Thomas

FALSE FACE BEGGARS, 1962
Ink, Graphite on Board. 20.4 x 28.3
William F. Stiles Collection, 23/3790
Celson S. Thomas

FALSE FACE BEGGARS, 1963
Watercolor, Graphite, Ink on Paper. 20.2 x 29.5
William F. Stiles Collection, 23/3791
Celson S. Thomas

OSAGE

CHIEF RED CLOUD, 1973
Ink on Paper. 76.0 x 63.8
Yeffe Kimball Collection, 24/8950
Yeffe Kimball (1914-1978)

OSAGE STRAIGHT DANCER, 1957
Watercolor on Paper. 42.8 x 32.5
Jeanne O. Snodgrass Collection, 23/8384
Carl Woodring (1920-)

IROQUOIS FALSE FACE MOTIF, 1959
Watercolor on Board. 38.0 x 27.8
Purchase, 25/1085
Carl Woodring (1920-)

OTTAWA-MIAMI

OLDTIME INDIAN METHOD OF GRINDING CORN, 1955
Watercolor on Board. 30.5 x 23.0
Byron Harvey III Collection, 23/1494
Bronson Edwards (1913-)

PICURIS

BELT DANCE, 1945
Watercolor on Construction Paper. 33.9 x 24.8
Oscar B. Jacobson Collection, 23/6015
George Duran

TWO DEER, 1946
Watercolor on Construction Paper. 25.8 x 37.8
Oscar B. Jacobson Collection, 23/6016
George Duran

PIMA

PIMA INDIAN, 1887
Graphite, Crayon on Lined Paper. 21.4 x 9.3
F.W. Hodge Collection, 16/5278
Artist Unknown

MAN SMOKING A PIPE, 1887
Graphite on Paper. 22.2 x 14.5
F.W. Hodge Collection, 21/0457
Artist Unknown

GIRL, 1887
Graphite, Watercolor on Paper. 22.1 x 14.4
F.W. Hodge Collection, 21/0458
Artist Unknown

SAN ILDEFONSO

RUNNING MALE FIGURE
Watercolor, Graphite on Paper. 27.8 x 20.1
Purchase, 10/7379
Artist Unknown

THE BUFFALO DANCER
Watercolor, Graphite on Paper. 36.0 x 28.4
Joseph Imhof Collection, 23/3318
Artist Unknown

KACHINA (?)
Ink, Watercolor on Paper. 12.4 x 17.8
Joseph Imhof Collection, 23/3358C
Artist Unknown

SPOTTED CORN DANCER, c.1945
Watercolor on Board. 28.8 x 21.6
Joseph Imhof Collection, 23/3323
Joe A. Aguilar

CORN DANCER MAIDEN, c.1945
Watercolor on Board. 28.9 x 23.5
Joseph Imhof Collection, 23/3324
Joe A. Aguilar

CORN DANCER, c.1945
Watercolor on Board. 28.6 x 25.3
Joseph Imhof Collection, 23/3325
Joe A. Aguilar

SPRUCE DANCER, c.1945
Watercolor on Board. 28.3 x 21.7
Joseph Imhof Collection, 23/3326
Joe A. Aguilar

BUFFALO DANCE, c.1940
Watercolor, Graphite on Paper. 28.5 x 10.3
Joseph Imhof Collection, 23/3353
Joe A. Aguilar

MAN WITH PIPE, SHIELD, AND SPEAR, c.1935
Watercolor on Paper. 28.7 x 20.3
Joseph Imhof Collection, 23/3354
Joe A. Aguilar

DANCER'S HEAD
Watercolor, Graphite on Paper. 15.2 x 10.1
Joseph Imhof Collection, 23/3380
Joe A. Aguilar

BUFFALO DANCER'S HEAD
Watercolor, Graphite on Paper. 15.2 x 10.1
Joseph Imhof Collection, 23/3381
Joe A. Aguilar

DANCER'S HEAD
Watercolor, Graphite on Paper. 15.2 x 10.1
Joseph Imhof Collection, 23/3382
Joe A. Aguilar

WARRIOR AND SHIELD
Watercolor, Graphite on Paper. 15.2 x 10.1
Joseph Imhof Collection, 23/3383
Joe A. Aguilar

DEER DANCER
Watercolor, Graphite on Paper. 15.3 x 10.1
Joseph Imhof Collection, 23/3384
Joe A. Aguilar

WOMAN
Watercolor, Graphite on Paper. 15.2 x 10.1
Joseph Imhof Collection, 23/3385
Joe A. Aguilar

WOMAN
Watercolor, Graphite on Paper. 15.2 x 10.1
Joseph Imhof Collection, 23/3386
Joe A. Aguilar

SNOW BIRD DANCE
Watercolor, Graphite on Paper. 15.2 x 10.2
Joseph Imhof Collection, 23/3387
Joe A. Aguilar

WOMAN
Watercolor on Paper. 15.2 x 10.1
Jeanne O. Snodgrass Collection, 23/8377
Joe A. Aguilar

DANCER'S RENDEZVOUS, 1955
Watercolor, Graphite on Paper. 19.0 x 26.9
Charles and Ruth DeYoung Elkus Collection, 23/1254
Jose Vincente Aguilar (1924-)

KOSHARES, 1954
Watercolor, Ink on Board. 34.5 x 55.4
Charles and Ruth DeYoung Elkus Collection, 23/1267
Jose Vincente Aguilar (1924-)

THE MARRIAGE, 1964
Oil on Board. 48.5 x 41.1
Byron Harvey III Collection, 23/4133
Jose Vincente Aguilar (1924-)

EAGLE DANCER, 1960
Watercolor, Graphite on Paper. 38.0 x 26.8
Charles and Ruth DeYoung Elkus Collection, 23/1264
Gilbert Atencio (1930-)

DEER DANCER, 1955
Watercolor on Board. 36.7 x 29.1
Charles and Ruth DeYoung Elkus Collection, 23/1265
Gilbert Atencio (1930-)

THE FOOD BEARERS, 1959
Watercolor on Paper. 49.0 x 72.4
Charles and Ruth DeYoung Elkus Collection, 23/1266
Gilbert Atencio (1930-)

WOMAN WITH DRUM, 1946
Watercolor on Paper. 36.9 x 22.9
Oscar B. Jacobson Collection, 23/6023
Gilbert Atencio (1930-)

SAN ILDEFONSO BUFFALO DANCE, 1967
Watercolor on Construction Paper. 58.6 x 73.6
Philbrook Art Center Annual, 23/9300
Gilbert Atencio (1930-)

KOSHARE, 1951
Watercolor on Paper. 28.0 x 19.3
Joseph Imhof Collection, 23/3350
Pat Atencio (1932-)

THREE KOSHARES, c.1945
Watercolor on Paper. 30.6 x 43.4
Joseph Imhof Collection, 23/3356
Pat Atencio (1932-)

TWO DEER, 1945
Watercolor, Graphite on Paper. 30.2 x 40.1
Oscar B. Jacobson Collection, 23/6025
Tony Atencio (1928-)

BLACK DANCE
Watercolor, Ink on Paper. 20.3 x 15.3
Purchase, 13/1608A
Awa Tsireh (c.1895-c.1955)

BOW AND ARROW DANCER
Watercolor, Ink, Graphite on Paper. 20.3 x 15.3
Purchase, 13/1608B
Awa Tsireh (c.1895-c.1955)

NAVAJO DANCE
Watercolor, Graphite on Paper. 20.3 x 15.4
Purchase, 13/1608C
Awa Tsireh (c.1895-c.1955)

SUN DANCE OR ZUNI DANCE
Watercolor, Graphite, Ink on Paper. 20.5 x 15.4
Purchase, 13/1608D
Awa Tsireh (c.1895-c.1955)

THUNDER DANCE
Watercolor, Graphite, Ink on Paper. 20.4 x 15.4
Purchase, 13/1608E
Awa Tsireh (c.1895-c.1955)

FLUTE PAINTING DANCER
Watercolor, Graphite on Paper. 20.4 x 15.2
Purchase, 13/1608F
Awa Tsireh (c.1895-c.1955)

THE RAIN COME STRAIGHT DANCE
Watercolor, Graphite, Ink on Paper. 20.3 x 15.3
Purchase, 13/1608G
Awa Tsireh (c.1895-c.1955)

WAR DANCE
Watercolor, Graphite, Ink on Paper. 20.4 x 15.2
Purchase, 13/1608H
Awa Tsireh (c.1895-c.1955)

MOUNTAIN SHEEP DANCE BY SANTA CLARA
Watercolor, Ink, Graphite on Paper. 20.4 x 25.4
Purchase, 13/1608I
Awa Tsireh (c.1895-c.1955)

AVANE DANCE
Watercolor, Graphite, Ink on Paper. 20.4 x 25.4
Purchase, 13/1608J
Awa Tsireh (c.1895-c.1955)

KO-SHA RAINBOW DANCE
Watercolor, Graphite, Ink on Paper. 20.3 x 25.4
Purchase, 13/1608K
Awa Tsireh (c.1895-c.1955)

DOG DANCE
Watercolor, Ink, Graphite on Paper. 20.2 x 25.6
Purchase, 13/1608L
Awa Tsireh (c.1895-c.1955)

SUN DANCE
Watercolor, Graphite, Ink on Paper. 20.3 x 25.0
Purchase, 13/1608M
Awa Tsireh (c.1895-c.1955)

CORN DANCE
Watercolor, Graphite, Ink on Paper. 20.3 x 25.6
Purchase, 13/1608N
Awa Tsireh (c.1895-c.1955)

SQUASH DANCE
Watercolor, Graphite, Ink on Paper. 20.2 x 25.5
Purchase, 13/1608O
Awa Tsireh (c.1895-c.1955)

BASKET DANCE
Watercolor, Graphite, Ink on Paper. 20.3 x 25.4
Purchase, 13/1608 P
Awa Tsireh (c.1895-c.1955)

THE SNOW BIRD DANCE
Watercolor, Graphite, Ink on Paper. 20.3 x 25.5
Purchase, 13/1608Q
Awa Tsireh (c.1895-c.1955)

THE EAGLE DANCE
Watercolor, Graphite, Ink on Paper. 20.3 x 25.4
Purchase, 13/1608R
Awa Tsireh (c.1895-c.1955)

COMANCHE DANCE
Watercolor, Graphite, Ink on Paper. 20.4 x 25.4
Purchase, 13/1608S
Awa Tsireh (c.1895-c.1955)

THE BUFFALO HUNTER DANCE
Watercolor, Graphite, Ink on Paper. 20.4 x 25.4
Purchase, 13/1608T
Awa Tsireh (c.1895-c.1955)

BUFFALO DANCE
Watercolor, Graphite, Ink on Paper. 20.0 x 25.4
Purchase, 13/1608U
Awa Tsireh (c.1895-c.1955)

ANTELOPE DANCE
Watercolor, Graphite, Ink on Paper. 20.3 x 25.4
Purchase, 13/1608V
Awa Tsireh (c.1895-c.1955)

MOUNTAIN SHEEP DANCE
Watercolor, Graphite, Ink on Paper. 20.3 x 25.5
Purchase, 13/1608W
Awa Tsireh (c.1895-c.1955)

DEER DANCE
Watercolor, Graphite, Ink on Paper. 20.5 x 25.4
Purchase, 13/1608X
Awa Tsireh (c.1895-c.1955)

BUFFALO DANCE AT SAN ILDEFONSO., c.1917
Watercolor, Graphite, Ink on Paper. 36.2 x 57.4
Carolyn Wicker Collection, 19/7561
Awa Tsireh (c.1895-c.1955)

EAGLE DANCER, c.1930
Watercolor, Ink, Graphite on Paper. 23.1 x 18.2
Harriet K. Roeder Collection, 22/7873
Awa Tsireh (c.1895-c.1955)

KOSHARE KACHINA DANCER
Ink, Watercolor on Paper. 28.2 x 18.2
Harriet K. Roeder Collection, 22/7874
Awa Tsireh (c.1895-c.1955)

BUFFALO DANCER, c.1930
Watercolor, Ink, Graphite on Paper. 28.2 x 19.8
Harriet K. Roeder Collection, 22/7875
Awa Tsireh (c.1895-c.1955)

MOTHER SKUNK AND YOUNG
Watercolor on Paper. 20.6 x 26.7
Harriet K. Roeder Collection, 22/7876
Awa Tsireh (c.1895-c.1955)

DESIGN OF SKUNKS
Ink on Board. 27.7 x 35.4
Henry Craig Fleming Collection, 22/8589
Awa Tsireh (c.1895-c.1955)

TWO DEER
Watercolor, Ink on Board. 27.1 x 35.5
Henry Criag Fleming Collection, 22/8607
Awa Tsireh (c.1895-c.1955)

SNOW BIRD DANCE, 1929
Ink on Board. 27.8 x 35.4
Henry Craig Fleming Collection, 22/8608
Awa Tsireh (c.1895-c.1955)

BUFFALO, DEER, ANTELOPE DANCE
Watercolor, Ink on Board. 28.5 x 71.0
Henry Craig Fleming Collection, 22/8609
Awa Tsireh (c.1895-c.1955)

STYLIZED SNAKE DANCERS
Watercolor on Board. 25.3 x 20.4
Countryman Collection, 24/2707
Awa Tsireh (c.1895-c.1955)

THE SACRED ATTUA-NEW (WATER SERPENT), 1967
Watercolor on Paper. 58.3 x 51.0
Philbrook Art Center Annual, 23/9301
Tony Da (1940-)

GEOMETRIC DESIGN WITH DEER
Watercolor on Board. 27.5 x 37.5
Anonymous Collection, 25/1128
Tony Da (1940-)

DANCER WITH KNEELING WOMAN, c.1940
Watercolor on Board. 36.5 x 26.3
Oscar B. Jacobson Collection, 23/6027
Carlos Garcia

CHRISTMAS CARD
Ink, Watercolor on Paper. 9.5 x 14.5
Joseph Imhof Collection, 23/3358A
Louis Gonzales (1907-)

CHRISTMAS CARD
Ink, Watercolor on Paper. 9.5 x 14.5
Joseph Imhof Collection, 23/3358B
Louis Gonzales (1907-)

CHRISTMAS CARD
Ink, Watercolor on Paper. 9.5 x 14.5
Joseph Imhof Collection, 23/3358F
Louis Gonzales (1907-)

CONVENTIONALIZED BIRD, 1931
Watercolor on Paper. 13.8 x 17.6
Harriet K. Roeder Collection, 22/7872
Julian Martinez (1879-1943)

ANIMAL DANCERS, c.1940
Watercolor, Graphite on Paper. 35.4 x 47.9
Henry Craig Fleming Collection, 22/8584
Julian Martinez (1879-1943)

DEER DANCER
Watercolor on Board. 35.4 x 27.7
Henry Craig Fleming Collection, 22/8590
Julian Martinez (1879-1943)

WAR DANCE, c.1920
Watercolor, Graphite on Board. 26.6 x 37.8
Henry Craig Fleming Collection, 22/8591
Julian Martinez (1879-1943)

MAN ON HORSEBACK, c.1920
Watercolor, Graphite on Board. 27.9 x 38.1
Henry Craig Fleming Collection, 22/8592
Julian Martinez (1879-1943)

MALE AND FEMALE DANCERS
Watercolor on Board. 30.1 x 44.2
Henry Craig Fleming Collection, 22/8593
Julian Martinez (1879-1943)

ALTAR IN KIVA AT SAN ILDEFONSO, c.1930
Watercolor on Board. 35.5 x 55.8
Henry Craig Fleming Collection, 22/8594
Julian Martinez (1879-1943)

KOSHARE WITH WATERMELONS, c.1938
Watercolor, Graphite on Paper. 36.4 x 28.3
Henry Craig Fleming Collection, 22/8629
Julian Martinez (1879-1943)

BUFFALO DANCERS
Watercolor on Hide. 80.5 x 60.5
Henry Craig Fleming Collection, 22/8644
Julian Martinez (1879-1943)

SKUNKS AND RAINBOW, c.1935
Watercolor, Graphite on Paper. 28.4 x 36.0
Joseph Imhof Collection, 23/3300
Julian Martinez (1879-1943)

SKUNKS AND BUFFALO, c.1935
Watercolor on Paper. 28.8 x 36.0
Joseph Imhof Collection, 23/3301
Julian Martinez (1879-1943)

CHICKENS AND RAINBOW, c.1930
Watercolor, Graphite on Paper. 20.3 x 23.0
Joseph Imhof Collection, 23/3302
Julian Martinez (1879-1943)

DEER DANCER
Watercolor, Graphite on Paper. 35.9 x 28.6
Joseph Imhof Collection, 23/3303
Julian Martinez (1879-1943)

DEER DANCER
Ink on Paper. 25.7 x 33.0
Joseph Imhof Collection, 23/3304
Julian Martinez (1879-1943)

DEER DANCER, c.1938
Watercolor, Graphite on Paper. 28.9 x 36.5
Joseph Imhof Collection, 23/3305
Julian Martinez (1879-1943)

DEER DANCER, c.1935
Watercolor, Graphite on Paper. 31.8 x 30.6
Joseph Imhof Collection, 23/3306
Julian Martinez (1879-1943)

MASKED HUNTER
Watercolor, Graphite on Wallpaper. 29.5 x 29.5
Joseph Imhof Collection, 23/3352
Julian Martinez (1879-1943)

BUFFALO DANCE
Watercolor, Graphite on Paper. 36.0 x 28.5
Oscar B. Jacobson Collection, 23/6024
Julian Martinez (1879-1943)

HUNTER AND DEER DANCERS, c.1924
Watercolor, Graphite on Board. 29.5 x 69.8
Anonymous Collection, 24/7983
Julian Martinez (1879-1943)

BUFFALO DANCE, c.1938
Watercolor on Paper. 18.0 x 34.4
Oscar B. Jacobson Collection, 23/6020
Phillip Martinez

WOMAN HOLDING POTS, c.1930
Watercolor, Graphite on Paper. 33.9 x 46.0
Henry Craig Fleming Collection, 22/8630
Richard Martinez (1904-)

STYLIZED DEER
Watercolor, Graphite on Paper. 36.4 x 57.4
Byron Harvey Collection, 23/1490
Richard Martinez (1904-)

DEER DANCER, c.1935
Watercolor, Ink, Graphite on Paper. 12.4 x 20.4
Joseph Imhof Collection, 23/3392
Richard Martinez (1904-)

THE BUFFALO HUNTER
Watercolor, Graphite on Paper. 28.0 x 13.8
Thomas Trippodo Collection, 23/6802
Santana Martinez

TURTLE DANCERS
Watercolor, Graphite on Paper. 38.0 x 28.0
Henry Craig Fleming Collection, 22/8585
Oqwa Pi (1899-1971)

NEW MEXICO LANDSCAPE
Watercolor, Graphite on Paper. 29.5 x 35.7
Henry Craig Fleming Collection, 22/8586
Oqwa Pi (1899-1971)

ABSTRACT BIRD WITH RAIN CLOUDS, c.1930
Watercolor on Paper. 29.5 x 45.5
Henry Craig Fleming Collection, 22/8602
Oqwa Pi (1899-1971)

OWL OR EAGLE DANCERS., c.1930
Watercolor, Graphite on Paper. 33.5 x 51.0
Henry Craig Fleming Collection, 22/8603
Oqwa Pi (1899-1971)

STYLIZED KACHINAS, c.1935
Watercolor, Graphite on Board. 34.6 x 27.6
Henry Craig Fleming Collection, 22/8604
Oqwa Pi (1899-1971)

BUFFALO DANCERS
Watercolor, Graphite on Paper. 32.1 x 50.4
Henry Craig Fleming Collection, 22/8605
Oqwa Pi (1899-1971)

PROCESSION
Graphite, Watercolor on Paper. 55.7 x 70.8
Henry Craig Fleming Collection, 22/8606
Oqwa Pi (1899-1971)

DEER AND BUFFALO DANCERS
Graphite, Watercolor on Paper. 54.5 x 72.4
Henry Craig Fleming Collection, 22/8632
Oqwa Pi (1899-1971)

SHEEP HERDER, c.1927
Watercolor, Graphite on Paper. 28.0 x 41.7
Henry Craig Fleming Collection, 22/8633
Oqwa Pi (1899-1971)

BASKET DANCE
Watercolor, Graphite on Paper. 36.4 x 57.2
Henry Craig Fleming Collection, 22/8634
Oqwa Pi (1899-1971)

CHICKEN RUN, 1930
Watercolor on Board. 35.4 x 66.4
Henry Craig Fleming Collection, 22/8635
Oqwa Pi (1899-1971)

GREETING CARD
Graphite, Watercolor, Ink on Board. 9.9 x 15.5
Anonymous Collection, 25/1121
Oqwa Pi (1899-1971)

GREETING CARD, 1932
Graphite, Watercolor, Ink on Board. 8.5 x 13.9
Anonymous Collection, 25/1122
Oqwa Pi (1899-1971)

PUMPKIN FLOWER DANCE, 1965
Watercolor, Graphite on Board. 39.1 x 29.8
Byron Harvey Collection, 23/6159
Jose Encarnacion Pena (1902-1979)

BUFFALO HUNTER, 1965
Watercolor, Graphite on Board. 38.9 x 29.8
Byron Harvey Collection, 23/6160
Jose Encarnacion Pena (1902-1979)

RAIN DANCER, 1960
Watercolor, Graphite on Paper. 37.9 x 55.9
Jeanne O. Snodgrass Collection, 23/8380
Jose Encarnacion Pena (1902-1979)

ON THE HOUSETOP, 1956
Watercolor, Ink on Paper. 27.0 x 21.3
Byron Harvey III Collection, 23/1491
Jose D. Roybal (1922-1978)

GREETING CARD, 1965
Watercolor, Ink on Paper. 12.7 x 9.8
Byron Harvey III Collection, 23/6422
Jose D. Roybal (1922-1978)

GREETING CARD, 1965
Watercolor, Ink on Paper. 12.9 x 9.9
Byron Harvey III Collection, 23/6423
Jose D. Roybal (1922-1978)

GREETING CARD, 1965
Watercolor, Ink on Paper. 12.9 x 9.8
Byron Harvey III Collection, 23/6424
Jose D. Roybal (1922-1978)

GREETING CARD, 1965
Watercolor on Paper. 12.7 x 9.8
Byron Harvey III Collection, 23/6425
Jose D. Roybal (1922-1978)

GREETING CARD, 1965
Watercolor, Ink on Paper. 12.7 x 9.8
Byron Harvey III Collection, 23/6442
Jose D. Roybal (1922-1978)

CLOWN AND TWO DANCERS, c.1960
Watercolor, Crayon on Paper. 36.8 x 28.5
Joe Rivera Collection, 24/9385
Jose D. Roybal (1922-1978)

FAWN, 1941
Watercolor on Paper. 10.2 x 15.3
E.K. Burnett Collection, 20/4154
Ramos Sanchez (1926-)

WILD HORSE, 1941
Watercolor on Paper. 10.0 x 15.3
Mrs. Dorothy Miller Collection, 24/9437
Ramos Sanchez (1926-)

SHALAKO AND TWO MUDHEADS
Ink on Paper. 55.5 x 35.6
Henry Craig Fleming Collection, 22/8595
Tse-ye-mu (1902-)

DOG DANCER
Watercolor, Ink on Paper. 27.7 x 17.7
Henry Craig Fleming Collection, 22/8596
Tse-ye-mu (1902-)

COMANCHE DANCER, c.1930
Ink, Graphite on Paper. 27.8 x 17.7
Henry Craig Fleming Collection, 22/8597
Tse-ye-mu (1902-)

NAVAJO WITH DRUM AND DANCERS, c.1930
Watercolor, Ink on Paper. 34.5 x 55.7
Henry Craig Fleming Collection, 22/8598
Tse-ye-mu (1902-)

CONVENTIONALIZED BIRDS, c.1930
Watercolor, Ink on Paper. 27.6 x 35.0
Henry Craig Fleming Collection, 22/8599
Tse-ye-mu (1902-)

LINE OF DANCERS AND RAINBOW
Ink, Watercolor on Paper. 54.4 x 72.6
Henry Craig Fleming Collection, 22/8631
Tse-ye-mu (1902-)

CONVENTIONALIZED BIRDS, c.1930
Watercolor, Ink on Paper. 28.7 x 18.2
Henry Craig Fleming Collection, 22/8636
Tse-ye-mu (1902-)

MAN, TWO DEER DANCERS & SNAKE
Watercolor on Paper. 50.6 x 65.0
George Terasaki Collection, 23/6865
Tse-ye-mu (1902-)

KOSHARE, c.1930
Watercolor on Paper. 15.1 x 10.5
Indianapolis Children's Museum Collection, 23/8403
Tse-ye-mu (1902-)

FLUTE DANCER
Watercolor, Graphite on Paper. 15.2 x 10.5
Indianapolis Children's Museum Collection, 23/8404
Tse-ye-mu (1902-)

KACHINA DANCER
Watercolor on Paper. 15.2 x 10.5
Indianapolis Children's Museum Collection, 23/8405
Tse-ye-mu (1902-)

BUFFALO DANCER
Watercolor on Paper. 15.2 x 10.4
Indianapolis Children's Museum Collection, 23/8406
Tse-ye-mu (1902-)

WATCH THE DANCE
Watercolor on Paper. 15.3 x 10.6
Indianapolis Children's Museum Collection, 23/8407
Tse-ye-mu (1902-)

BOW & ARROW DANCER
Watercolor, Graphite on Paper. 15.2 x 10.5
Indianapolis Children's Museum Collection, 23/8408
Tse-ye-mu (1902-)

FLUTE SHIVAN
Watercolor, Graphite on Paper. 15.2 x 10.5
Indianapolis Children's Museum Collection, 23/8409
Tse-ye-mu (1902-)

CORN DANCER, c.1930
Watercolor on Paper. 15.2 x 10.5
Indianapolis Children's Museum Collection, 23/8412
Tse-ye-mu (1902-)

CORN DANCER
Watercolor on Paper. 15.2 x 10.5
Indianapolis Children's Museum Collection, 23/8413
Tse-ye-mu (1902-)

BUFFALO DANCE WOMAN
Watercolor on Paper. 15.2 x 10.5
Indianapolis Children's Museum Collection, 23/8414
Tse-ye-mu (1902-)

PEACOCKS WITH GEOMETRIC DESIGN
Watercolor on Paper. 56.7 x 69.8
Anonymous Collection, 25/1129
Tse-ye-mu (1902-)

WOMAN IN BUFFALO DANCE, 1946
Watercolor on Paper. 31.9 x 19.5
Oscar B. Jacobson Collection, 23/6021
Albert Vigil

WOMAN'S DANCE, c.1937
Watercolor, Ink on Board. 26.9 x 48.8
Oscar B. Jacobson Collection, 23/6022
Albert Vigil

FLAG DANCERS, 1938
Watercolor on Paper. 22.9 x 30.4
Joseph Imhof Collection, 23/3351
Tomo Yowa

SAN JUAN

ANTELOPE DANCERS
Watercolor on Paper. 12.4 x 18.8
Katherine Harvey Collection, 23/3557
Emiliano Abeyta

SAN JUAN EAGLE DANCE, c.1935
Watercolor on Paper. 28.7 x 36.5
Joseph Imhof Collection, 23/3327
Juan B. Montoya

DEER DANCER
Watercolor on Cardboard. 27.5 x 42.2
Joseph Imhof Collection, 23/3328
Juan B. Montoya

WOMAN BUFFALO DANCER
Watercolor on Paper. 33.0 x 29.2
Oscar B. Jacobson Collection, 23/6026
Nellie Montoya

A MATACHINA DANCE, 1942
Watercolor on Paper. 31.6 x 48.2
Oscar B. Jacobson Collection, 23/6028
Geronima Cruz Montoya (1915-)

MOUNTAIN SHEEP HUNT
Watercolor on Paper. 45.4 x 57.7
Philbrook Art Center Annual, 23/6417
Geronima Cruz Montoya (1915-)

BEYOND THE RAINBOW, 1963
Watercolor on Board. 36.5 x 52.2
Philbrook Art Center Annual, 23/6418
Geronima Cruz Montoya (1915-)

LIFE LINE, 1961
Watercolor on Paper. 30.2 x 45.2
Philbrook Art Center Annual, 23/6419
Geronima Cruz Montoya (1915-)

SPRING, 1961
Watercolor on Paper. 30.2 x 45.2
Philbrook Art Center Annual, 23/6420
Geronima Cruz Montoya (1915-)

RAIN GOD, 1965
Ink on Paper. 76.3 x 56.1
Philbrook Art Center Annual, 23/6421
Geronima Cruz Montoya (1915-)

SANTA CLARA

GROUP OF INDIANS MEETING A WHITE MAN
Graphite on Paper. 22.5 x 30.2
Joseph Imhof Collection, 23/3330
Louis Cordova

MEN HUNTING
Watercolor, Graphite, Ink on Paper. 20.8 x 27.1
Joseph Imhof Collection, 23/3331
Louis Cordova

THREE ANTELOPE
Watercolor, Graphite, Ink on Paper. 22.2 x 24.5
Joseph Imhof Collection, 23/3332
Louis Cordova

INDIAN TRACKERS
Watercolor, Graphite, Ink on Paper. 22.4 x 30.1
Joseph Imhof Collection, 23/3333
Louis Cordova

WARRIOR DANCE
Watercolor, Graphite, Ink on Paper. 19.4 x 34.5
Joseph Imhof Collection, 23/3334
Louis Cordova

HORSETAIL DANCER
Watercolor, Graphite, Ink on Paper. 27.8 x 17.0
Joseph Imhof Collection, 23/3335
Louis Cordova

INDIAN SCOUT
Watercolor, Graphite, Ink on Paper. 22.5 x 30.2
Joseph Imhof Collection, 23/3336
Louis Cordova

INCOMPLETE SKETCHES
Watercolor, Graphite, Ink on Paper. 22.5 x 30.2
Joseph Imhof Collection, 23/3337
Louis Cordova

WOMAN AT HOME
Watercolor, Graphite, Ink on Paper. 22.5 x 30.1
Joseph Imhof Collection, 23/3338
Louis Cordova

EAGLE DANCERS
Watercolor, Graphite, Ink on Paper. 22.5 x 30.2
Joseph Imhof Collection, 23/3339
Louis Cordova

ANTELOPE DANCERS
Watercolor, Graphite on Paper. 19.9 x 33.7
Joseph Imhof Collection, 23/3340
Louis Cordova

THE BUFFALO HUNTER
Watercolor, Graphite, Ink on Paper. 22.4 x 30.2
Joseph Imhof Collection, 23/3341
Louis Cordova

THE DEER HUNTER
Watercolor, Graphite, Ink on Paper. 22.6 x 30.1
Joseph Imhof Collection, 23/3342
Louis Cordova

MOUNTAIN VIEW
Watercolor, Graphite, Ink on Paper. 22.5 x 30.1
Joseph Imhof Collection, 23/3343
Louis Cordova

THREE ANTELOPE
Watercolor, Graphite, Ink on Paper. 19.9 x 34.0
Joseph Imhof Collection, 23/3344
Louis Cordova

DANCERS WITH ARTIST'S COMMENTS ON DANCE STEPS
Watercolor, Graphite on Paper. 19.5 x 34.5
Joseph Imhof Collection, 23/3345
Louis Cordova

TURTLE DANCE
Watercolor, Graphite on Paper. 16.0 x 27.0
Joseph Imhof Collection, 23/3346
Louis Cordova

GROUP OF TAOS SINGERS
Watercolor on Paper. 25.2 x 34.3
Joseph Imhof Collection, 23/3347
Louis Cordova

DEER DANCE WITH DEER MOTHERS
Watercolor, Graphite on Paper. 27.0 x 37.0
Joseph Imhof Collection, 23/3348
Louis Cordova

MEN SMOKING PIPE
Watercolor on Paper. 15.3 x 10.4
Joseph Imhof Collection, 23/3363
Louis Cordova

KOSHARE
Watercolor, Graphite on Paper. 21.7 x 7.7
Joseph Imhof Collection, 23/3364
Louis Cordova

WOMAN TABLITA DANCER
Watercolor, Crayon on Paper. 14.0 x 9.0
Joseph Imhof Collection, 23/3362
Jose Delores Naranjo

DEER DANCER
Watercolor on Paper. 16.0 x 12.7
Joseph Imhof Collection, 23/3391
Teofilo Tafoya (1915-)

BUFFALO DANCER
Watercolor, Ink on Paper. 15.2 x 9.0
Joseph Imhof Collection, 23/3372
Pablita Velarde (1918-)

ANTELOPE DANCER
Watercolor, Ink on Paper. 15.2 x 10.2
Joseph Imhof Collection, 23/3373
Pablita Velarde (1918-)

ANTELOPE
Watercolor, Ink on Paper. 15.3 x 10.2
Joseph Imhof Collection, 23/3374
Pablita Velarde (1918-)

MOUNTAIN SHEEP DANCER
Watercolor, Ink on Paper. 15.8 x 10.3
Joseph Imhof Collection, 23/3375
Pablita Velarde (1918-)

DEER DANCER
Watercolor, Graphite on Paper. 15.3 x 10.0
Joseph Imhof Collection, 23/3376
Pablita Velarde (1918-)

SANTO DOMINGO

BIG CHIEF
Watercolor on Canvas. 35.5 x 24.2
Harmon W. Hendricks Collection, 10/8690
Artist Unknown

ABSTRACT DESIGN
Watercolor on Canvas. 20.8 x 30.1
Harmon W. Hendricks Collection, 10/8691
Artist Unknown

ABSTRACT DESIGN
Graphite, Watercolor on Lined Paper. 22.3 x 16.0
Harmon W. Hendricks Collection, 10/8692
Artist Unknown

SNAKES
Graphite, Watercolor on Lined Paper. 16.0 x 22.3
Harmon W. Hendricks Collection, 10/8693
Artist Unknown

SYMBOLIC DESIGN
Watercolor, Graphite on Lined Paper. 16.0 x 22.4
Harmon W. Hendricks Collection, 10/8694
Artist Unknown

ANIMALS WATCHING FOR THE MOON
Watercolor, Graphite on Lined Paper. 16.0 x 22.4
Harmon W. Hendricks Collection, 10/8695
Artist Unknown

KACHINA FIGURE
Watercolor, Graphite on Paper. 16.0 x 22.4
Harmon W. Hendricks Collection, 10/8696
Artist Unknown

TWO FIGURES
Graphite, Watercolor on Lined Paper. 16.3 x 22.3
Harmon W. Hendricks Collection, 10/8697
Artist Unknown

MAN WITH DRUM AND CORN, 1949
Watercolor on Paper. 38.0 x 51.0
Joseph Imhof Collection, 23/3355
F. Atencio

SENECA

MAN IN FALSE FACE MASK ENTERING ROOM
Graphite, Ink on Paper. 20.2 x 25.3
Joseph Keppler Collection, 16/5333
Artist Unknown

INDIAN SQUAWS POUNDING CORN
Graphite, Watercolor on Paper. 20.0 x 25.0
Joseph Keppler Collection, 11/2914
Carrie Cornplanter

PUCK/INDIAN CORNHUSK DANCE
Graphite, Watercolor on Paper. 30.4 x 24.0
Joseph Keppler Collection, 16/5334
Jesse J. and Carrie Cornplanter

SENECA INDIAN WAR DANCE
Ink on Lined Paper. 19.8 x 25.4
Joseph Keppler Collection, 11/2913
Jesse Cornplanter

SENECA SQUAW IN OLD COSTUME, 1907
Ink on Paper. 25.0 x 19.6
W.R. Blackie Collection, 11/7025
Jesse Cornplanter

SELF PORTRAIT
Graphite, Watercolor on Paper. 20.0 x 12.5
Joseph Keppler Collection, 20/5845
Jesse Cornplanter

MAN WITH WEAPONS
Graphite, Watercolor on Paper. 18.5 x 11.2
Joseph Keppler Collection, 20/5846
Jesse Cornplanter

EDWARD CORNPLANTER, 1900
Graphite, Watercolor, Colored Pencil on Paper. 20.0 x 12.5
Joseph Keppler Collection, 20/5847
Jesse Cornplanter

FALSE FACE DANCE, 1901
Graphite, Watercolor on Paper. 23.9 x 30.0
Joseph Keppler Collection, 20/5848
Jesse Cornplanter

INDIAN LACROSSE PLAYERS
Graphite, Ink on Lined Paper. 19.8 x 25.4
Joseph Keppler Collection, 20/5902
Jesse Cornplanter

FALSE FACE DOCTOR'S DOOR KEEPERS
Graphite, Ink on Lined Paper. 19.7 x 25.4
Joseph Keppler Collection, 20/5903
Jesse Cornplanter

JAVELIN GAME
Graphite, Ink on Lined Paper. 19.8 x 25.4
Joseph Keppler Collection, 20/5904
Jesse Cornplanter

INDIAN SNOW SNAKEPLAYERS AT NEWTOWN
Graphite, Ink on Lined Paper. 19.8 x 25.4
Joseph Keppler Collection, 20/5905
Jesse Cornplanter

AMERICAN INDIAN NEW YEARS, 1901
Graphite, Ink, Watercolor on Paper. 24.0 x 30.5
Joseph Keppler Collection, 20/5908
Jesse Cornplanter

PUCK, 1900
Graphite, Watercolor on Paper. 18.4 x 11.5
Joseph Keppler Collection, 20/6003
Jesse Cornplanter

MAN WITH WEAPONS
Graphite, Watercolor on Paper. 18.5 x 11.2
Joseph Keppler Collection, 21/5846
Jesse Cornplanter

SHOOTING THE SUN, c.1965
Ink, Watercolor on Board. 37.8 x 50.6
William F. Stiles Collection, 24/7875
Ernest P. Smith (1907-1975)

A MAN'S VISION OF THE FALSE FACE SOCIETY, 1972
Watercolor, Ink on Paper. 53.0 x 66.5
William F. Stiles Collection, 24/8847
Ernest P. Smith (1907-1975)

MAN ON SICKBED WITH SPIRITS AND TEXT
Watercolor, Graphite on Paper. 35.7 x 49.5
Joseph Keppler Collection, 11/2912
George Wilson

SERI (Mexico)

THE BIG SNAKE, 1932
Graphite on Paper. 21.5 x 27.9
Dane Coolidge Collection, 20/3404
Artist Unknown

THE GIANT WOMAN FROM AFAR, 1932
Ink on Paper. 27.9 x 21.5
Dane Coolidge Collection, 20/3405
Artist Unknown

BOLICA, 1932
Ink on Paper. 21.5 x 27.9
Dane Coolidge Collection, 20/3406
Artist Unknown

BIG FISH, 1932
Ink on Paper. 21.5 x 27.9
Dane Coolidge Collection, 20/3407
Artist Unknown

CACTUS PLANTS, 1932
Ink on Paper. 27.9 x 21.5
Dane Coolidge Collection, 20/3408
Artist Unknown

CACTUS PLANTS, 1932
Ink on Paper. 27.9 x 21.5
Dane Coolidge Collection, 20/3409
Artist Unknown

CACTUS PLANTS, 1932
Ink on Paper. 27.9 x 21.5
Dane Coolidge Collection, 20/3410
Artist Unknown

WOMAN'S FACE PAINTING, 1932
Ink on Paper. 27.9 x 21.5
Dane Coolidge Collection, 20/3382
Buro Alazan

WOMAN'S FACE PAINTING, 1932
Ink on Paper. 27.9 x 21.5
Dane Coolidge Collection, 20/3383
Buro Alazan

FACE PAINTING, 1932
Ink on Paper. 21.5 x 27.9
Dane Coolidge Collection, 20/3384
Buro Alazan

MAN & WOMAN'S FACE PAINTING, 1932
Ink, Graphite on Paper. 21.5 x 27.9
Dane Coolidge Collection, 20/3385
Buro Alazan

MAN'S FACE PAINTINGS, 1932
Ink on Paper. 27.9 x 21.5
Dane Coolidge Collection, 20/3386
Buro Alazan

MAN'S FACE PAINTINGS, 1932
Ink on Paper. 27.9 x 21.5
Dane Coolidge Collection, 20/3387
Buro Alazan

A MAN'S FACE PAINTING, 1932
Ink on Paper. 27.9 x 21.5
Dane Coolidge Collection, 20/3388
Buro Alazan

A MAN'S FACE PAINTING, 1932
Ink on Paper. 27.9 x 21.5
Dane Coolidge Collection, 20/3389
Buro Alazan

WHALE, 1932
Ink on Paper. 21.5 x 27.9
Dane Coolidge Collection, 20/3401
Buro Alazan

MEN'S FACE PAINTINGS, 1932
Watercolor on Paper. 27.8 x 21.5
Dane Coolidge Collection, 20/3373
Blanco family

MEN'S FACE PAINTINGS, 1932
Watercolor on Board. 28.2 x 21.5
Dane Coolidge Collection, 20/3374
Blanco family

MEN'S FACE PAINTINGS, 1932
Watercolor on Board. 28.1 x 21.5
Dane Coolidge Collection, 20/3375
Blanco family

MEN'S FACE PAINTINGS, 1932
Watercolor on Board. 28.3 x 21.5
Dane Coolidge Collection, 20/3376
Blanco family

MEN'S FACE PAINTINGS, 1932
Watercolor on Board. 28.1 x 21.6
Dane Coolidge Collection, 20/3377
Blanco family

WOMEN'S FACE PAINTINGS, 1932
Watercolor on Board. 28.0 x 21.5
Dane Coolidge Collection, 20/3378
Blanco family

FACE PAINTING DESIGNS, 1932
Watercolor on Board. 28.0 x 21.5
Dane Coolidge Collection, 20/3379
Blanco family

FACE PAINTING DESIGNS, 1932
Watercolor on Board. 28.1 x 21.5
Dane Coolidge Collection, 20/3380
Blanco family

FACE PAINTING DESIGNS, 1932
Watercolor on Board. 28.0 x 21.6
Dane Coolidge Collection, 20/3381
Blanco family

BURRO GRANDE, 1932
Ink on Paper. 21.5 x 27.9
Dane Coolidge Collection, 20/3390
Blanco family

MAGUEY, 1932
Ink on Paper. 27.9 x 21.5
Dane Coolidge Collection, 20/3391
Blanco family

KILLER WHALE WITH 2 SERIS IN HIS STOMACH, 1932
Ink on Paper. 27.9 x 21.5
Dane Coolidge Collection, 20/3392
Blanco family

PAINTED WOMAN, 1932
Ink, Graphite on Paper. 27.9 x 21.5
Dane Coolidge Collection, 20/3393
Blanco family

ANIMALS, 1932
Ink, Graphite on Paper. 27.9 x 21.5
Dane Coolidge Collection, 20/3394
Blanco family

A GOD AND TWO LITTLE ONES, 1932
Ink on Paper. 27.9 x 21.5
Dane Coolidge Collection, 20/3395
Blanco family

MAN SHOOTING DEER, 1932
Ink on Paper. 27.9 x 21.5
Dane Coolidge Collection, 20/3396
Blanco family

CACTI, 1932
Ink on Paper. 27.9 x 21.5
Dane Coolidge Collection, 20/3397
Blanco family

RATTLESNAKE EATING COTTONTAIL, 1932
Ink, Graphite on Paper. 27.9 x 21.5
Dane Coolidge Collection, 20/3398
Blanco family

PELICANS EATING SARDINES, 1932
Ink on Paper. 27.9 x 21.5
Dane Coolidge Collection, 20/3399
Blanco family

GIANT RAY FROM BELOW, 1932
Ink on Paper. 27.9 x 21.5
Dane Coolidge Collection, 20/3400
Blanco family

MOUNTAIN, 1932
Ink on Paper. 27.9 x 21.5
Dane Coolidge Collection, 20/3411
Blanco family

BLACK CORMORANTS, 1932
Ink on Paper. 27.9 x 21.5
Dane Coolidge Collection, 20/3412
Blanco family

MULLETS AND SMALL BIRDS IN MOUNTAINS, 1932
Ink on Paper. 27.9 x 21.5
Dane Coolidge Collection, 20/3413
Blanco family

MULLETS AND SPARROWHAWKS, 1932
Ink on Paper. 27.9 x 21.5
Dane Coolidge Collection, 20/3414
Blanco family

OLD STYLE SERI HOUSE, 1932
Ink on Paper. 21.5 x 27.9
Dane Coolidge Collection, 20/3402
Ocatillo

FIRST TYPE OF SERI HOUSE, 1932
Ink on Paper. 21.5 x 27.9
Dane Coolidge Collection, 20/3403
Ocatillo

SHAWNEE

A INDIAN HUNTER IN 1870
Crayon, Graphite, Ink on Paper. 23.2 x 28.0
Frank G. Speck Collection, 7/3505A
Johnny John

HOT TIMES IN THE OLD TOWN, WITH COWBOYS
Crayon, Graphite, Ink on Paper. 23.0 x 24.9
Frank G. Speck Collection, 7/3505B
Johnny John

HOUSE, 1903
Crayon, Graphite, Ink on Paper. 23.2 x 27.4
Frank G. Speck Collection, 7/3505C
Johnny John

GOING HOME FROM THE DANCE ON HIGH LOPE
Crayon, Ink, Graphite on Paper. 23.2 x 27.2
Frank G. Speck Collection, 7/3505D
Johnny John

CHEROKEE BILL IN SHOOTING CONTEST
Crayon, Graphite, Ink on Paper. 23.3 x 27.5
Frank G. Speck Collection, 7/3505E
Johnny John

WAR DANCE AND GATHERING SCENE
Watercolor, Graphite, Crayon on Board. 44.0 x 63.5
M.R. Harrington Collection, 2/5614
Earnest L. Spybuck (1883-1949)

PROCESSION BEFORE WAR DANCE
Graphite, Watercolor on Board. 44.2 x 63.9
M.R. Harrington Collection, 2/5735
Earnest L. Spybuck (1883-1949)

FOOTBALL GAME
Watercolor, Graphite on Board. 43.0 x 65.4
M.R. Harrington Collection, 2/5784
Earnest L. Spybuck (1883-1949)

SHAWNEE HOME ABOUT 1890
Graphite, Watercolor on Board. 44.1 x 62.2
M.R. Harrington Collection, 2/5785
Earnest L. Spybuck (1883-1949)

MEN GAMBLING-MOCCASIN GAME
Graphite, Watercolor, Crayon on Board. 42.5 x 65.5
M.R. Harrington Collection, 2/5786
Earnest L. Spybuck (1883-1949)

KICKAPOO FEATHER DANCE
Watercolor, Graphite, Crayon on Board. 47.8 x 72.8
M.R. Harrington Collection, 2/5787
Earnest L. Spybuck (1883-1949)

SACRED BUNDLE DANCE BEFORE WAR DANCE
Watercolor, Graphite on Board. 44.9 x 69.4
M.R. Harrington Collection, 2/6396
Earnest L. Spybuck (1883-1949)

CHICKEN DANCE
Watercolor, Graphite, Crayon on Board. 44.7 x 62.9
M.R. Harrington Collection, 2/6397
Earnest L. Spybuck (1883-1949)

LEADER DANCE
Watercolor, Graphite, Crayon on Board. 29.9 x 48.8
M.R. Harrington Collection, 2/6926
Earnest L. Spybuck (1883-1949)

SHAWNEE INDIANS HAVING CORNBREAD DANCE
Watercolor, Graphite on Paper. 50.5 x 63.3
M.R. Harrington Collection, 2/6927
Earnest L. Spybuck (1883-1949)

PUMPKIN DANCE-PART OF BREAD DANCE
Graphite, Watercolor, Crayon on Paper. 50.5 x 63.0
M.R. Harrington Collection, 2/6928
Earnest L. Spybuck (1883-1949)

WOMAN'S DANCE AT NIGHT-PIGEON DANCE
Graphite, Watercolor, Crayon on Board. 35.7 x 50.5
M.R. Harrington Collection, 2/7135
Earnest L. Spybuck (1883-1949)

DANCE AT NIGHT- FISH DANCE
Watercolor, Graphite on Board. 38.1 x 50.5
M.R. Harrington Collection, 2/7136
Earnest L. Spybuck (1883-1949)

KILLING DOGS FOR SAC & FOX MEDAWIN CEREMONY
Graphite, Watercolor, Crayon on Paper. 47.8 x 64.0
M.R. Harrington Collection, 2/7479
Earnest L. Spybuck (1883-1949)

SAC & FOX EMERGING FROM SWEAT HOUSE
Watercolor, Graphite on Paper. 40.4 x 58.8
M.R. Harrington Collection, 2/7480
Earnest L. Spybuck (1883-1949)

SAC & FOX MEDAWIN CEREMONY
Watercolor, Graphite, Crayon on Paper. 48.2 x 66.1
M.R. Harrington Collection, 2/7481
Earnest L. Spybuck (1883-1949)

SAC & FOX DRUM DANCE
Graphite, Watercolor, Crayon on Board. 47.9 x 64.3
M.R. Harrington Collection, 2/7644
Earnest L. Spybuck (1883-1949)

DANCE AT SAC & FOX SACRED BUNDLE FEAST
Watercolor, Graphite, Crayon on Board. 44.6 x 65.5
M.R.Harrington Collection, 2/7650
Earnest L. Spybuck (1883-1949)

SINGEING DOGS BY SAC & FOX FOR FEAST
Graphite, Watercolor on Board. 45.4 x 68.0
M.R. Harrington Collection, 2/8437
Earnest L. Spybuck (1883-1949)

DELAWARE CEREMONY IN OKLAHOMA,1912
Watercolor, Graphite on Board. 45.3 x 70.4
M.R. Harrington Collection, 3/2720
Earnest L. Spybuck (1883-1949)

DELAWARE ANNUAL CEREMONY IN OKLAHOMA
Watercolor, Graphite on Board. 45.0 x 67.5
M.R. Harrington Collection, 3/2720A
Earnest L. Spybuck (1883-1949)

KICKAPOO PEYOTE CEREMONY
Watercolor, Graphite on Board. 43.0 x 65.4
M.R. Harrington Collection, 3/3612
Earnest L. Spybuck (1883-1949)

DELAWARE PEYOTE CEREMONY
Watercolor, Graphite on Board. 45.4 x 68.3
M.R. Harrington Collection, 3/3612A
Earnest L. Spybuck (1883-1949)

TWO SPELL SCENES
Graphite, Watercolor on Board. 49.2 x 39.8
M.R. Harrington Collection, 3/3613
Earnest L. Spybuck (1883-1949)

WITCH IN HUMAN AND ANIMAL GUISES
Watercolor, Graphite on Board. 49.5 x 39.6
M.R. Harrington Collection, 3/3613A
Earnest L. Spybuck (1883-1949)

SAC AND FOX BUFFALO DANCE
Watercolor, Graphite on Board. 45.3 x 69.0
M.R. Harrington Collection, 7/4791
Earnest L. Spybuck (1883-1949)

MY HOME, 1921
Watercolor, Crayon, Graphite on Lined Paper. 18.9 x 25.1
M.R. Harrington Collection, 25/1105
Earnest L. Spybuck (1883-1949)

SIOUX

LEDGER BOOK BY SEVERAL ARTISTS, 1898
Graphite, Crayon on Paper. 13.9 x 20.3
Mrs. John Jay White Collection, 11/1708
Artists Unknown

HAITSAI 'THIS KIOWA GIRL MY GIRL'
Graphite, Ink, Crayon on Lined Paper. 15.2 x 15.2
General William Nicholson Grier Collection, 23/2854B
Artist Unknown

MAN ON HORSE WITH GIRL
Ink, Crayon, Graphite on Lined Paper. 15.2 x 19.0
General William Nicholson Grier Collection, 23/2854C
Artist Unknown

THREE FIGURES
Ink, Crayon on Lined Paper. 12.7 x 12.0
General William Nicholson Grier Collection, 23/2854D
Artist Unknown

'THIS YOUNG MAN AND LADIE MEET THERE GOOD FRIEND'
Crayon, Graphite on Paper. 21.5 x 27.9
General William Nicholson Grier Collection, 23/2854E
Artist Unknown

TASUKE HISA
Graphite, Crayon on Vellum. 17.7 x 26.9
Mrs. Reese Franklin Hill Collection, 23/6866
Artist Unknown

TASUKE HISA
Graphite, Crayon on Paper. 17.6 x 20.5
Mrs. Reese Franklin Hill Collection, 23/6867
Artist Unknown

CAJE YATAPAWIN
Graphite, Colored Pencil on Paper. 27.4 x 17.0
Mrs. Reese Franklin Hill Collection, 23/6868
Artist Unknown

TAIUKE HISA
Graphite, Crayon on Paper. 18.7 x 19.4
Mrs. Reese Franklin Hill Collection, 23/6869
Artist Unknown

WAGON TEAM
Graphite on Paper. 21.8 x 30.4
Anonymous Collection, 25/1096
Artist Unknown

TWO RIDERS AND BUCKING HORSE
Graphite on Paper. 21.8 x 30.4
Anonymous Collection, 25/1097
Artist Unknown

SKETCHES OF ANIMALS, 1890
Graphite on Paper. 13.8 x 10.3
Mrs. Emma Dow Collection, 13/3908
Thomas Firecloud Louis Firetail Daniel W. Hermans

MEN AND WOMAN
Ink, Crayon, Graphite on Lined Paper. 12.7 x 17.7
General William Nicholson Grier Collection, 23/2854A
Samuel

COVERED WAGON, 1895
Graphite on Paper. 21.5 x 30.4
Anonymous Collection, 25/1099A
James Abraham & Garfield Raymond

HORSES
Graphite on Paper. 21.5 x 30.4
Anonymous Collection, 25/1099B
James Abraham & Garfield Raymond

WAGON DRIVER AND TEAM OF HORSES
Graphite on Lined Paper. 13.4 x 20.2
Anonymous Collection, 25/1100
James Abraham & Garfield Raymond

BOY WITH HEADDRESS
Graphite on Paper. 21.5 x 30.3
Anonymous Collection, 25/1094
Black Bear

GEOMETRIC DESIGNS
Graphite on Paper. 21.5 x 21.2
Anonymous Collection, 25/1098
Angelique Greenwood

FIELD SPORTS NEAR FORT BUFORD;1868., 1884
Ink on Board. 15.3 x 29.0
DeCost Smith Collection, 20/1632
His Fight.

ONE STAR(?) BEAR AND WOMAN
Graphite, Watercolor on Paper. 16.6 x 21.4
Joseph Keppler Collection, 11/2915
Looks at the Mountain

TWO RIDERS
Graphite on Paper. 15.0 x 21.5
Anonymous Collection, 25/1101A
Peter Poor-Elk

TWO HORSES, ELEPHANT
Graphite on Paper. 15.1 x 21.5
Anonymous Collection, 25/1101B
Peter Poor-Elk

A WARRIOR, 1934
Watercolor on Paper. 24.8 x 22.5
Charles and Ruth DeYoung Elkus Collection, 23/1253
Dan Quiver

BOOK OF DRAWINGS, c.1884
Crayon, Ink on Paper. 19.1 x 12.7
Eleanor Sherman Fitch Collection, 20/6230
Red Dog

MEN AND HORSES
Graphite on Paper. 20.2 x 12.4
Anonymous Collection, 25/1093
Jesse Ross

WAGON DRIVER AND TEAM OF 4 HORSES
Graphite on Paper. 21.8 x 30.4
Anonymous Collection, 25/1095A
Jesse Ross

COWBOY ON HORSE ROPING HORSE
Graphite on Paper. 21.8 x 30.4
Anonymous Collection, 25/1095B
Jesse Ross

TWO COWBOYS ON HORSEBACK ROPING TWO HORSES
Graphite on Paper. 21.8 x 30.4
Anonymous Collection, 25/1095C
Jesse Ross

COWBOY ON HORSE
Graphite on Paper. 21.8 x 30.4
Anonymous Collection, 25/1095D
Jesse Ross

TWO MEN ON HORSEBACK, 1936
Watercolor on Paper. 26.5 x 23.8
Oscar B. Jacobson Collection, 23/6036
O.B. Runner

MOUNTAIN SCENE; MAN WITH 3 HORSES, 1973
Graphite, Watercolor, Pen on Board. 37.9 x 50.5
Marvin Runs Above Collection, 24/8914
Marvin Runs Above

WOLAKOTA WACIN, 1973
Pen, Marker on Construction Paper. 37.9 x 50.9
Purchase, 24/8915
Marvin Runs Above

HEYOKA, 1966
Watercolor on Paper. 39.5 x 45.0
Philbrook Art Center Annual, 23/6990
Tahcawin (1929-)

HUNKPAPA SIOUX

MEN ON HORSES, 1884
Ink on Board. 15.5 x 29.1
DeCost Smith Collection, 20/1633
Artist Unknown

WOMAN NEAR MAN ON HORSEBACK, 1884
Graphite, Crayon on Lined Paper. 17.5 x 21.7
DeCost Smith Collection, 20/1625
Hawk Man (-c.1890)

FIELD SPORTS NEAR FORT BUFORD IN 1868, 1884
Ink, Watercolor on Board. 15.6 x 23.9
DeCost Smith Collection, 20/1631
His Fight

MEN DANCING, 1885
Graphite, Crayon on Paper. 11.4 x 17.7
DeCost Smith Collection, 20/1626
Rain-in-the-Face (c.1825-1904)

MAN KILLING MAN ON WOUNDED HORSE, 1885
Graphite, Crayon on Paper. 11.5 x 17.7
DeCost Smith Collection, 20/1627
Rain-in-the-Face (c.1825-1904)

MEN DANCING, 1885
Graphite, Crayon on Paper. 11.4 x 17.7
DeCost Smith Collection, 20/1628
Rain-in-the-Face (c.1825-1904)

PICTORAL AUTOGRAPH OF ARTIST AND SKETCH, 1885
Graphite on Paper. 17.7 x 11.5
DeCost Smith Collection, 20/1629
Rain-in-the-Face (c.1825-1904)

SIGNATURE OF ARTIST, 1884
Graphite, Ink on Paper. 11.4 x 17.7
DeCost Smith Collection, 20/1630
Rain-in-the-Face (c.1825-1904)

DEER DANCER
Graphite, Watercolor on Paper. 18.4 x 27.7
Purchase, 22/9018
Rain-in-the-Face (c.1825-1904)

DEER FIGURE HOLDING HOOP
Graphite, Watercolor on Paper. 17.3 x 26.6
Purchase, 22/9019
Rain-in-the-Face (c.1825-1904)

WOMAN AND TIPIS
Graphite, Watercolor on Paper. 18.4 x 26.8
Purchase, 22/9020
Rain-in-the-Face (c.1825-1904)

MAN ON WOUNDED HORSE
Graphite, Watercolor on Paper. 18.7 x 27.6
Purchase, 22/9021
Rain-in-the-Face (c.1825-1904)

MAN IN MASK NEXT TO TIPI
Graphite, Watercolor on Paper. 17.2 x 26.8
Purchase, 22/9022
Rain-in-the-Face (c.1825-1904)

MAN IN BUFFALO MASK
Graphite, Watercolor on Paper. 18.8 x 26.1
Purchase, 22/9023
Rain-in-the-Face (c.1825-1904)

MAN IN BEAR MASK
Graphite, Watercolor on Paper. 17.4 x 26.4
Purchase, 22/9024
Rain-in-the-Face (c.1825-1904)

MAN KILLING BEARS WITH BOW AND ARROWS
Graphite, Watercolor on Paper. 18.3 x 26.6
Purchase, 22/9025
Rain-in-the-Face (c.1825-1904)

MAN AND WOMAN EMBRACING
Graphite, Watercolor on Paper. 17.4 x 27.4
Purchase, 22/9026
Rain-in-the-Face (c.1825-1904)

MAN AND WOMAN EMBRACING
Graphite, Watercolor on Paper. 18.2 x 27.6
Purchase, 22/9027
Rain-in-the-Face (c.1825-1904)

MINICONJOU SIOUX

GRASS DANCE, c.1890
Ink on Paper. 82.6 x 47.0
Captain Joseph Hurst Collection, 15/3231
Pete Three Legs

OGLALA SIOUX

PICTURE SIGNATURES OF OGLALA AT PINE RIDGE
Graphite, Ink, Crayon on Lined Paper. 32.5 x 41.5
E.L. Guthrie Collection, 12/2929
Artist Unknown

DON'T BRAID HIS HAIR FIGHTING A CROW, c.1880
Ink, Crayon, Graphite on Lined Paper. 28.1 x 50.9
John W. Alder Collection, 10/9627
Dont-Braid-His-Hair

CAPTURE OF DULL-KNIFE'S BAND, c.1880
Graphite, Crayon on Lined Paper. 40.5 x 25.0
John W. Alder Collection, 10/9626
Lone Bear

WOMAN WITH MAN ON YELLOW HORSE, c.1880
Ink, Graphite, Crayon on Lined Paper. 19.0 x 28.1
John W. Alder Collection, 10/9620
Long Cat

LONG CAT GOING TO SUN DANCE, c.1880
Graphite, Ink on Lined Paper. 20.3 x 31.7
John W. Alder Collection, 10/9621A
Long Cat

LONG CAT COUNTING COUPS AS A CHIEF, c.1880
Graphite, Ink on Lined Paper. 20.3 x 31.7
John W. Alder Collection, 10/9621B
Long Cat

LONG CAT MADE DANCE CHIEF AND SOLDIER CHIEF, c.1880
Graphite, Ink on Lined Paper. 20.3 x 31.7
John W. Alder Collection, 10/9621C
Long Cat

LONG CAT AT WHITE RIVER, c.1880
Graphite, Ink on Lined Paper. 20.3 x 31.7
John W. Alder Collection, 10/9621D
Long Cat

LONG CAT ON HORSEBACK, c.1880
Graphite, Ink on Lined Paper. 20.3 x 31.7
John W. Alder Collection, 10/9621E
Long Cat

LONG CAT AT SUN DANCE MADE DRUM CHIEF, c.1880
Graphite, Ink on Lined Paper. 20.3 x 31.7
John W. Alder Collection, 10/9621F
Long Cat

LONG CAT MADE GAME CHIEF, c.1880
Graphite, Ink on Lined Paper. 20.3 x 31.7
John W. Alder Collection, 10/9621G
Long Cat

LONG CAT AND OMAHA CHIEF, c.1880
Graphite, Ink on Lined Paper. 20.3 x 31.7
John W. Alder Collection, 10/9621H
Long Cat

LONG CAT MADE CHIEF, c.1880
Graphite, Ink on Lined Paper. 20.3 x 31.7
John W. Alder Collection, 10/9621I
Long Cat

LONG CAT MADE CHIEF AT CHATREN CREEK, c.1880
Graphite, Ink on Lined Paper. 20.3 x 31.7
John W. Alder Collection, 10/9621J
Long Cat

THE TIME LONG CAT QUIT HIS WILD WAYS, c.1880
Graphite, Ink on Lined Paper. 20.3 x 31.7
John W. Alder Collection, 10/9621K
Long Cat

SPOTTED TAIL AGENCY CAMP, c.1880
Graphite, Ink on Lined Paper. 20.3 x 31.7
John W. Alder Collection, 10/9621L
Long Cat

MADE CHIEF TO HUNT THE POLE, c.1880
Graphite, Ink on Lined Paper. 20.3 x 31.7
John W. Alder Collection, 10/9621M
Long Cat

LONG CAT ON HORSEBACK, c.1880
Graphite, Ink on Lined Paper. 20.3 x 31.7
John W. Alder Collection, 10/9621N
Long Cat

AN OMAHA KILLS A HORSE UNDER LONG CAT, c.1880
Ink, Graphite, Colored Pencil on Lined Paper. 20.0 x 31.5
John W. Alder Collection, 10/9622
Long Cat

LONG CAT KILLING A PAWNEE, c.1880
Ink, Watercolor, Crayon on Lined Paper. 20.4 x 31.5
John W. Alder Collection, 10/9623
Long Cat

LONG CAT TAKING AN OMAHA PRISONER, c.1880
Graphite, Ink, Crayon on Lined Paper. 19.8 x 31.8
John W. Alder Collection, 10/9624
Long Cat

LONG CAT SURROUNDED BY PAWNEE, c.1880
Ink, Crayon on Lined Paper. 20.1 x 32.0
John W. Alder Collection, 10/9625
Long Cat

MAN ON HORSEBACK, 1880
Ink, Graphite, Crayon on Lined Paper. 33.5 x 32.2
John W. Alder Collection, 10/9628
Man-Who-Carries-The-Sword

SIOUX MAN ON HORSEBACK, c.1880
Ink, Crayon, Graphite on Lined Paper. 35.4 x 51.6
John W. Alder Collection, 10/9629
Man-Who-Carries-The-Sword

MAN ON HORSEBACK WITH LANCE, c.1880
Ink, Crayon on Lined Paper. 35.8 x 40.5
John W. Alder Collection, 10/9630
Man-Who-Carries-The-Sword

YANKTON SIOUX

BUFFALO'S FOOT, 1883
Graphite, Watercolor on Paper. 24.5 x 33.7
DeCost Smith Collection, 20/1226
Little Cook

THREE FIGURES, TWO ARE WOUNDED, 1883
Watercolor, Graphite on Paper. 24.7 x 32.0
DeCost Smith Collection, 20/1623
Little Cook

MAN ON HORSEBACK CHASING TWO BUFFALO, 1883
Graphite on Paper. 24.5 x 31.8
DeCost Smith Collection, 20/1624
Little Cook

TIMUCUA (FLORIDA) 1564
Watercolor, Graphite on Paper. 43.5 x 30.1
Oscar B. Jacobson Collection, 24/9000
Oscar Howe (1915-)

SECOTA (VIRGINIA) 1590
Watercolor, Graphite on Paper. 43.5 x 30.1
Oscar B. Jacobson Collection, 24/9001
Oscar Howe (1915-)

POWHATAN 1607
Watercolor, Graphite on Paper. 43.5 x 30.1
Oscar B. Jacobson Collection, 24/9002
Oscar Howe (1915-)

POCAHONTAS IN ENGLISH COURT DRESS 1615
Watercolor, Graphite on Paper. 43.5 x 30.1
Oscar B. Jacobson Collection, 24/9003
Oscar Howe (1915-)

MAHICAN 1650
Watercolor, Graphite on Paper. 43.5 x 30.1
Oscar B. Jacobson Collection, 24/9004
Oscar Howe (1915-)

COCOPA (YUMA) 1700
Watercolor, Graphite on Paper. 43.5 x 30.1
Oscar B. Jacobson Collection, 24/9005
Oscar Howe (1915-)

SENECA 1700
Watercolor, Graphite on Paper. 43.5 x 30.1
Oscar B. Jacobson Collection, 24/9006
Oscar Howe (1915-)

MOHAWK CHIEF 1750
Watercolor, Graphite on Paper. 43.5 x 30.1
Oscar B. Jacobson Collection, 24/9007
Oscar Howe (1915-)

IROQUOIS 1776
Print. 43.5 x 30.1
Oscar B. Jacobson Collection, 24/9008
Oscar Howe (1915-)

SAUK CHIEF 1780
Watercolor, Graphite on Paper. 43.5 x 30.1
Oscar B. Jacobson Collection, 24/9009
Oscar Howe (1915-)

MOHAVE 1800
Watercolor, Graphite on Paper. 43.5 x 30.1
Oscar B. Jacobson Collection, 24/9010
Oscar Howe (1915-)

CHEROKEE 1790
Watercolor, Graphite on Paper. 43.5 x 30.1
Oscar B. Jacobson Collection, 24/9011
Oscar Howe (1915-)

CLAYOQUOT, NOOTKA TRIBE 1800
Watercolor, Graphite on Paper. 43.5 x 30.1
Oscar B. Jacobson Collection, 24/9012
Oscar Howe (1915-)

CROW WOMAN 1804
Watercolor, Graphite on Paper. 43.5 x 30.1
Oscar B. Jacobson Collection, 24/9013
Oscar Howe (1915-)

SEMINOLE CHIEF 1810
Watercolor, Graphite on Paper. 43.5 x 30.1
Oscar B. Jacobson Collection, 24/9014
Oscar Howe (1915-)

CREEK 1812
Watercolor, Graphite on Paper. 43.5 x 30.1
Oscar B. Jacobson Collection, 24/9015
Oscar Howe (1915-)

OJIBWAY CHIEF 1820
Watercolor, Graphite on Paper. 43.5 x 30.1
Oscar B. Jacobson Collection, 24/9016
Oscar Howe (1915-)

MANDAN 1832
Watercolor, Graphite on Paper. 43.5 x 30.1
Oscar B. Jacobson Collection, 24/9017
Oscar Howe (1915-)

IOWA 1840
Watercolor, Graphite on Paper. 43.5 x 30.1
Oscar B. Jacobson Collection, 24/9018
Oscar Howe (1915-)

PAPAGO 1850
Watercolor, Graphite on Paper. 43.5 x 30.1
Oscar B. Jacobson Collection, 24/9019
Oscar Howe (1915-)

OJIBWAY GIRL 1850
Watercolor, Graphite on Paper. 43.5 x 30.1
Oscar B. Jacobson Collection, 24/9020
Oscar Howe (1915-)

YUROK 1850
Watercolor, Graphite on Paper. 43.5 x 30.1
Oscar B. Jacobson Collection, 24/9021
Oscar Howe (1915-)

BLACKFOOT 1850
Watercolor, Graphite on Paper. 43.5 x 30.1
Oscar B. Jacobson Collection, 24/9022
Oscar Howe (1915-)

CHEYENNE WARRIOR 1860
Watercolor, Graphite on Paper. 43.5 x 30.1
Oscar B. Jacobson Collection, 24/9023
Oscar Howe (1915-)

PAWNEE 1860
Watercolor, Graphite on Paper. 43.5 x 30.1
Oscar B. Jacobson Collection, 24/9024
Oscar Howe (1915-)

KANSA OR KAW 1865
Watercolor, Graphite on Paper. 43.5 x 30.1
Oscar B. Jacobson Collection, 24/9025
Oscar Howe (1915-)

PIMA WOMAN 1870
Watercolor, Graphite on Paper. 43.5 x 30.1
Oscar B. Jacobson Collection, 24/9026
Oscar Howe (1915-)

OMAHA 1870
Watercolor, Graphite on Paper. 43.5 x 30.1
Oscar B. Jacobson Collection, 24/9027
Oscar Howe (1915-)

ARAPAHO 1875
Watercolor, Graphite on Paper. 43.5 x 30.1
Oscar B. Jacobson Collection, 24/9028
Oscar Howe (1915-)

HOPI BRIDE 1880
Watercolor, Graphite on Paper. 43.5 x 30.1
Oscar B. Jacobson Collection, 24/9029
Oscar Howe (1915-)

DAKOTA WOMAN 1880
Watercolor, Graphite on Paper. 43.5 x 30.1
Oscar B. Jacobson Collection, 24/9030
Oscar Howe (1915-)

OSAGE 1880
Watercolor, Graphite on Paper. 43.5 x 30.1
Oscar B. Jacobson Collection, 24/9031

HUPA GIRL 1880
Watercolor, Graphite on Paper. 43.5 x 30.1
Oscar B. Jacobson Collection, 24/9032
Oscar Howe (1915-)

QUANNAH PARKER, COMANCHE CHIEF 1880
Watercolor, Graphite on Paper. 43.5 x 30.1
Oscar B. Jacobson Collection, 24/9033
Oscar Howe (1915-)

CHEYENNE 1880
Watercolor, Graphite on Paper. 43.5 x 30.1
Oscar B. Jacobson Collection, 24/9034
Oscar Howe (1915-)

APACHE 1885
Watercolor, Graphite on Paper. 43.5 x 30.1
Oscar B. Jacobson Collection, 24/9035
Oscar Howe (1915-)

OGLALA SIOUX CHIEF (FORMAL) 1885
Watercolor, Graphite on Paper. 43.5 x 30.1
Oscar B. Jacobson Collection, 24/9036
Oscar Howe (1915-)

ASSINIBOIN WOMAN 1890
Watercolor, Graphite on Paper. 43.5 x 30.1
Oscar B. Jacobson Collection, 24/9037
Oscar Howe (1915-)

TAOS PUEBLO 1930
Watercolor, Graphite on Paper. 43.5 x 30.1
Oscar B. Jacobson Collection, 24/9038
Oscar Howe (1915-)

HAIDA 1900
Watercolor, Graphite on Paper. 43.5 x 30.1
Oscar B. Jacobson Collection, 24/9039
Oscar Howe (1915-)

PONCA 1910
Watercolor, Graphite on Paper. 43.5 x 30.1
Oscar B. Jacobson Collection, 24/9040
Oscar Howe (1915-)

NAVAJO 1920
Watercolor, Graphite on Paper. 43.5 x 30.1
Oscar B. Jacobson Collection, 24/9041
Oscar Howe (1915-)

NAVAJO WOMAN 1920
Watercolor, Graphite on Paper. 43.5 x 30.1
Oscar B. Jacobson Collection, 24/9042
Oscar Howe (1915-)

TSA-TO-KE, KIOWA 1930
Watercolor, Graphite on Paper. 43.5 x 30.1
Oscar B. Jacobson Collection, 24/9043
Oscar Howe (1915-)

KIOWA MOTHER 1930
Watercolor, Graphite on Paper. 43.5 x 30.1
Oscar B. Jacobson Collection, 24/9044
Oscar Howe (1915-)

OKLAHOMA INDIAN 1930
Watercolor, Graphite on Paper. 43.5 x 30.1
Oscar B. Jacobson Collection, 24/9045
Oscar Howe (1915-)

SEMINOLE (FLORIDA) 1945
Watercolor, Graphite on Paper. 43.5 x 30.1
Oscar B. Jacobson Collection, 24/9046
Oscar Howe (1915-)

APACHE SCHOOL GIRL 1948
Watercolor, Graphite on Paper. 43.5 x 30.1
Oscar B. Jacobson Collection, 24/9047
Oscar Howe (1915-)

YOUNG INDIAN 1950
Watercolor, Graphite on Paper. 43.5 x 30.1
Oscar B. Jacobson Collection, 24/9048
Oscar Howe (1915-)

Watercolor, Graphite on Paper. 43.5 x 30.1
Oscar B. Jacobson Collection, 24/9049
Oscar Howe (1915-)

ALGONQUIN WOMAN SUMMER DRESS 1700
Watercolor, Graphite on Paper. 43.5 x 30.1
Oscar B. Jacobson Collection, 24/9050
Oscar Howe (1915-)

COWICHAN, SALISH TRIBE 1912
Watercolor, Graphite on Paper. 43.5 x 30.1
Oscar B. Jacobson Collection, 24/9051
Oscar Howe (1915-)

SECOTA WOMAN (VIRGINIA) 1590
Watercolor, Graphite on Paper. 43.5 x 30.1
Oscar B. Jacobson Collection, 24/9052
Oscar Howe (1915-)

CLAYOQOUT WHALER, NOOTKA TRIBE (VANCOUVER IS.) 1800
Watercolor, Graphite on Paper. 43.5 x 30.1
Oscar B. Jacobson Collection, 24/9053
Oscar Howe (1915-)

KWAKIUTL WARRIOR 1800
Watercolor, Graphite on Paper. 43.5 x 30.1
Oscar B. Jacobson Collection, 24/9054
Oscar Howe (1915-)

OTO 1880
Watercolor, Graphite on Paper. 43.5 x 30.1
Oscar B. Jacobson Collection, 24/9055
Oscar Howe (1915-)

KICKAPOO 1825
Watercolor, Graphite on Paper. 43.5 x 30.1
Oscar B. Jacobson Collection, 24/9056
Oscar Howe (1915-)

QUINAULT WOMAN, SALISH TRIBE (WASHINGTON) EARLY 1800
Watercolor, Graphite on Paper. 43.5 x 30.1
Oscar B. Jacobson Collection, 24/9057
Oscar Howe (1915-)

APACHE 1750
Watercolor, Graphite on Paper. 43.5 x 30.1
Oscar B. Jacobson Collection, 24/9058
Oscar Howe (1915-)

THE COLLEGE INDIAN '49
Watercolor, Graphite on Paper. 43.5 x 30.1
Oscar B. Jacobson Collection, 24/9059
Oscar Howe (1915-)

WOMAN
Watercolor, Graphite on Paper. 43.5 x 30.1
Oscar B. Jacobson Collection, 24/9060
Oscar Howe (1915-)

PUEBLO WOMAN/MAN
Watercolor, Graphite on Paper. 43.5 x 30.1
Oscar B. Jacobson Collection, 24/9061
Oscar Howe (1915-)

WOMAN
Watercolor, Graphite on Paper. 43.5 x 30.1
Oscar B. Jacobson Collection, 24/9062
Oscar Howe (1915-)

TAOS

PUEBLO SCENE, c.1920
Oil on Canvas. 18.3 x 26.0
Mrs. H.U. Stillek Collection, 23/2014
Albert Lujan

TURTLE DANCE, 1951
Watercolor on Paper. 30.3 x 22.7
Byron Harvey III Collection, 23/6158
Vicente Lujan

TAOS GIRL, 1945
Watercolor on Paper. 27.5 x 17.0
Oscar B. Jacobson Collection, 23/6018
Margaret Lujan (c.1928-)

PUEBLO SCENE
Oil on Board. 17.7 x 22.7
Henry Craig Fleming Collection, 22/8611
Albert Martinez (-c.1941)

PUEBLO SCENE
Oil on Board. 17.4 x 22.9
Henry Craig Fleming Collection, 22/8612
Albert Martinez (-c.1941)

FEATHER DANCE
Ink, Graphite, Crayon on Paper. 15.9 x 24.0
Joseph Imhof Collection, 23/3365
Albert Martinez (-c.1941)

NIGHT CHANT
Graphite, Ink, Crayon on Paper. 16.0 x 24.2
Joseph Imhof Collection, 23/3366
Albert Martinez (-c.1941)

EAGLE DANCER
Crayon, Graphite, Ink on Paper. 15.9 x 12.2
Joseph Imhof Collection, 23/3367
Albert Martinez (-c.1941)

HOOP DANCE
Ink, Crayon, Graphite on Paper. 15.8 x 23.7
Joseph Imhof Collection, 23/3368
Albert Martinez (-c.1941)

DEER DANCE
Ink, Graphite, Crayon on Paper. 16.0 x 24.2
Joseph Imhof Collection, 23/3369
Albert Martinez (-c.1941)

HORSETAIL DANCE
Ink, Graphite, Crayon on Paper. 16.1 x 24.3
Joseph Imhof Collection, 23/3370
Albert Martinez (-c.1941)

BUFFALO DANCE
Graphite, Ink, Crayon on Paper. 15.8 x 12.2
Joseph Imhof Collection, 23/3371
Albert Martinez (-c.1941)

HORSE TAIL DANCER OR KIOWA PEYOTE DANCER, 1938
Watercolor on Paper. 28.3 x 21.7
Charles and Ruth DeYoung Elkus Collection, 23/1258
Vicenti Mirabal (1918-1946)

TESUQUE

BUFFALO DANCER
Watercolor, Graphite on Paper. 14.9 x 9.7
Anonymous Collection, 22/8520
Thomas Vigil (1889-1960)

DEER DANCER
Watercolor, Graphite on Paper. 15.1 x 10.1
Anonymous Collection, 22/8521
Thomas Vigil (1889-1960)

ZIA

TWO MEN ROPING HORSES
Watercolor on Board. 40.5 x 65.7
Henry Craig Fleming Collection, 22/8582
Velino Shije Herrera (1902-1973)

BLUE DEERS, 1938
Watercolor on Paper. 25.3 x 32.4
Jeanne O. Snodgrass Collection, 23/8379
Velino Shije Herrera (1902-1973)

TWO BIRDS, c.1935
Watercolor on Paper. 29.0 x 33.5
Charles and Ruth DeYoung Elkus Collection, 23/1257
J.B. Medina

CORN DANCE, 1964
Watercolor, Graphite on Paper. 17.0 x 12.0
Byron Harvey III Collection, 23/6157
J.B. Medina

THE CLOWNS, c.1940
Watercolor, Graphite on Paper. 42.2 x 35.0
Byron Harvey III Collection, 25/1090
Delfico Moquino

MUDHEADS AND WHIP DANCERS, 1952
Watercolor, Graphite on Paper. 42.2 x 35.0
Byron Harvey III Collection, 25/1091
Delfico Moquino

ZIA MUDHEADS, KOSHARE, AND KACHINA
Watercolor on Paper. 27.9 x 36.2
Charles and Ruth DeYoung Elkus Collection, 23/1255
Waka

ELK AND BUFFALO DANCE
Watercolor on Paper. 32.3 x 49.4
Oscar B. Jacobson Collection, 23/6017
Waka

ZUNI

POTS WITH DESIGNS, c.1935
Watercolor on Construction Paper. 21.5 x 26.7
Charles and Ruth DeYoung Elkus Collection, 23/1270
Artist Unknown

2 STYLIZED BIRDS, c.1935
Watercolor on Paper. 22.6 x 15.4
Charles and Ruth DeYoung Elkus Collection, 23/1273
Artist Unknown

ABSTRACT DESIGNS, c.1935
Watercolor on Construction Paper. 15.0 x 17.5
Charles and Ruth DeYoung Elkus Collection, 23/1271
Loretta and Stella

POTS WITH DESIGNS, c.1935
Watercolor on Construction Paper. 15.0 x 17.5
Charles and Ruth DeYoung Elkus Collection, 23/1272
Marian, Esther, and Ellen

RAIN DANCER, 1929
Watercolor, Graphite on Paper. 35.5 x 25.5
F.W. Hodge Collection, 19/8615
Charlie Boy

RAIN DANCER, 1929
Watercolor, Graphite on Paper. 35.5 x 25.5
F.W. Hodge Collection, 19/8616
Charlie Boy

LONG HAIR KATSINA DANCER, 1955
Watercolor on Board. 50.5 x 40.6
Byron Harvey III Collection, 23/1486
Anthony P. Edaakie

LONG HAIR KACHINA DANCER, 1955
Watercolor on Board. 50.8 x 40.6
Byron Harvey III Collection, 23/1487
Anthony P. Edaakie

ANTELOPE KATSINA, 1955
Watercolor on Board. 27.4 x 21.8
Byron Harvey III Collection, 23/1488
Anthony P. Edaakie

MITOTASHA KACHINA, c.1940
Watercolor on Paper. 56.0 x 38.0
Byron Harvey III Collection, 25/1088
Anthony P. Edaakie

NAHALICO KACHINA, c.1940
Watercolor, Graphite on Paper. 50.7 x 38.0
Byron Harvey III Collection, 25/1089
Anthony P. Edaakie

LAPILAWKA - MALE DANCER, 1955
Watercolor on Paper. 51.0 x 40.6
Byron Harvey Jr. Collection, 22/9521
Edmund J. Ladd

KACHINA
Watercolor on Paper. 50.9 x 40.5
Byron Harvey Jr. Collection, 22/9522
Edmund J. Ladd

HILILI OR HELELE KACHINA
Ink on Paper. 42.0 x 35.0
Byron Harvey Jr. Collection, 22/9523
Edmund J. Ladd

COMANCHI
Watercolor, Graphite on Paper. 30.0 x 22.5
Charles H. Kelsey Collection, 9/7042A
Lamina

INA MO MOWA
Watercolor, Graphite on Paper. 22.5 x 30.0
Charles H. Kelsey Collection, 9/7042B
Lamina

SHALICO
Watercolor, Graphite on Paper. 30.0 x 22.5
Charles H. Kelsey Collection, 9/7042C
Lamina

HEAH
Watercolor, Graphite on Paper. 30.0 x 22.5
Charles H. Kelsey Collection, 9/7042D
Lamina

KOYNESHES
Watercolor, Graphite on Paper. 22.5 x 30.0
Charles H. Kelsey Collection, 9/7042E
Lamina

CHA KA WIN
Watercolor, Graphite on Paper. 22.5 x 30.0
Charles H. Kelsey Collection, 9/7042F
Lamina

GIGALE
Watercolor, Graphite on Paper. 30.0 x 22.5
Charles H. Kelsey Collection, 9/7042G
Lamina

SIATASHI HAMOHATO
Watercolor, Graphite on Paper. 22.5 x 30.0
Charles H. Kelsey Collection, 9/7042H
Lamina

KACHINAS/SANTA FE INDIAN SCHOOL
Watercolor on Board. 28.0 x 17.8
Charles and Ruth DeYoung Elkus Collection, 23/1274
Howard Leekela

LITTLE FIRE GOD AND PRIEST, c.1950
Watercolor on Board. 31.8 x 38.1
Charles and Ruth DeYoung Elkus Collection, 23/1256
Luci

KACHINA MASK, 1929
Watercolor, Graphite on Paper. 8.7 x 13.5
F.W. Hodge Collection, 19/8613
Tomas Pablito

EAGLE KACHINA, 1929
Graphite, Watercolor on Paper. 19.5 x 25.6
F.W. Hodge Collection, 19/8614
Tomas Pablito

SHALAKO DANCER, 1929
Watercolor on Paper. 35.5 x 25.5
F.W. Hodge Collection, 19/8617
Tomas Pablito

ANG-A KACHINA AND ANG-A KACHINA MANA, 1929
Watercolor, Ink on Lined Paper. 48.8 x 43.0
F.W. Hodge Collection, 20/8955
Tomas Pablito

TWO NAHALICO KACHINAS, 1951
Watercolor on Board. 29.9 x 39.6
Byron Harvey III Collection, 23/6156
Peter Pincion

KACHINA
Watercolor, Graphite on Paper. 30.2 x 22.6
Mrs. E.B. Johnson Collection, 16/5279
Emily Pinto

ZUNI JAR, 1929
Watercolor on Paper. 35.6 x 25.5
F.W. Hodge Collection, 19/8618
Emily Pinto

ZUNI JAR, 1929
Watercolor on Paper. 25.5 x 35.5
F.W. Hodge Collection, 19/8619
Emily Pinto

ZUNI JAR
Watercolor on Paper. 25.4 x 35.5
F.W. Hodge Collection, 19/8620
Emily Pinto

HILILI KACHINA, 1923
Watercolor on Board. 30.5 x 22.9
Byron Harvey III Collection, 23/7576
Raynold Poblano

KACHINA DANCER, 1926
Watercolor, Graphite on Paper. 34.8 x 28.0
Byron Harvey III Collection, 23/7591
Anthony Sanchez

KACHINA DANCER, 1924
Watercolor, Graphite on Paper. 32.4 x 24.7
Byron Harvey III Collection, 23/7592
Anthony Sanchez

KACHINA DANCER, 1925
Watercolor, Graphite on Paper. 34.8 x 28.1
Byron Harvey III Collection, 23/7593
Anthony Sanchez

PEPPERS
Graphite, Watercolor on Paper. 17.7 x 28.9
Joseph Imhof Collection, 23/3307
Percy Sandy (1918-)

CORN
Watercolor, Graphite on Paper. 17.3 x 28.0
Joseph Imhof Collection, 23/3308
Percy Sandy (1918-)

GOURDS (AND 2 RATTLES), c.1945
Graphite, Watercolor on Paper. 17.9 x 28.9
Joseph Imhof Collection, 23/3309
Percy Sandy (1918-)

4 SQUASH, c.1945
Watercolor, Graphite on Paper. 18.4 x 29.3
Joseph Imhof Collection, 23/3310
Percy Sandy (1918-)

SWALLOWING THE SWORD, c.1945
Watercolor, Graphite on Paper. 27.9 x 20.1
Joseph Imhof Collection, 23/3311
Percy Sandy (1918-)

ZUNI CORN DANCE, c.1945
Watercolor, Graphite on Paper. 30.3 x 23.0
Joseph Imhof Collection, 23/3312
Percy Sandy (1918-)

SERANADING THE CORN ALTAR, c.1950
Watercolor, Graphite on Paper. 22.7 x 30.4
Joseph Imhof Collection, 23/3313
Percy Sandy (1918-)

BLUE CORN MAN AND THE CORN MAIDENS, c.1945
Watercolor, Graphite on Paper. 20.1 x 28.0
Joseph Imhof Collection, 23/3314
Percy Sandy (1918-)

GRINDING YELLOW AND BLUE CORN, c.1945
Watercolor, Graphite on Paper. 19.9 x 22.7
Joseph Imhof Collection, 23/3315
Percy Sandy (1918-)

CORN MAIDENS SERANADING CORNS, c.1950
Watercolor, Graphite on Paper. 22.2 x 30.3
Joseph Imhof Collection, 23/3316
Percy Sandy (1918-)

PLANTING OF THE YELLOW CORN, c.1945
Watercolor, Graphite on Paper. 27.9 x 20.1
Joseph Imhof Collection, 23/3317
Percy Sandy (1918-)

GETTING FOOD FOR DINNER, c.1945
Watercolor on Paper. 36.7 x 28.2
Joseph Imhof Collection, 23/3319
Percy Sandy (1918-)

BLUE AND WHITE CORN GRINDING, c.1945
Watercolor on Paper. 29.1 x 37.0
Joseph Imhof Collection, 23/3320
Percy Sandy (1918-)

GIRL DRESSING, c.1945
Watercolor on Paper. 28.0 x 38.0
Joseph Imhof Collection, 23/3321
Percy Sandy (1918-)

ZUNI CORN CEREMONIAL, c.1955
Watercolor on Paper. 29.2 x 35.1
Joseph Imhof Collection, 23/3322
Percy Sandy (1918-)

THREE AROUND KACHINA IN MIST UNDER RAINBOW.
Graphite , Watercolor on Paper. 69.5 x 58.3
Jeanne O. Snodgrass Collection, 23/8391
Percy Sandy (1918-)

KNEELING WOMEN MAKING CORN MEAL
Ink on Paper. 19.2 x 16.0
Anonymous Collection, 25/1144
Percy Sandy (1918-)

MAN ON STOOL MAKING HAIR ORNAMENTS
Ink on Paper. 19.2 x 16.0
Anonymous Collection, 25/1145
Percy Sandy (1918-)

MAN WITH HOE AND CORNSTALK
Ink on Paper. 19.2 x 16.0
Anonymous Collection, 25/1146
Percy Sandy (1918-)

WOMAN PUTTING POTATOES IN OVEN
Ink on Paper. 19.2 x 16.0
Anonymous Collection, 25/1147
Percy Sandy (1918-)

ZUNI FIRE GOD, 1964
Watercolor on Board. 51.0 x 38.5
Philbrook Art Center Collection, 23/4135
Sullivan Shebola

HOME LIFE, 1955
Watercolor on Paper. 21.7 x 28.0
Byron Harvey Collection, 23/1489
Charles Vicenti

DEER KATSINA DANCER, 1935
Watercolor , Graphite on Paper. 30.4 x 21.0
Charles and Ruth DeYoung Elkus Collection, 23/1235
Marco Vigil

David M. Fawcett is Registrar at the Museum of the American Indian. He also teaches Museum Studies at Hunter College and is enrolled in the Doctoral Program in Anthropology at the Graduate Center of the City University of New York.

Lee A. Callander is Assistant Registrar at the Museum of the American Indian. She is a student in the Doctoral Program in Anthropology at the State University of New York at Stony Brook.